The World of Wade
Ireland

Ian Warner and Mike Posgay

MW00333909

Schiffer Publishing Ltd

4880 Lower Valley Road Atglen, pennsylvania 19310

Published by Schiffer Publishing Ltd.
4880 Lower Valley Road
Atglen, PA 19310
Phone: (610) 593-1777; Fax: (610) 593-2002
E-mail: Info@schifferbooks.com

For the largest selection of fine reference books on this and related subjects, please visit our web site at
www.schifferbooks.com
We are always looking for people to write books on new and related subjects. If you have an idea for a
book please contact us at the above address.

This book may be purchased from the publisher.
Include $3.95 for shipping.
Please try your bookstore first.
You may write for a free catalog.

In Europe, Schiffer books are distributed by
Bushwood Books
6 Marksbury Ave.
Kew Gardens
Surrey TW9 4JF England
Phone: 44 (0) 20 8392-8585; Fax: 44 (0) 20 8392-9876
E-mail: info@bushwoodbooks.co.uk
Website: www.bushwoodbooks.co.uk
Free postage in the U.K., Europe; air mail at cost.

Other Schiffer Books by Ian Warner and Mike Posgay
The World of Wade: Figurines and Miniatures

Other Schiffer Books on Related Subjects
Wade Miniatures, Revised 3rd Edition, by Donna S. Baker

Copyright © 2007 by Ian Warner and Mike Posgay
Library of Congress Control Number: 2006940718

All rights reserved. No part of this work may be reproduced or used in any form or by any means—graphic, electronic, or mechanical, including photocopying or information storage and retrieval systems—without written permission from the publisher.

The scanning, uploading and distribution of this book or any part thereof via the Internet or via any other means without the permission of the publisher is illegal and punishable by law. Please purchase only authorized editions and do not participate in or encourage the electronic piracy of copyrighted materials.

"Schiffer," "Schiffer Publishing Ltd. & Design," and the "Design of pen and ink well" are registered trademarks of Schiffer Publishing Ltd.

Covers and book designed by: Bruce Waters
Type set in Zapf Humanist Demi BT/Souvenir Lt BT

ISBN: 978-0-7643-2618-9
Printed in China

Copyrights

All figurines or items that are covered by trademarks, copyrights or logos, and used in this book, are for identification purposes only. All rights are reserved by their respective owners. Copyrights of journals, magazines, or other publications mentioned in this book are reserved by their respective owners or publishers. The Wade name and its trading style are registered copyright designs and are used by permission.

Dedication

This book is dedicated to the memory of our friend and fellow Wade collector, Jo-Ann Mandryk. Best known in North America, Jo-Ann was also well known by her many contacts overseas via the Internet. Jo-Ann is sorely missed by many.

Contents

Preface

From the early days of Wade (Ulster) Limited, all production of items, other than those for industrial use, was referred to as Gift Ware. In this book, we have categorized items into chapters such as Tableware, Tankards, etc., which is purely a means of separating the Gift Ware into a more easily controlled sequence.

This book is by no means complete as far as all the items produced by the Irish pottery. However, it is a start on documenting much of the Irish gift ware.

Although we deal with historical facts regarding the pottery, this book is not a detailed history of the Wade pottery in Portadown. Rather, this book is presented with the interests of the collector of Irish Wade in mind.

We have illustrated a number of prototypes in this book. We must note that those shown were photographed either at the home of the designer or modeler or had been in the possession of past factory employees and have since been handed down or sold at auction.

We advise collectors who have the opportunity to purchase prototype figurines to check first with Wade Ceramics Limited to verify that the items offered for sale have not been stolen.

Introduction

At the end of the Second World War in 1945, Colonel G.A. Wade (later Sir George Wade), as chairman of the British Electrical Ceramic Manufacturer's Association and as owner of George Wade and Son Ltd., was pressured by the British government to create new production facilities in depressed areas of the country. New plants in areas of high unemployment would go a long way towards helping servicemen and women find work upon their return from wartime assignments.

On returning from active service, Major H.S. Carryer, the husband of Col. Wade's daughter Iris, was asked by Col. Wade to scout the British Isles for a location for a new pottery. Eventually, in 1946, an old mill located on Watson Street in Portadown, Ulster (Northern Ireland), was chosen to be the new pottery. This mill was once owned by Linen Manufacturers Messrs. Armstrong and Company. The reasons for choosing the linen mill were the availability of 150,000 square feet of building area, plenty of good labor eager for training, and reasonable transportation facilities. The financial incentives from the Northern Ireland Ministry of Commerce provided additional reasons for choosing this site for the new pottery. With all this in mind, a 204 year long lease was signed in May 1947 and the renovations to the building began.

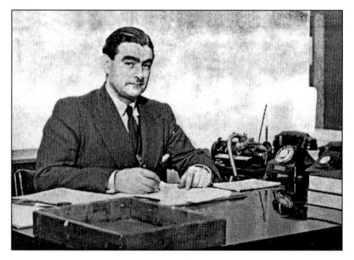

H. Straker Carryer circa mid 1950s.

The pottery was to produce much needed industrial ceramics, namely die-pressed porcelain insulators and refractories with which to help rebuild the sagging post-war economy. The plant was to contain a 300 foot long continuous oil fired tunnel kiln and employ a maximum of 450 operatives. The goal was to have the plant up and running within twelve months—rather a daunting proposition.

After much discussion, and somewhat reluctantly, Straker and Iris Carryer agreed to take on the job of establishing the new pottery and give up their cherished idea of making a new life in California. Under Straker Carryer's guidance (even though he had no experience in the field of potting) the new venture became a great success.

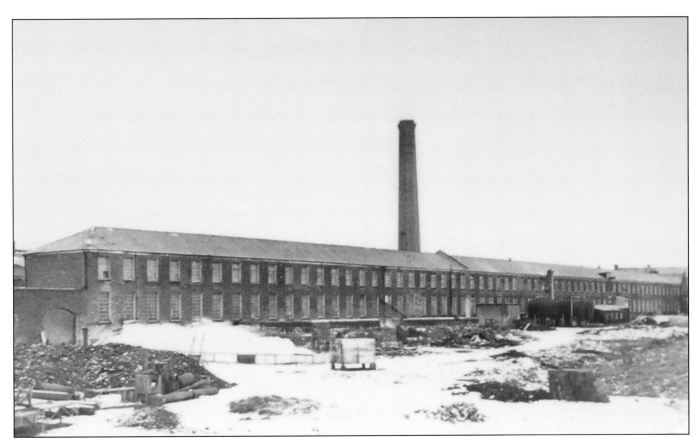

Wade (Ulster) Ltd. Pottery, early 1950s. View from across Watson Street.

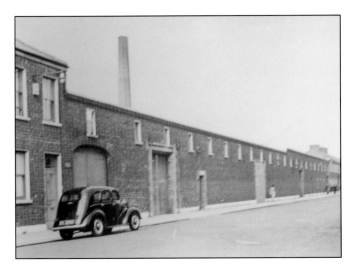

Wade (Ulster) Ltd. Pottery, circa early 1950s.
Front view to Watson Street.

First things first, the Carryers had to find a place in which to live. In 1947, with the help of a local real estate salesman, one Horace McClee, a rather run down house by the name of "Millview" was purchased and the Carryers moved in. It did not take long to realize the house was too far from the pottery, so a new house was built nearer the pottery in Portadown and by the early 1950s the family had once again moved house. In her book, *Searching for the Pony,* Iris writes: "Our new house was built with love. There were watercolor views from every window and it was only two miles from the new factory where I could wander and smell the clay and talk about important stuff like potting."

In January 1950, the pottery became a private limited company and was incorporated under the name of Wade (Ulster) Ltd., becoming a subsidiary of George Wade & Son Ltd. Local employees of the new pottery were quick to learn a new trade and proved the forecasts of doom and gloom by friends and competitors to be groundless.

Production prospered until around the early 1950s, when demand for die-pressed insulators slackened off. It was then decided to develop the production of turned insulators. These were made on lathes from solid, extruded clay. The Irish pottery had little experience with this type of operation so finally a long standing Wade employee from Burslem was persuaded to relocate in

Portadown to help out. This person was Ernest Taylor. In no time at all, Wade (Ulster) Ltd., with the help of Taylor, was producing and supplying all the telephone insulators used in the United Kingdom along with High Tension Insulators used in power transmission.

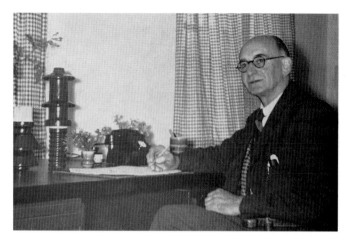

Ernest Taylor, from the Summer 1954 issue of *The Jolly Potter.*

It was not too long before there was another slow-down in demand for industrial ceramics so new ideas to keep the expensive production tools in use were sought. An unfortunate historical event turned out to be the answer to this quest.

In 1952, King George VI died and the coronation of the young Queen Elizabeth II was planned for 1953. Coronations and other royal events had traditionally been a busy time for potteries, as royal souvenirs had become quite collectible. Coronations caused somewhat of a problem for the potteries as the time between accession to the throne and the actual coronation was usually short. This left very little time for the design and production of the commemorative souvenirs. The potteries had also been "burned" when King Edward VIII abdicated just months before his coronation, leaving many firms holding onto worthless (at that time) commemorative items. British potters agreed, after that event, to limit production of future souvenir items.

At Wade (Ulster) Ltd., Straker Carryer needed a quantity of coronation tankards for a local celebration party. Carryer asked Wade Heath and Co. Ltd. to help out with this request but was informed that their quota for coronation souvenirs had been met and sold, and that the agreement for limited pieces was firm. A plea for help was then made to Col. Wade, who suggested that as Wade (Ulster) Ltd. was not a part of the original agreement, the pottery should go ahead and produce their own commemorative pieces.

Wade (Ulster) Ltd. was not equipped to manufacture gift ware but this new opportunity for increased production was too good a chance to pass up. Straker Carryer

gave Ernest Taylor an old pewter mug and asked him to create a similar tankard in porcelain. With the ingenuity of the Carryers and their staff, a lathe once used for the production of insulators was retooled to produce six samples of the tankard out of solid wads of clay.

Taylor then applied a unique design known as "knurling" onto the tankards, using a hand-held tool that formed small embossed or engraved decorations around the tankard whilst still in the "green" state and still turning on the lathe. This process was to become a standard for much of the gift ware produced in Portadown and the hand-held knurling tool was soon reproduced in a steel format by employees in the pottery tool room.

The six tankards were handed over to Cecil Holland, the glazing foreman, with instructions to glaze two white, two cobalt, and two rockingham brown. Three days later, Holland brought the tankards to Carryer's office with many apologies as he had messed up the glazes and the two supposedly cobalt blue tankards were nothing like the original request. The unexpected color that resulted from the mix up was immediately approved however, and poor Cecil Holland was asked to recreate his mistake and discover which glazes he had accidentally blended to produce such a unique result. This unique glaze has since become well known as the familiar "Irish Porcelain Glaze." The folks at the pottery all agreed that the unusual glaze was caused by "Leprechauns in the kiln" and over the years has proven to be impossible to recreate by potteries other than the Irish plant.

Cecil Holland's retirement in 1983. From left: Brian Burns (manager of the casting shop, clay manufacturing, and forming areas), Muriel Trouton (secretary to the Managing Director), G. Anthony J. Wade, Cecil Holland, Eileen Moore (casting shop director), and Jack Johnston.

Wade (Ulster) Ltd. annual outing, September 27th, 1952. From the Winter 1952 issue of *The Jolly Potter*.

As with most royal events, decorative transfers (first approved by the government and royal household) were made available to the potteries. Wade (Ulster) Ltd. chose the most simple of transfers for its first venture into gift ware. This was a simple monogram of the new queen supplied by Johnson and Matthey.

Quality control was very strict for the production of industrial ceramics and as every item produced had to pass through the Quality Control department, so did the new gift ware items. On seeing an inspector rejecting hundreds of perfect tankards simply because they were 200th of an inch undersize, Carryer decided something must be done! Discussing the problem with his wife one evening, it was decided that Iris Carryer, who had extensive experience in the field of ceramics and design, should become the Art Director of the Irish pottery. Under her direction, the pottery began the production of a long lasting and extensive line of gift ware items, from mugs and goblets to ashtrays, vases, cruets, and figurines, just to name a few.

In the early 1950s, demand for industrial ceramics tapered off and, as Iris Carryer wrote in her book, *Searching for the Pony*, "No-one anticipated a slump in insulator sales. No-one expected Government contracts to be canceled overnight, leaving new and specialized machinery lying idle. The threat of unemployment loomed again...Management of all Wade companies met in England."

At the Wade management meeting in Burslem, ideas for new products were fielded around but it wasn't until Iris Carryer looked at some complicated, pressed porcelain switches sitting on a mantle shelf that a truly inspired thought came to her. "I was thinking of my childhood 'Noah's Ark.' All the little animals, two by two. If we can press small insulators, why can't we press small animals instead?"

At first others at the meeting thought the idea technically impossible, but not Sir George Wade, who said "why not?" So from the agile brain of Iris Carryer, this was how the world famous "Whimsies" were born.

Modeler William Harper was given the task of designing the miniature animals and production was to be shared between the Irish and English potteries. The dies for all the Whimsies were made in Burslem, even those to be used at the Irish pottery. There were to be ten sets of figurines, of which sets 2, 4, 6, 8, and 10 were to be made in Ireland. The Irish pottery was not too happy that figurines to be made in Ireland were to be marked with a Wade England transfer, but Straker Carryer calmed the waters and production went ahead.

At first the Whimsies were not popular with the wholesalers, but when Wade displayed the first set of five boxed Whimsies at a British Industrial Fair, one European customer was intrigued and placed a large order. Other wholesalers soon followed suit and the Whimsies took off.

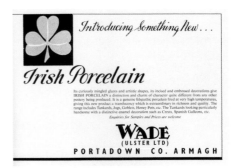

The first advertisement for Irish porcelain from the December 1953 issue of *Pottery and Glass*.

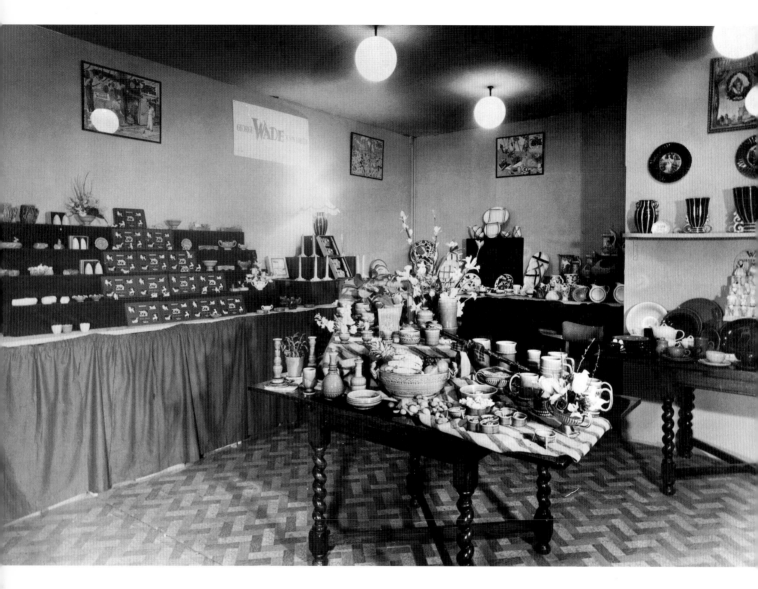

Wade exhibit at the 1954 British Industries Fair. Note the table of Irish Wade in the center of the picture.

Disaster struck the pottery in October 1956, when an early morning fire destroyed a large part of the building—approximately 20,000 square feet of the floor space. The tunnel kiln was buried under what was once the roof of the building and all that remained of the pottery were bare walls and twisted steel roof beams. However, within six days, the area had been cleared of debris and one hundred yards of new roof installed, the kiln relit, and power restored. Within another 24 hours, three quarters of the employees were back at their jobs. Luckily the business and property were well insured and the company received £87,323 (including £10,000 for loss of profits) under Policies of Insurance. By early 1958, the pottery had been completely restored and full production went ahead.

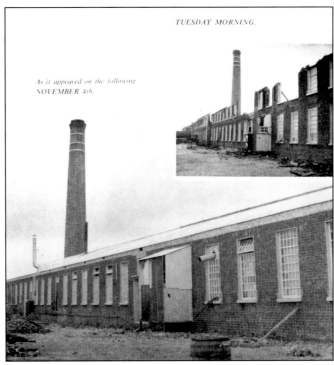

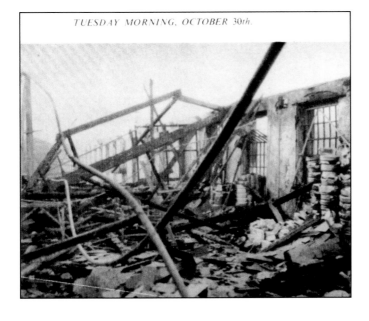

Left and above: After the fire. Tuesday morning October 30th, and as it appeared on the following November 4th, 1956. From the Winter 1956 issue of *The Jolly Potter*.

While Straker Carryer kept his eye on running the pottery, Iris Carryer widened her production of figurines from the Whimsies to a line of miniature leprechaun and pixie figurines, and later a line of much larger figurines in a style similar to the Lladro figures but based on typical Irish folklore characters. The folklore figurines were designed and modeled by William Harper and Raymond Piper. A set of less detailed figurines was also issued and given the name of Irish Character Figures. The Irish porcelain proved to be popular throughout the world, and over the years additional figural gift ware items were added to the line. An article in the November 1958 issue of *The Pottery Gazette and Glass Trade Review* shows a picture of an extensive display of Irish Wade at The Ghent International Fair.

With the Irish pottery up and running, Straker and Iris Carryer decided it was now time to leave Ireland and make a new home in the United States of America. So, in September 1964, the Carryer family left Ireland and sailed for the States.

Iris Carryer in her retirement, with a painting by her father, Sir George Wade, in the background.

In 1966, the Irish pottery had a change of name, becoming Wade (Ireland) Ltd., and at the same time went through a period of renovations. Production of the gift ware lines continued through the 1960s and 1970s. Sales were slow but the pottery struggled on. The January 1971 issue of *Tableware International and Pottery Gazette* reported that in early 1969, the operations of Wade (Ireland) Ltd. were to be more closely aligned with those of George Wade & Son Ltd. to help achieve stability and increased profitability. This alignment proved to be a success and record profits were achieved by both companies. The agreement lasted for a number of years. However by 1986, with sales slipping drastically at the Irish pottery, production of all gift ware lines was discontinued. No longer producing gift ware, the pottery completely retooled the production lines for the manufacture of fine ceramic tableware, which was introduced at the Birmingham and Frankfurt Spring Fairs of 1989.

Starting in the mid 1970s, long time employees of the Irish pottery were given awards for unbroken service under the "Long Service Award" program. For 10 years of service the award was a Plaque, for 15 years service the award was a Goblet, and for 25 years service the award was a Loving Cup. The first awards were given in 1977 presented by the late G. Anthony J. Wade. This program was discontinued sometime before 1980.

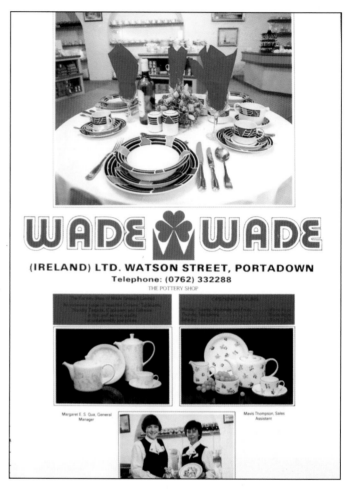

The Factory Shop. From an advertisement in the March 1990 *Ulster Tatler*.

The porcelain plaque awarded to Muriel Trouton, long time secretary to the Managing Director of Wade (Ireland) Ltd. Mrs. Trouton actually began working at the pottery in its very early days but until 1966 her service was not continuous.

Late in 1989, Beauford PLC took over the Wade Potteries. This takeover involved a number of changes to the Potteries, one of which was a change in name of the Irish pottery to Seagoe Ceramics Ltd., which then became an independent concern. Seagoe Ceramics Ltd. however, continued to manufacture tableware that was sold under the Wade brand name. In the early 1990s, whilst still producing tableware, Seagoe Ceramics Ltd. reissued the popular Wade (Ireland) Ltd. lines of Irish Character Figures and Irish Song Figures.

Unfortunately, the tableware did not become successful and the Irish Tableware and Gift Ware departments of the pottery ceased manufacturing in April 1993 to concentrate on engineering ceramics. Eventually, the Watson Street pottery ceased production and closed its premises. Seagoe Ceramics Limited moved to new premises outside of Portadown and in 1998 changed the name of the company to VZS Seagoe Advanced Ceramics. In 2002, production was ended in Northern Ireland when the company transferred all production to Scotland.

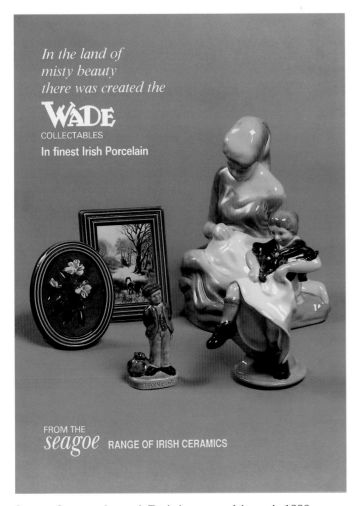

Seagoe Ceramics Limited. Trade literature of the early 1990s.

The Official International Wade Collectors Club

The Official International Wade Collectors Club was launched in 1994. The club was formed with the intention to unite Wade collectors throughout the world in their common enthusiasm for Wade products both, new and old.

Collectors who join the club receive a quarterly magazine. Issue No. 1 was published in September 1994. *The Official Wade Club Magazine* contains notices of new figurines to be released, interesting articles, letters from club members, Wade fair/show dates and reviews in both the U.K. and the U.S.A.

Members of the OIWCC receive a free exclusive figurine each year. These figurines are available only to club members. Throughout each membership year, special limited edition figurines are offered to club members.

To become a member of the OIWCC, write to:

The Official International Wade Collectors Club
Wade Ceramics Limited
Royal Victoria Pottery
Westport Road
Burslem, Stoke-on-Trent
Staffordshire, ST6 4AG, England U.K.

The email address is: club@wade.co.uk
The website for the club is: www.wade.co.uk

What to Look for When Purchasing Wade Items for Personal Collections

All prices are for items in excellent condition. We prefer not to use the overworked expression "mint," as this would refer to unused items still contained in the original unopened packaging. Of course it is also possible for so-called "mint" items to be damaged between final glazing and the original packaging.

It is advisable for collectors to remember a few tips when looking for Wade at flea markets, car boot sales, etc. It is often quite an exciting experience to find unusual or rare Wade items at the types of location listed above. To avoid disappointment when unpacking a "find" on arriving home, bear in mind the following suggestions:

1) Check for defects such as cracks or chips, either minor or extensive. It is amazing how easy it is to overlook damage of many sorts on dirty, unwashed items.

2) If, by any chance there are two similar items on a table, compare them for any damage, missing glaze, chips, etc. If there are rare or unusual items in large numbers, beware of reproductions!

3) Always buy what you really want and at prices that are realistic and also at prices that suit your pocketbook. As a collector, do not buy purely for investment.

Method of Establishing Prices

The suggested prices in *The World of Wade Ireland* are derived from prices submitted to us by advisers and contributors from both the United Kingdom and the United States of America.

It must be pointed out that the prices quoted are average prices.

Remember, this is a suggested price guide only. Prices suggested are not to be interpreted literally as final dealer prices; rather it is an indication of the range around which collectors might expect to pay.

Neither the authors nor the publisher are responsible for any outcomes resulting from consulting this reference.

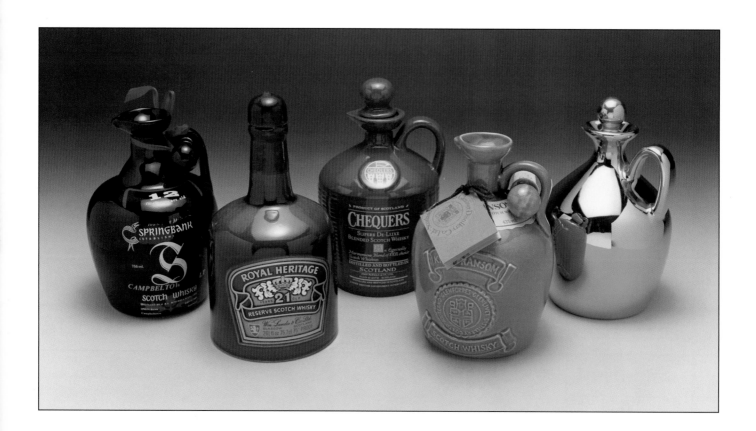

Acknowledgments

We would like to thank all former employees of the Irish pottery, whose skills, talent, and dedication to their work has given so much pleasure to collectors of Irish Wade porcelain.

We would also like to extend our sincere gratitude to the many Wade collectors and enthusiasts who have helped us over the past several months to bring this book to completion. Some have helped by supplying photographs from their collections, and some have invited us into their homes to photograph their collections. To all of you we say thank you.

Iris Lenora Carryer has been a long time supporter of our books on Wade pottery. Over the years, by letters and long telephone conversations, we have learned a great deal about the Irish pottery in its early years. We sincerely thank Iris and her late husband Straker Carryer for the help and information so freely given.

We extend our sincere gratitude to Mary Ashby and Alan Clark, who not only allowed us to photograph items from their extensive collections but also welcomed us into their home, entertained us, and showed us around a part of the British Isles we had not visited before.

We would like to thank Ralph Brough, former Sales and Marketing Director of Wade Ceramics, for his continued help and support with our books. Ralph's recollections of his many years with Wade have been a mine of information.

We sincerely thank Peg and Roger Johnson for their help with this book and for welcoming us to their home to photograph items from their collection. Rog and Peg are long time friends and we thank them for their continued support with our books.

Muriel Trouton has been of tremendous help with this book. With her many years at the Irish pottery, her recollections have been of great help. We thank you, Muriel, both for your help and friendship.

Our sincere thanks go to Phyllis McKeag, whose memories of many years at the Irish pottery were of great help in answering questions.

We thank Don Mandryk for inviting us to his home and allowing us to finish photographing items from the collection of his late wife, Jo-Ann.

We would like to thank Sarah Smith for inviting us to her home and for her help over the long hours spent photographing her collection. Sarah, your enthusiasm is catching.

Much gratitude goes to Tess Contois for sharing pictures from her extensive collection of Irish leprechauns. Tess is surely one of the major collectors of the Irish "Little People."

A special thank you goes to Michelle Tenty of The Netherlands, who so tirelessly took photographs from her collection and sent them across the air waves to us in Canada.

We thank Dianne LeBlanc, who set aside a Saturday from her busy schedule to allow us to photograph many items from her collection.

A very special thank you goes to Eileen McKinley and her late husband Frank, who traveled many miles to show us (and let us photograph) a cherished item from her collection.

Jenny Wright of Wade Ceramics Limited has been a great supporter of our books over many years and we sincerely thank her for her continued interest, help, and encouragement.

We also thank Kim Rowley of Wade Ceramics Limited for her help over the years.

We are most grateful to Bob and Helen Murfet, Tasmania, who so willingly took photographs of items from their collection and sent them over the miles to Canada.

To Peter Schiffer and Donna Baker, we are deeply indebted for your help and support with this book on Wade pottery.

We thank Naseem Wahlah for making photographing her collection so much fun. It was a joy to spend time with you.

Following are just some of the many collectors and friends to whom we owe thanks for sending pictures and for their encouragement. We also thank those of you who preferred to remain anonymous:

Caryl Alcock, Yorkshire, U.K.
Bob and Gail Barnhart, Michigan, U.S.A.
Linda K. Bray, Washington, U.S.A.
Regan Brumagen, The Corning Glass Museum, Corning, New York
Robert Coleman, Nevada, U.S.A.
The late Derek Dawe.
Ben Dawson, Derbyshire, U.K.
Joyce and David Divelbiss, Pennsylvania, U.S.A.
David Chown, C&S Collectables, U.K.
Father David Cox, Missouri, U.S.A.
David and Hilary Elvin, Kent, U.K.
Peggy A. Fyffe, Indiana, U.S.A.
Lee and Mark Gillespie, Virginia, U.S.A.
Tony Graham, Buckinghamshire, U.K.
Martin Gurney, Fudge Collectables, U.K.
Margaret Hamer, Lancashire, U.K.
Betty and Denny Hannigan, Pennsylvania, U.S.A.

William Harper, Staffordshire, U.K.
Vince Harvey, England
Andrew Herron, Northern Ireland, U.K.
Fred and Ann Howard, Wales, U.K.
Beth Hylen, The Corning Glass Museum, Corning, New York
Scott Ickes, Pennsylvania, U.S.A.
Pat and Gary Keenan, Pennsylvania, U.S.A.
Esther Kramer, Pennsylvania, U.S.A.
The late R. Alec McCullough.
Valerie and Wayne Moody, Colorado, U.S.A.
Brian and Judi Morris, Kansas, U.S.A.
Stephanie & Larry Moxon, Connecticut, U.S.A.
Carole and John Murdock, Colorado, U.S.A.
Molly Newman, Oregon, U.S.A.

William L. Read, Washington, U.S.A.
Bob and Marge Rolls, New York, U.S.A.
Ed and Bev Rucker, Kansas, U.S.A.
Russell Schooley, C&S Collectables, U.K.
LeAnne, Chuck and Jennifer Smith, Illinois, U.S.A.
Libuse Smykal, Ontario, Canada
Ed Smoller, New Jersey, U.S.A.
John A. Stringer, Northern Ireland, U.K.
Fay Thompson, Ontario, Canada
Penny Webber, Isle of Wight, U.K.
Juanita & Erick Wowra, North Carolina, U.S.A.
Margaret, B. Wowra, Florida, U.S.A.
Jo-Ann Yadro, Oregon, U.S.A.
Last but by no means the least, we thank "Queen Mary" herself, i.e., Mary Yager, Kansas, U.S.A.

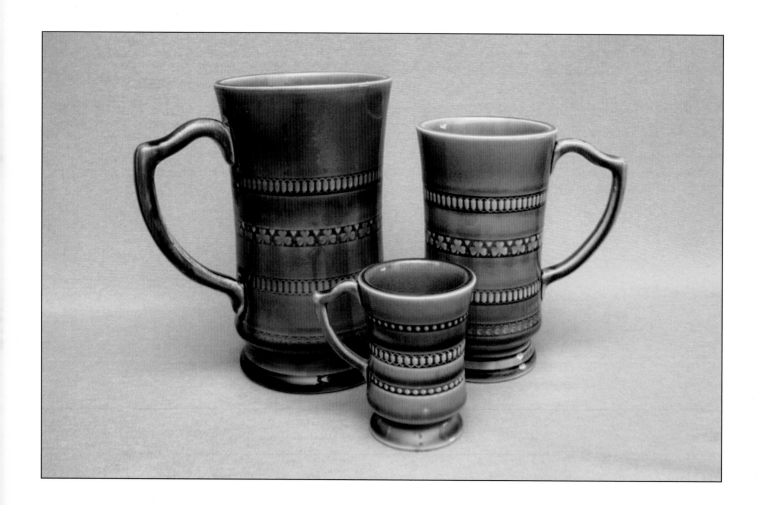

Dating Wade Products by the Use of Backstamps

Because many items produced by Wade (Ulster) Ltd. and Wade (Ireland) Ltd. were in production for a great many years, it is sometimes difficult, if not impossible, to give exact production dates. A large number of backstamps, both molded, impressed, and transfer-applied, have been used over the years. It is only from these marks that one is able to obtain an idea of the date an item was produced.

The items illustrated are noted with their Mark Type (backstamps), but it is possible that a number of similar items may be found with a different Mark Type. This would occur when an old and worn mold was replaced and the then current backstamp was applied to the new mold.

In the very early days of Wade (Ulster) Ltd., when work at the pottery became slow, a number of steel dies for figurines were made in Burslem and sent to Ireland for production. Many of these figurines did not have any molded marks such as the Flying Birds. Some of the Whimsies made in Ireland did have a Made in England mark, and although this caused a bit of a problem for the Irish staff of the pottery, the marks were allowed to stay.

To complicate matters a little more, when the molds for the Wade tankards were transferred to the Irish pottery from England, the remaining stock of "Made in England" transfer marks was also sent over. It is therefore possible that, for a time, a number of Irish made items had a "Made in England" mark.

When we visited the Irish pottery in 1990, we saw a number of Irish made items in the Factory Shop with marks similar to those used at the Burslem pottery. These marks were either "Genuine Wade Porcelain" or simply "Wade" but without naming the country of origin.

For additional Wade backstamps, please refer to *The World of Wade Figurines and Miniatures*.

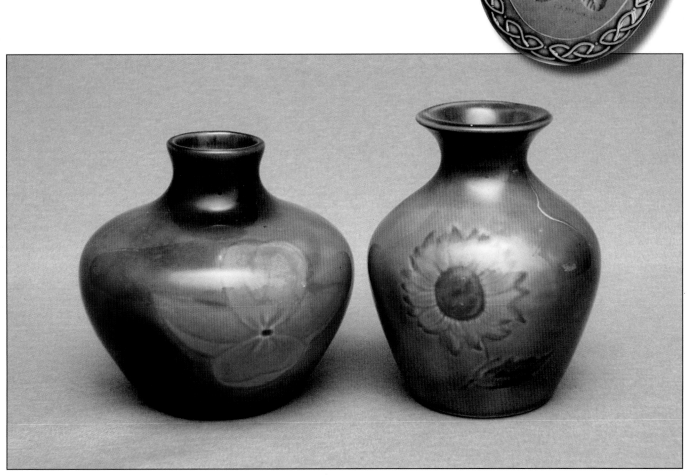

Marks and Backstamps

Wade (Ulster) Ltd. 1950-1966
Wade (Ireland) Ltd. 1966-1990

Mark Type 27c
Circa 1950+
Ink Stamp

Mark Type 27D
Circa 1952 - 1953
Ink Stamp

WADE (ULSTER) LTD
PORCELAIN

Mark Type 27E
Circa mid 1950s
Impressed

Mark Type 28
1953+
Impressed

Mark Type 29
1954+
Impressed

Mark Type 30
1954+
Transfer

Mark Type 31
Mid 1950s+
Molded

Mark Type 32
1955+
Impressed

Mark Type 32A
Circa Early 1960s
- 1967
Transfer

Mark Type 32B
Circa Early 1960s
- 1967
Transfer

MADE IN
IRELAND
BY
WADE
CO ARMAGH

Mark Type 32C
Circa 1963 - 1964
Transfer

Mark Type 33
1962
Molded
(Included the name of
the modeler/designer)

Mark Type 33A
1962
Molded

Mark Type 33B
1962 - 1986
Transfer

Mark Type 34
Mid 1960s
Molded

Mark Type 34A
Circa mid 1960s +
Impressed

Mark Type 35
1970
Impressed

& DESIGN

WADE
COUNTRY
WARE
MADE IN IRELAND

Mark Type 36
1973
Impressed

BALLYFREE FARMS
WADE
IRISH PORCELAIN
MADE IN IRELAND

Mark Type 36A
1974 - 1975
Impressed

WÂDE
IRELAND

Mark Type 37
1970+
Transfer

MADE IN
IRELAND
BY
WÂDE

Mark Type 38
Mid 1970s
Impressed

MADE IN
A.S.Cooper
IRELAND

Mark Type 39
1965 - 1968
Impressed

PORCELAIN
MADE BY
WADE
IRELAND

Mark Type 39A
Mid 1970s +
Molded

IRISH PORCELAIN
MADE BY
WADE
IRELAND

Mark Type 39B
Mid 1970s +
Molded

IRISH PORCELAIN
WADE
IRELAND

Mark Type 40
1977+
Molded

IRISH PORCELAIN
WADE
MADE IN IRELAND

Mark Type 40A
Late 1970s
Molded

WADE PORCELAIN Made in Ireland

Mark Type 40B
Late 1970s
Molded

MADE IN IRELAND
PORCELAIN
WADE
eire zír a dheanta

Mark Type 40C
Late 1970s +
Molded and Transfer

MADE IN IRELAND
IRISH PORCELAIN
WADE
eire zír a dheanta

Mark Type 41
1980+
Molded and Transfer

SEAGOE CERAMICS
WADE '91
IRELAND

Mark Type 41A
1991
Ink Stamp

MADE IN IRELAND
PORCELAIN
WADE
eire zír a dheanta

Mark Type 41B
1991+
Transfer

MADE IN IRELAND
WADE
classic linen
eire zír a dheanta

Mark Type 41C
1992 - 1993
Transfer

Summer Fruit
WÂDE
U.K.
FINE QUALITY
TABLEWARE
DISHWASHER AND
MICROWAVE SAFE

Mark Type 41D
1992 - 1993
Transfer

"Henri"
DESIGN
EXCLUSIVE TO
WÂDE
U.K.
FINE QUALITY
TABLEWARE
DISHWASHER & MICROWAVE SAFE

Mark Type 41E
1992 - 1993
Transfer

ROYAL COMMEMORATIVE ISSUES

1953 - 1986

Much has been written in the introduction to this book about the origin and development of the first royal commemorative pieces to be produced by the Irish pottery in 1953, but such items didn't stop there. Wade (Ireland) Ltd. went on to produce a number of other royal event commemorative items to celebrate such events as the 1977 Silver Jubilee of Queen Elizabeth II and the marriage of Prince Charles and Lady Diana Spencer in 1981.

Wade (Ireland) Ltd. also produced a number of the Bell's whisky decanters to celebrate the marriage of Prince Charles and Lady Diana Spencer. The numbers for this wedding decanter ended up between 225,000 and 250,000, so production of this item was divided between the Portadown pottery and the Burslem pottery.

A number of the items used to commemorate the wedding of Prince Charles and Lady Diana Spencer were produced from molds that would form part of the Shamrock Porcelain Gift Ware range to be fully issued in 1982. These items were only marked WADE but were produced by the Irish pottery.

Records are vague as to the number of Bell's whisky decanters issued for other royal occasions, but Wade (Ireland) Ltd. personnel recall decanters being made for both the Queen's 60th birthday and the marriage of Prince Andrew to Sarah Ferguson. Also not clear is whether production of these decanters was shared between Burslem and Portadown.

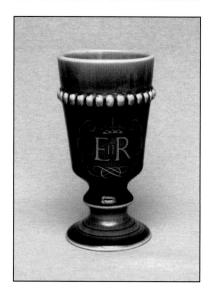

Straight sided goblet commemorating the 1953 coronation of Queen Elizabeth II. The goblet is 4-3/4" high and is unmarked ($55, £28).

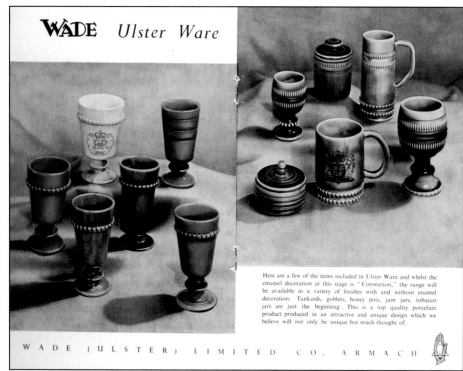

Here are a few of the items included in Ulster Ware and whilst the emamel decoration at this stage is "Coronation," the range will be available in a variety of finishes with and without enamel decoration. Tankards, goblets, honey pots, jam jars, tobacco jars are just the beginning. This is a top quality porcelain product produced in an attractive and unique design which we believe will not only be unique but much thought of.

WADE (ULSTER) LIMITED CO. ARMACH

Wade Ulster Ware from the Summer 1953 issue of *The Jolly Potter*.

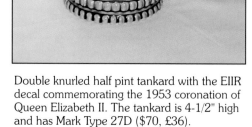

Double knurled half pint tankard with the EIIR decal commemorating the 1953 coronation of Queen Elizabeth II. The tankard is 4-1/2" high and has Mark Type 27D ($70, £36).

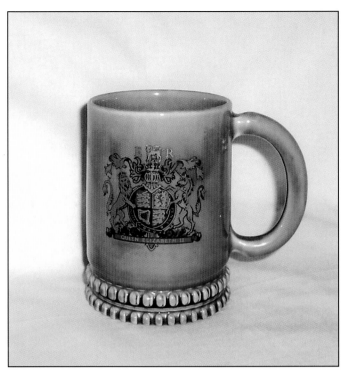

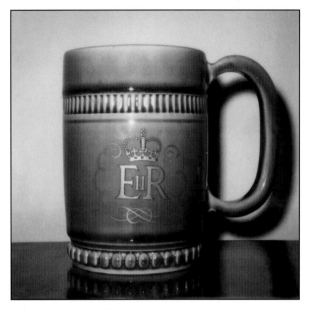

"The Original" 4-1/2" high Irish porcelain coronation tankard.

Double knurled half pint tankard with the royal coat of arms commemorating the 1953 coronation of Queen Elizabeth II. The tankard is 4-1/2" high and has Mark Type 27D ($70, £36).

Base of the original Irish porcelain coronation tankard signed by Straker Carryer.

Traditional half pint tankards issued in 1977 to celebrate the Silver Jubilee of Queen Elizabeth II. Both tankards have Mark Type 37 on the base ($45 each, £24 each). This decal was also used on a commemorative plate.

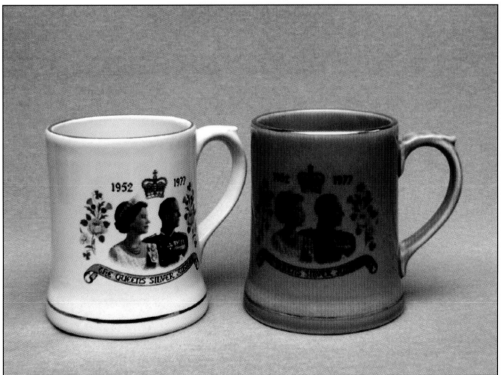

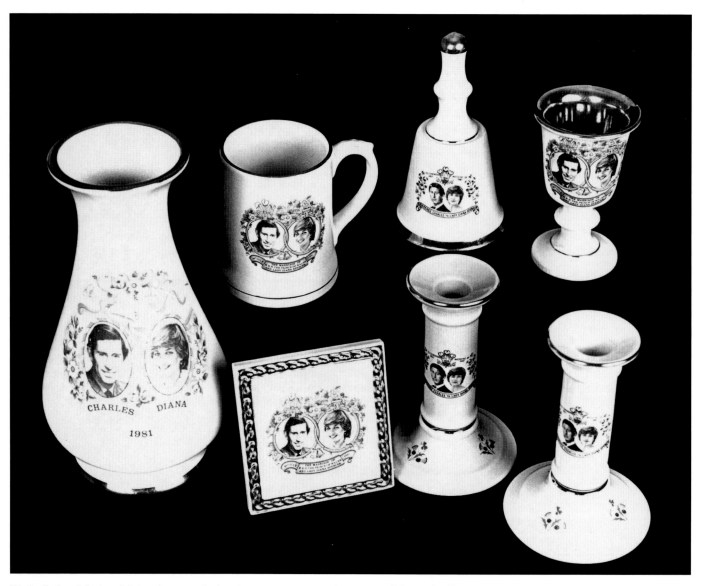

Wade (Ireland) Ltd. publicity photograph showing an assortment of items to celebrate the Prince Charles and Lady Diana Spencer wedding.

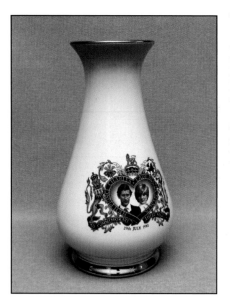

Vase (decoration 1) issued in 1981 to commemorate the marriage of H.R.H. Prince Charles and Lady Diana Spencer on the 29th July 1981. The vase is 8-3/4" high and is marked WADE on the underside of the base ($75, £40).

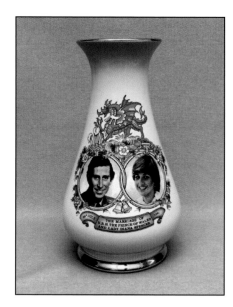

Vase (decoration 2) issued in 1981 to commemorate the marriage of H.R.H. Prince Charles and Lady Diana Spencer on the 29th July 1981. The vase is 8-3/4" high and is marked WADE on the underside of the base ($75, £40).

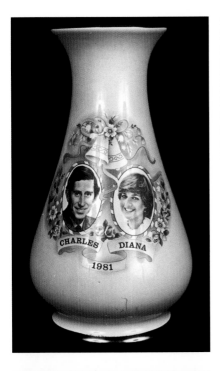

Vase (decoration 3) issued in 1981 to commemorate the marriage of H.R.H. Prince Charles and Lady Diana Spencer on the 29th July 1981. The vase is 8-3/4" high and is marked WADE on the underside of the base ($75, £40).

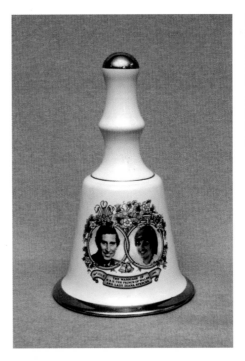

Bell issued in 1981 to commemorate the marriage of H.R.H. Prince Charles and Lady Diana Spencer. The bell measures 5-3/4" high and is transfer marked WADE on the inside, upper part of the bell ($60, £32).

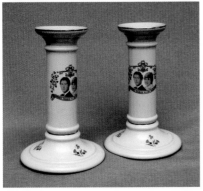

Candle Holders issued in 1981 to commemorate the marriage of H.R.H. Prince Charles and Lady Diana Spencer. The candle holders measure 5-3/4" high and are transfer marked WADE on the underside of the base ($150 pair, £80 pair).

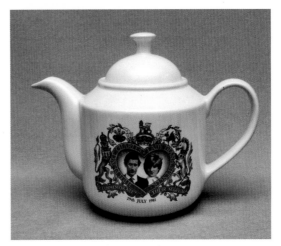

Prince Charles and Lady Diana Spencer commemorative teapot. Only a very small number of these teapots were issued. The teapot measures 6-3/8" high and is marked: Genuine Wade Porcelain. This mark was used mainly in Burslem but the teapot was produced in Ireland ($100, £52).

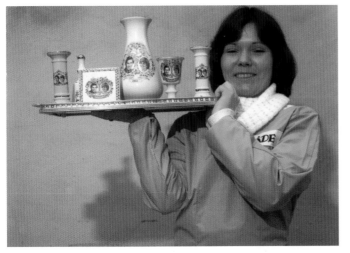

Mary Neill holding a tray of Charles and Diana commemorative items. Note the pink candle holder on the left of the picture.

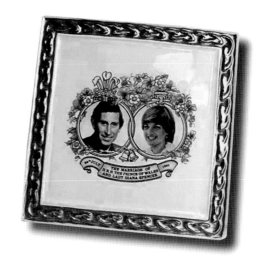

Self standing plaque issued in 1981 to commemorate the marriage of H.R.H. Prince Charles and Lady Diana Spencer. The plaque measures 4" by 4" and is marked WADE on the back ($80, £44).

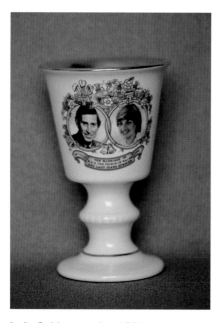
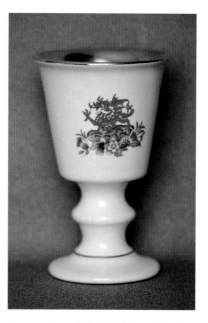

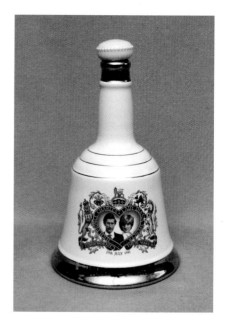

Left: Goblet issued in 1981 to commemorate the marriage of H.R.H. Prince Charles and Lady Diana Spencer. The goblet measures 4-1/2" high and is transfer marked Wade on the underside of the base. Right: View of the back of the goblet ($60, £32).

Bell's Whisky Decanter issued in 1981 to commemorate the marriage of H.R.H. Prince Charles and Lady Diana Spencer. This 75 cl size decanter is marked 'WADE' on the underside of the recessed base ($1,275 full, sealed and boxed, $120 empty; £750 full, sealed and boxed, £70 empty).

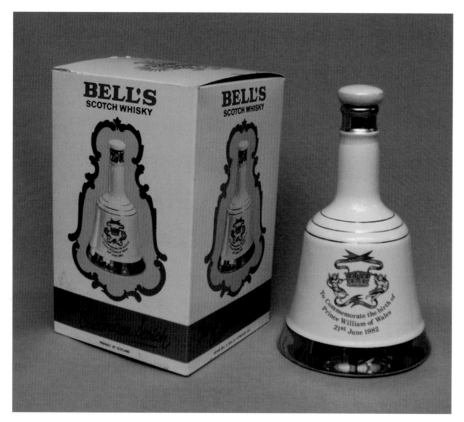

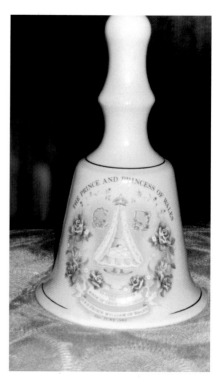

Bell's Whisky Decanter issued in 1982 to commemorate the birth of Prince William of Wales on the 21st of June 1982. This 50 cl decanter is transfer marked WADE on the underside of the recessed base ($190 full, sealed and boxed, $35 empty; £110 full, sealed and boxed, £20 empty).

Bell issued in 1982 to commemorate the birth of H.R.H. Prince William of Wales. The bell measures 5-3/4" high and is transfer marked WADE on the inside, upper part of the bell. The lettering on the back of the bell reads: To Commemorate the Birth of the First Child of T.R.H. the Prince and Princess of Wales 1982 ($60, £32).

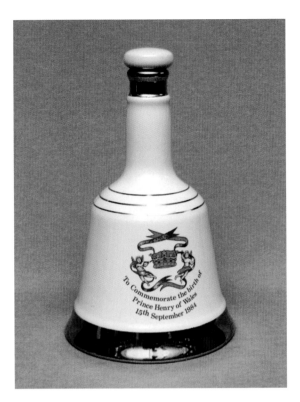

Bell's Whisky Decanter issued in 1984 to commemorate the birth of Prince Henry of Wales on the 15th of September 1984. This 50 cl decanter is marked WADE on the underside of the recessed base ($590 full, sealed and boxed, $95 empty; £350 full, sealed and boxed, £55 empty).

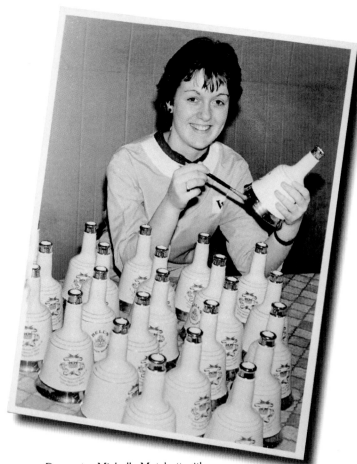

Decorator Michelle Matchett with Prince Henry of Wales decanters.

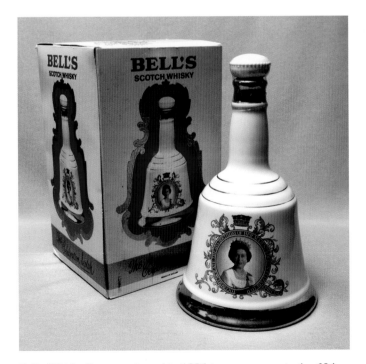

Bell's Whisky Decanter issued in 1986 to commemorate the 60th Birthday of Queen Elizabeth II. This 75 cl size decanter is marked WADE on the underside of the recessed base ($190 full, sealed and boxed, $35 empty; £110 full, sealed and boxed, £35 empty).

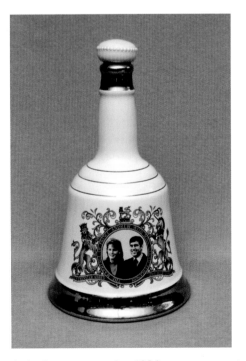

Bell's Whisky Decanter issued in 1986 to commemorate the marriage of H.R.H. Prince Andrew and Sarah Ferguson. This 75 cl size decanter is marked WADE on the underside of the recessed base ($240 full, sealed and boxed, $70 empty; £140 full, sealed and boxed, £40 empty).

Chapter 2
TANKARDS, MUGS AND GOBLETS

early 1950s - 1986

"IRISH GLAZE" TANKARD RANGE

In the early 1950s, Wade (Ulster) Ltd. introduced a one pint, half pint, children's size, and miniature tankards to the gift ware lines using typical Irish shapes such as the "Tyrone" tankard and the popular knurled design tankards. These tankards usually had the typical Irish glaze but a number of them are to be found with a white glaze.

The majority of the tankards with the "Irish" glaze had applied decals, such as pheasants, coaching scenes, fishing scenes, hunting scenes, and many more. Many of these decals were from open stock supplied by Johnson, Matthey & Co., Limited of Hatton Garden, London. An advertisement in the March 1958 issue of *Pottery and Glass* illustrates a number of decals used by the Irish pottery. As these decals were from open stock, it is possible to find them on items made by companies other than Wade (Ulster) Ltd. and Wade (Ireland) Ltd.

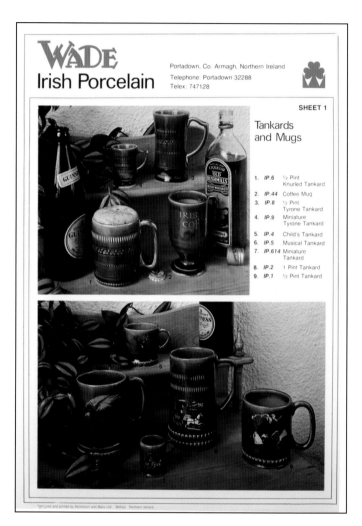

Irish Glaze Tankard Range. Trade literature, circa early 1980s - mid 1980s.

Mrs. Wilson (whose main job was to apply handles to tankards) talking to visitors at the pottery.

One Pint Tankards

The one pint tankards with the Irish glaze are shape number I.P. 2 and are approximately 6-1/4" high. This height varies slightly due to mold differences that occurred when molds wore out and had to be replaced.

One Pint Tankard with Stage Coach decal No. 2. The tankard has Mark Type 41 ($30, £18).

One Pint Tankard with Irish Harp decal. The tankard has Mark Type 29 ($30, £18).

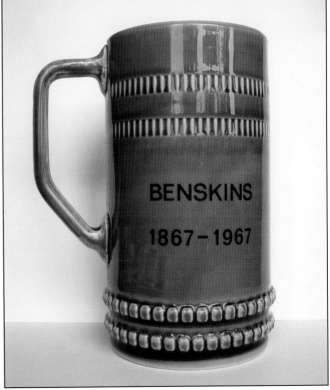

Left: One Pint Tankard with Benskins Brewery decal. Right: Back of the tankard. The tankard has Mark Type 41 ($36, £20).

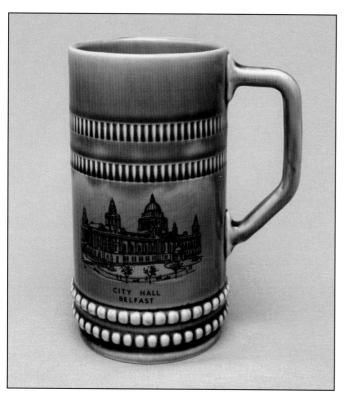

One Pint Tankard with City Hall, Belfast decal. The tankard has Mark Type 41 ($30, £18).

One Pint Tankard with Piccadilly Circus decal No. 2. The tankard has Mark Type 28 with the letter 'D' in the leaf ($36, £20).

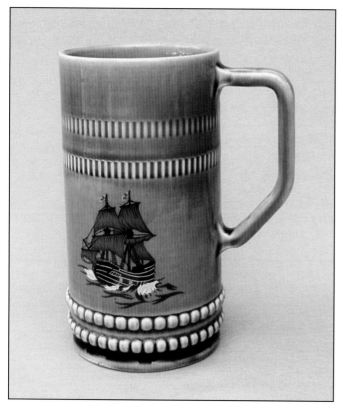

One Pint Tankard with Galleon decal. The tankard has Mark Type 29 ($36, £20).

One Pint Tankard with University of Toronto decal. The tankard has Mark Type 29 ($30, £18).

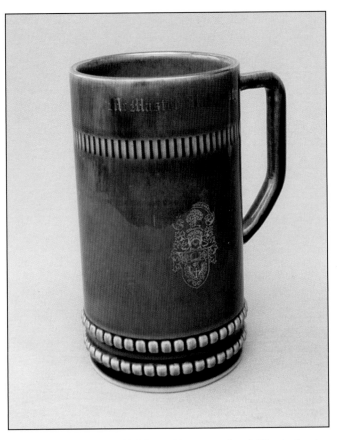

One Pint Tankard with McMaster University decal. The tankard has Mark Type 28 ($30, £18).

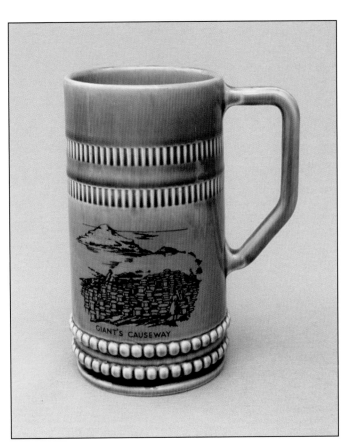

One Pint Tankard with Giant's Causeway decal. The tankard has Mark Type 29 ($30, £18).

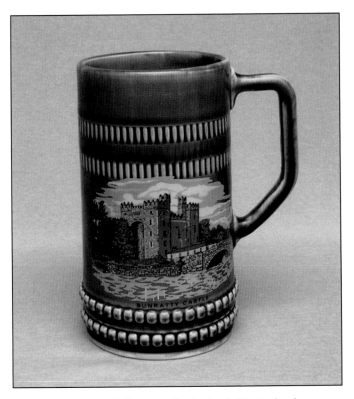

One Pint Tankard with Bunratty Castle decal. The tankard has Mark Type 41 ($30, £18).

One Pint Tankard with Mt. St. Vincent University decal. The tankard has Mark Type 28 ($30, £18).

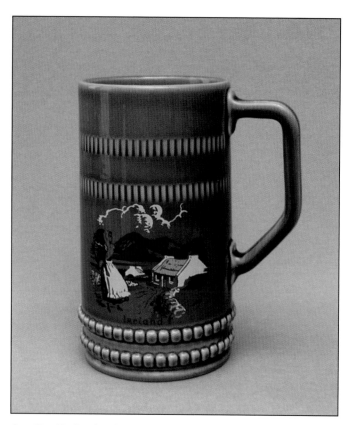

One Pint Tankard with Irish Colleen decal. The tankard has Mark Type 28 ($30, £18).

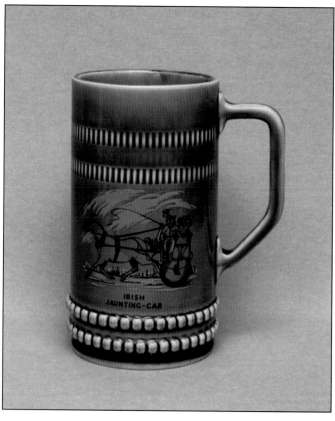

One Pint Tankard with Irish Jaunting Car decal. The tankard has Mark Type 28 ($30, £18).

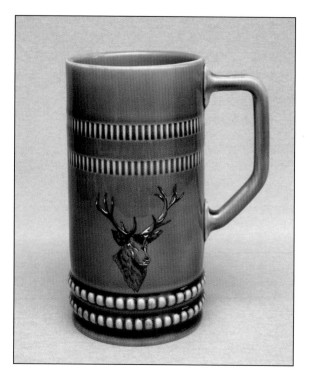

One Pint Tankard with Stag Head decal. The tankard is marked: Made in Ireland ($30, £18).

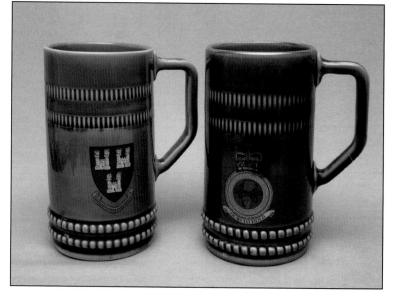

One Pint Tankards. Left: Tankard with logo reading: Obedientia civium urdis felicitas. Right: Tankard with Royal Air Force Station Aldergrove logo. Both tankards have mark Type 28 ($30 each, £18 each).

Half Pint Tankards

The half pint tankards with the Irish glaze are shape number I.P. 1 and are approximately 4-1/4" high. This height varies slightly due to mold differences.

Half Pint Tankard without decal. The tankard has Mark Type 29 ($15, £8).

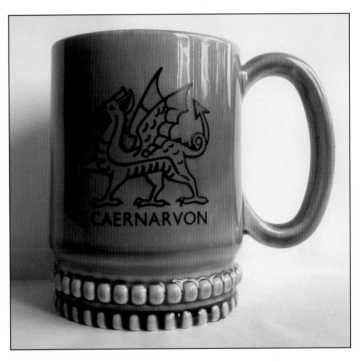

Half Pint Tankard with Caernarvon decal. The tankard has Mark Type 29 with the letter 'K' under the mark ($20, £12).

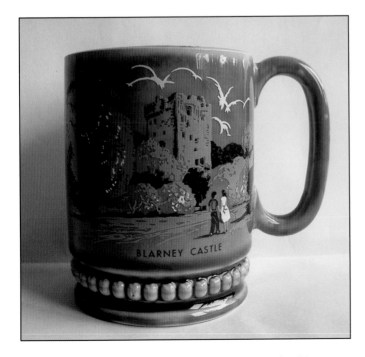

Half Pint Tankard with Blarney Castle decal. The tankard has Mark Type 28 with the letter 'A' in the leaf ($20, £12).

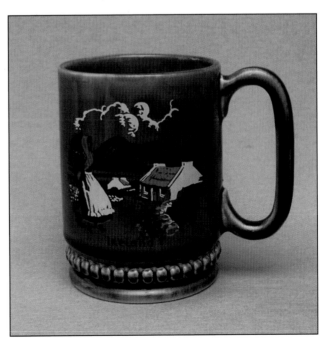

Half Pint Tankard with Irish Colleen decal. The tankard has Mark Type 28 ($20, £12).

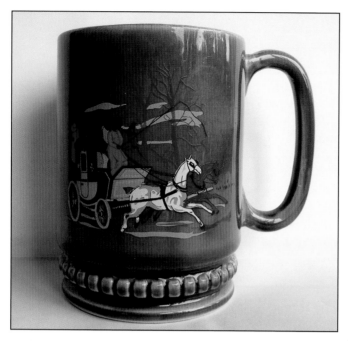

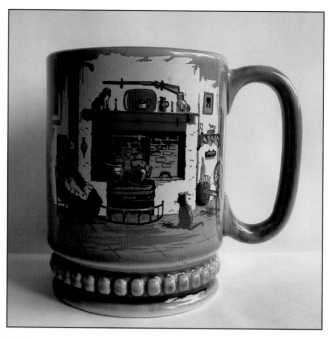

Half Pint Tankard with Coaching Scene decal No. 2. The tankard has Mark Type 41 ($20, £12).

Half Pint Tankard with Kitchen Scene decal. The tankard has Mark Type 41 ($28, £15).

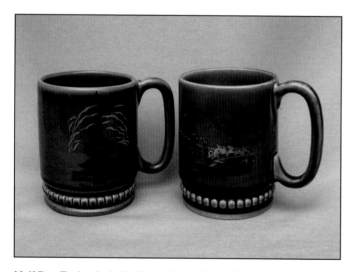

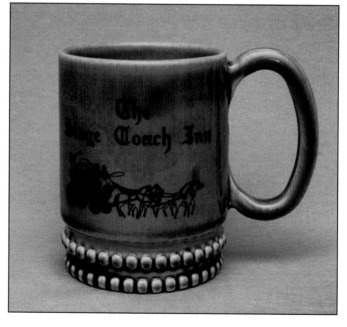

Half Pint Tankards. Left: Tankard with Piccadilly Circus decal No. 1. Right: Tankard with the Houses of Parliament decal. Both tankards have Mark Type 28 ($28 each, £15 each).

Half Pint Tankard with "The Old Stage Coach Inn" decal. The tankard has Mark Type 29 ($28, £15).

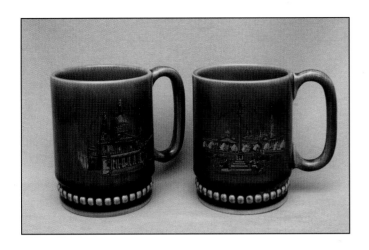

Half Pint Tankards. Left: Tankard with St. Paul's Cathedral decal. Right: Tankard with Nelson's Column, Trafalgar Square decal No. 1. Both tankards have Mark Type 28 ($28 each, £15 each).

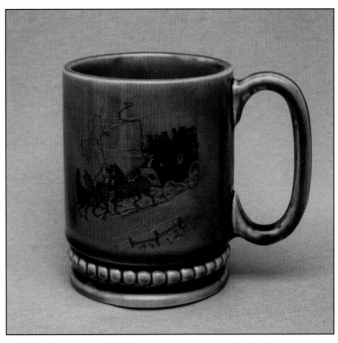

Half Pint Tankard with Stage Coach decal No. 1. The tankard has Mark Type 28 ($20, £12).

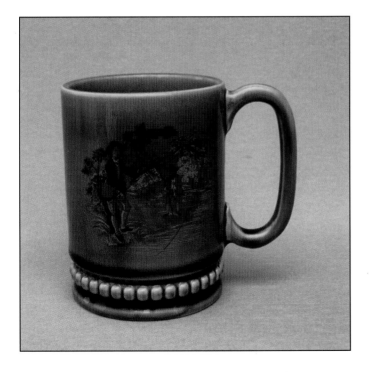

Half Pint Tankard with Fishing Scene decal. The tankard has Mark Type 28 ($20, £12).

Half Pint Tankard with Pheasant decal. The tankard has Mark Type 28 ($20, £12).

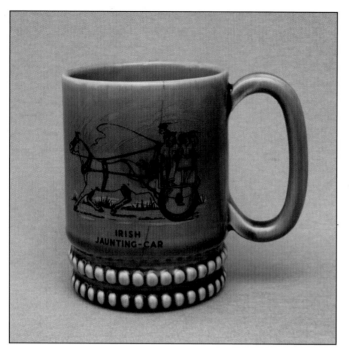

Half Pint Tankard with Irish Jaunting Car decal. This tankard has two rows of knurls at the base and has Mark Type 29 ($20, £12).

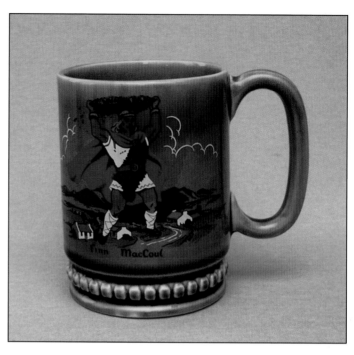

Half Pint Tankard with Finn MacCoul decal. The tankard has Mark Type 28 ($20, £12).

Half Pint Tankard with Fox Hunting Scene decal No. 2. The tankard has Mark Type 28 ($20, £12).

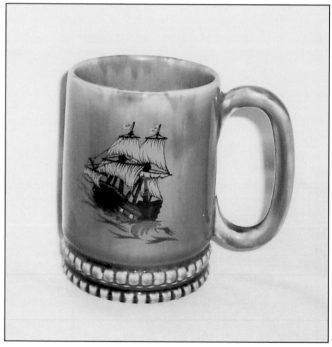

Half Pint Tankard with Sailing Ship decal. The tankard has Mark Type 28 ($28, £15).

Half Pint Tankard with Scottish Dancer decal. The tankard has Mark Type 28 ($28, £15).

Irish tankard in original box ($36, £20).

Child's Tankards

The child's tankards with the Irish glaze are shape number I.P. 4 and are approximately 3" high. This height varies slightly due to mold differences.

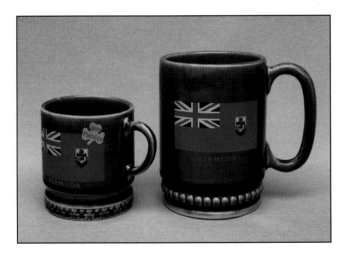

Left: Child's Tankard with Bermuda decal. The tankard has Mark Type 41 ($15, £9). Right: Half pint tankard with Bermuda decal. The tankard has Mark Type 28 ($20, £12).

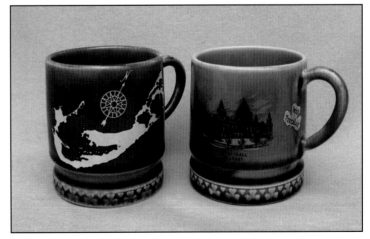

Left: Child's Tankard with Map of Bermuda decal. The tankard has Mark Type 41 ($15, £9). Right: Child's Tankard with City Hall, Belfast decal. The tankard has Mark Type 29 ($15, £9).

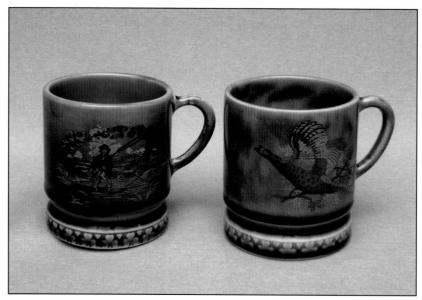

Left: Child's Tankard with Fishing decal. Right: Child's Tankard with Pheasant decal. Both tankards are 3" high and have Mark Type 28 with the letter 'J' in the leaf ($15 each, £9 each).

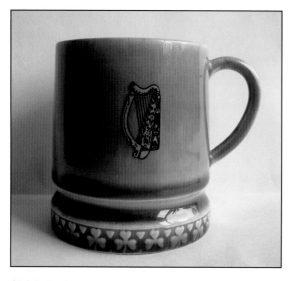

Child's Tankard with Irish Harp decal. The tankard has Mark Type 29 with the letter 'K' under the mark ($15, £9).

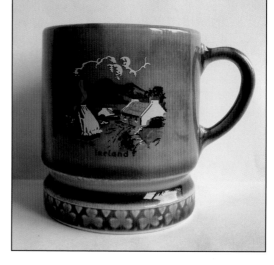

Child's Tankard with Irish Colleen decal. The tankard has Mark Type 28 with the letter 'A' in the leaf ($15, £9).

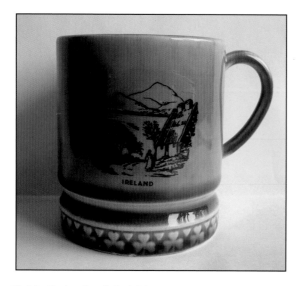

Child's Tankard with Irish Mountain scene decal. The tankard has Mark Type 29 with the letter 'N' under the mark ($15, £9).

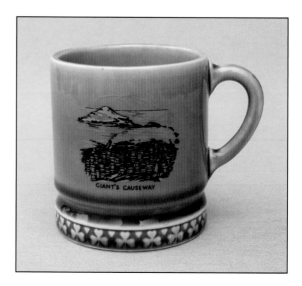

Child's Tankard with Giant's Causeway decal. The tankard has Mark Type 28 ($15, £9).

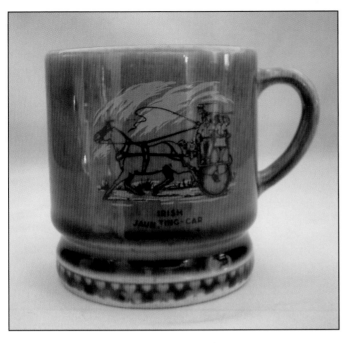

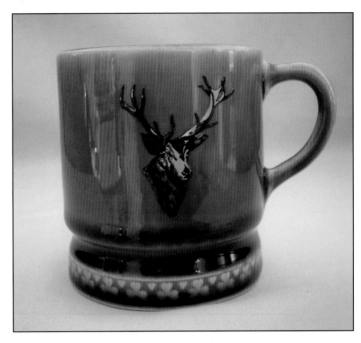

Child's Tankard with Irish Jaunting Car decal. The tankard has Mark Type 28 ($15, £9).

Child's Tankard with Stag Head decal. The tankard has Mark Type 28 ($15, £9).

Miniature Tankards

Unless noted otherwise, the miniature tankards with the Irish glaze are shape number I.P. 614 and are approximately 2" high by 1-3/4" diameter at the base. These dimensions vary slightly due to mold differences.

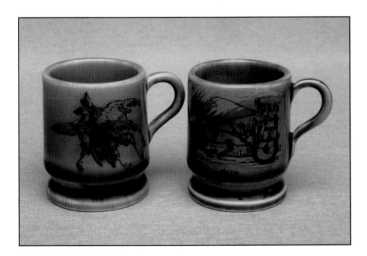

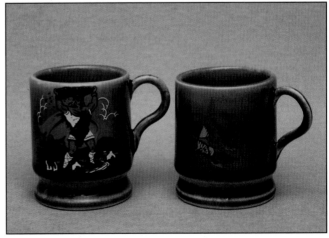

Left: Miniature Tankard with Cock Fighting decal. Right: Miniature Tankard with Irish Jaunting Car decal. Both tankards have Mark Type 28 ($12 each, £6 each).

Left: Miniature Tankard with Finn MacCoul decal. Right: Miniature Tankard with Flying Ducks decal. Both tankards have Mark Type 28 ($12 each, £6 each).

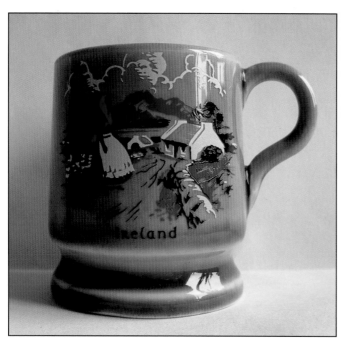

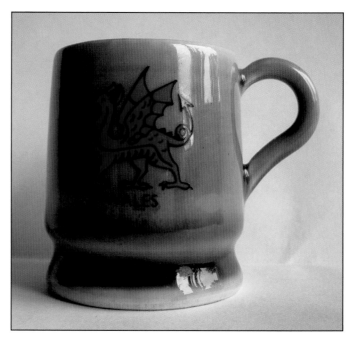

Miniature Tankard with Irish Colleen decal. The tankard has Mark Type 28 with the letter 'E' in the leaf and the letter 'A' under the mark ($12, £6).

Miniature Tankard with a Welsh Dragon decal. The tankard has Mark Type 28 ($12, £6).

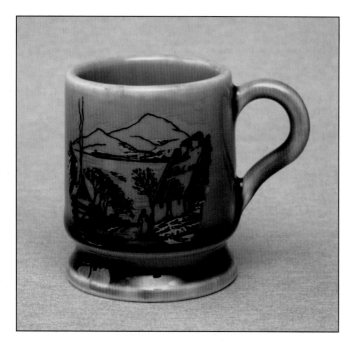

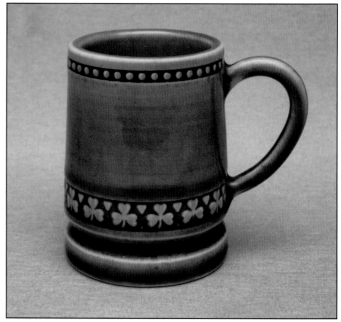

Miniature Tankard with Irish Mountain scene decal. The tankard has Mark Type 32 ($12, £6).

Miniature Mug. The mug measures 2-3/4" high, 1-7/8" dia. at the top, and 2" dia. at the base, and has Mark Type 28 ($20, £12).

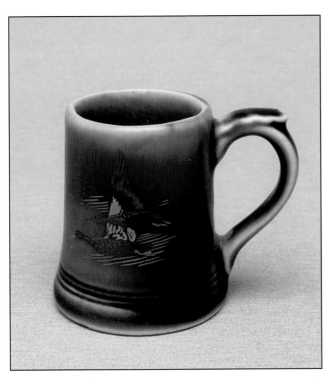

Miniature Traditional Tankard – shape WH 3 with Flying Ducks decal. The tankard measures 2" high and has Mark Type 37 ($15, £8).

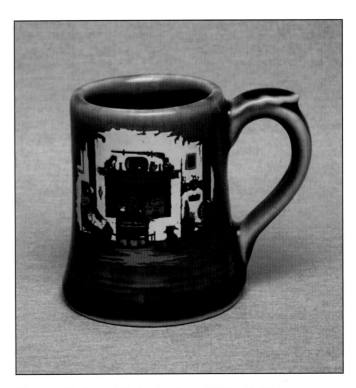

Miniature Traditional Tankard – shape WH 3 with Kitchen Scene decal. The tankard measures 2" high and has Mark Type 37 ($15, £8).

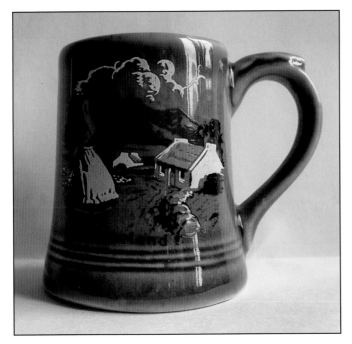

Miniature Traditional Tankard – shape WH 3 with Irish Colleen decal. The tankard measures 2" high and has Mark Type 37 ($15, £8).

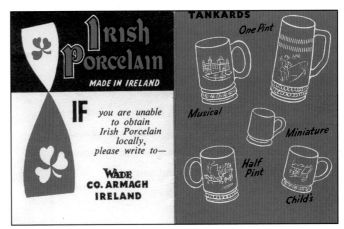

Miscellaneous Tankards

Irish stein tankards and Tyrone tankards were manufactured by the Irish pottery from the mid 1950s through to the end of production in 1986. Following are examples of these tankards. Other styles and decals are to be found.

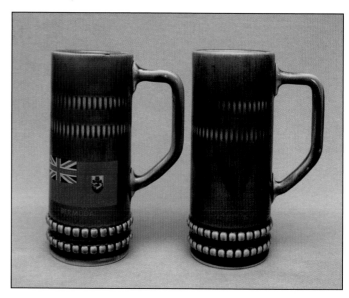

Irish Stein Tankards – shape number I.P. 3. Left: Stein tankard with Bermuda decal has Mark Type 41 ($25, £12). Right: Stein tankard without decal has Mark Type 27 ($20, £11). Both tankards measure 6-3/8" high.

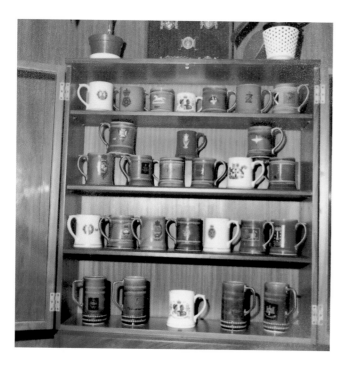

Display of miscellaneous tankards at the Irish pottery circa 1977.

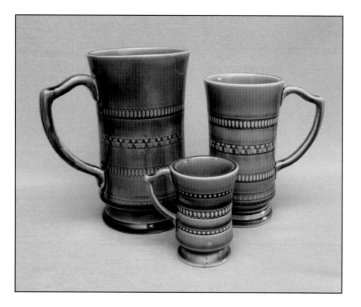

Tyrone Tankards. Left: One Pint Tyrone Tankard – shape number I.P. 10, measures 6-1/2" high and has Mark Type 28 ($35, £20). Center: Miniature Tyrone Tankard – shape number I.P. 9, measures 3" high and has Mark Type 28 ($15, £8). Right: Half Pint Tyrone Tankard – shape number I.P. 8 measures 5-1/2" high ($28, £15).

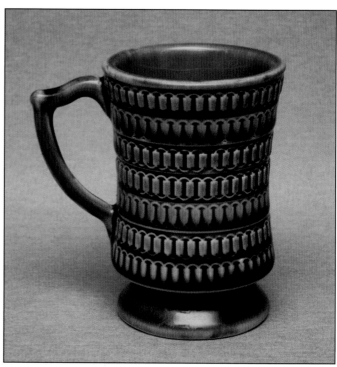

Miniature Tyrone Tankard. This tankard, with the unusual molded decoration, measures 3" high and has Mark Type 28 ($20, £12).

Variation of a Traditional One Pint Tankard with "Royal Hussars" decal.
The tankard measures 4-3/4" high and has Mark Type 41 ($36, £20).

 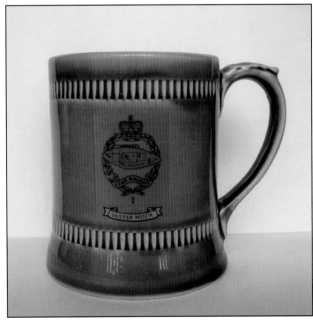

Variation of a Traditional One Pint Tankard with "Fear Naught"
decal. Left: Left handed version. Right: Right handed version. The
decals appear once only on the tankards. The tankards measure
4-3/4" high and have Mark Type 28 with the letter 'E' in the center
of the leaf ($36, £20).

Musical Tankards, *1958 – circa 1986*

In the late 1950s, musical tankards (shape No. I.P. 5) were added to the line with the introduction of the My Fair Lady musical tankard. The musical tankards measure between 5-1/4" and 5-3/8" high. Some tankards are ink stamped Made in Ireland on the underside of the base rim but many are unmarked. There is usually a paper label on the base of the Swiss musical movement giving the name of the tune played.

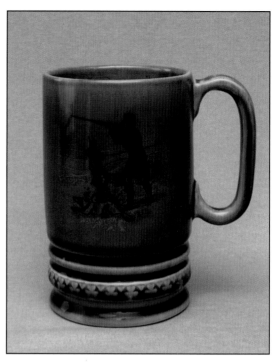

Musical Tankard with Shooting scene decal. The tankard is ink stamped: Made in Ireland and plays the tune "My Wild Irish Rose." ($65, £35).

An advertisement from the July 1960 issue of *Pottery and Glass.*

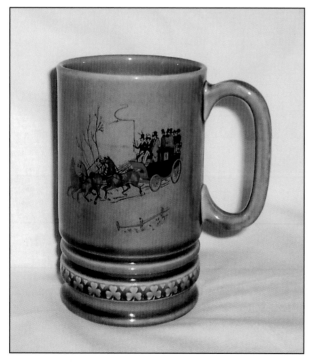

Musical Tankard with Stage Coach decal No. 1. The tankard is ink stamped: Made in Ireland and plays the tune "Mother MacCree" ($65, £35).

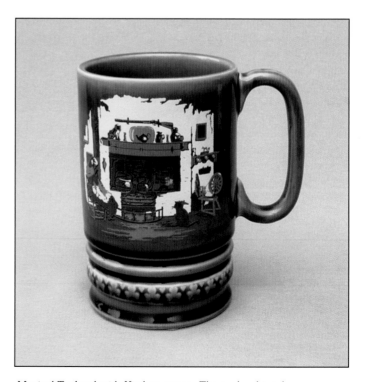

Musical Tankard with Kitchen scene. The tankard is ink stamped: Made in Ireland and plays the tune "Mountains of Mourne" ($65, £35).

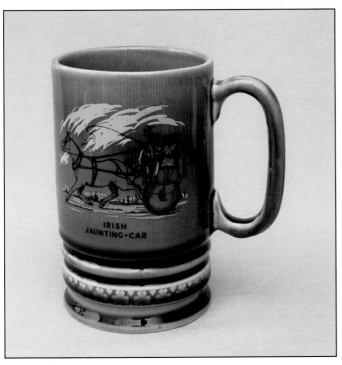

Musical Tankard with Irish Jaunting Car decal. The tankard is ink stamped: Made in Ireland and plays the tune "My Wild Irish Rose" ($65, £35).

Musical Tankard with Irish Colleen decal. The tankard is unmarked and plays the tune "Mother Machree" ($65, £35).

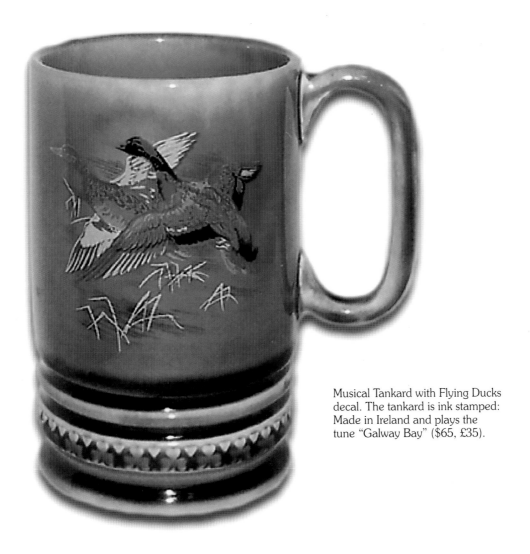

Musical Tankard with Flying Ducks decal. The tankard is ink stamped: Made in Ireland and plays the tune "Galway Bay" ($65, £35).

GOBLETS, *1953 - mid 1970s*

Goblets were introduced to the range of gift ware in the early 1950s with the issue of the straight sided goblet (I.P. 12) commemorating the coronation of Queen Elizabeth II. The small and large stemmed goblets (I.P. 10A and I.P. 11) were also issued at that time. The small stemmed and straight sided goblets were still in production until the mid 1970s. The large stemmed goblet was discontinued a few years earlier.

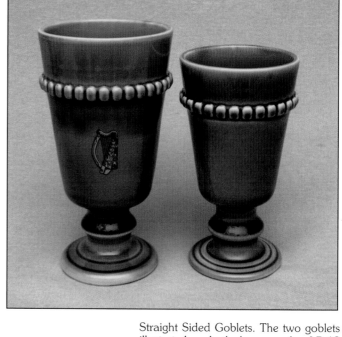

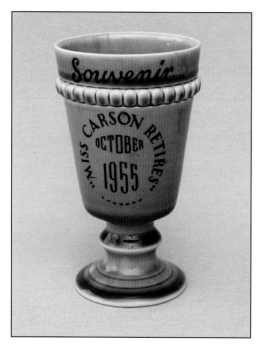

Miss Carson Retires. This goblet is shape I.P. 12, measures 5" high, and was issued in 1955. There does not appear to be a record of Miss Carson as a Wade (Ulster) Ltd. employee; it is therefore possible that this goblet was part of a contract for an outside company ($60, £32).

Straight Sided Goblets. The two goblets illustrated are both shape number I.P. 12 but due to old and discarded molds and new replacement molds the height of the goblets changed over the years. Left: Goblet with Harp decal measures 5-1/2" high and has Mark Type 29. Right: Undecorated goblet measures 4-3/4" high and has Mark Type 28 ($18 each, £9 each).

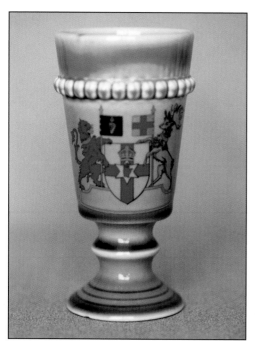

Straight Sided Goblet with coat of arms decal and Mark Type 27E on the underside of the base ($60, £32).

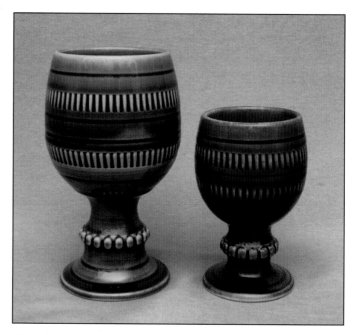

Footed Goblets. Left: Large Goblet – shape number I.P. 11, measures 5-1/2" high and has Mark Type 29 ($35, £20). Right: Small Goblet – shape number I.P. 10A, measures 4-1/8" high and has Mark Type 41 ($25, £15).

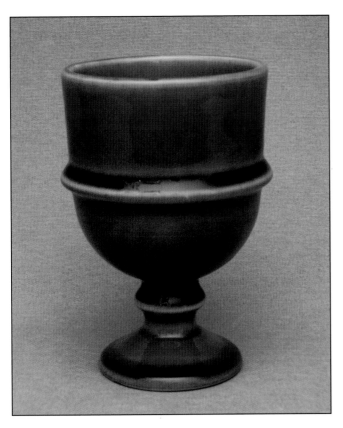

Footed Goblet. The goblet measures 4-1/2" high and has Mark Type 28 ($25, £15).

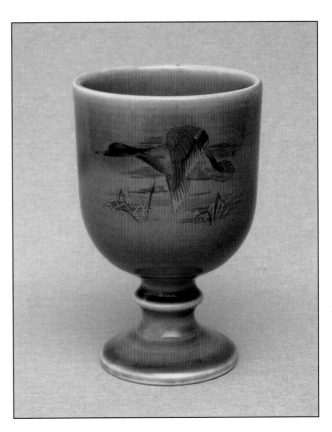

Footed Goblet with Flying Ducks decal. The goblet has Mark Type 28 and measures 4-1/2" high by 3" diameter at the top ($35, £20).

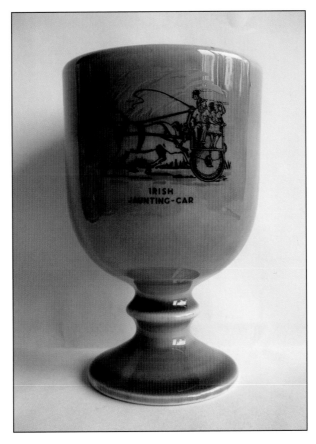

Footed Goblet with Irish Jaunting Car decal. The goblet has Mark Type 28 and measures 4-1/2" high by 3" diameter at the top ($35, £20).

MY FAIR LADY GIFT WARE, *1958*

With the success of the musical "My Fair Lady," Wade (Ulster) Ltd. produced a line of tankards featuring decals of scenes from the show. It was with this line that the first musical tankard was introduced to the Irish line of gift ware. Approval for the design of the decals for this line necessitated a number of visits to the Drury Lane Theater in London by the Carryer family. Iris Carryer writes: "…because of that tankard we saw "My Fair Lady" dozens of times…" The musical tankard was also sold at the theater as a souvenir item. The "My Fair Lady" series was distributed solely by Kenleys Limited of London.

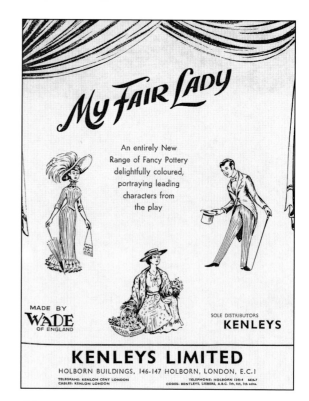

My Fair Lady

An entirely New Range of Fancy Pottery delightfully coloured, portraying leading characters from the play

MADE BY
WADE OF ENGLAND

SOLE DISTRIBUTORS
KENLEYS

KENLEYS LIMITED
HOLBORN BUILDINGS, 146-147 HOLBORN, LONDON, E.C.1
TELEGRAMS: KENLON CENT LONDON TELEPHONE: HOLBORN 1543-4 6036-7
CABLES: KENLON LONDON CODES: BENTLEYS, LIEBERS, A.B.C. 5th, 6th, 7th edns.

Advertisement as it appeared in the June 1958 issue of *The Pottery Gazette and Glass Trade Review*. Note the advertisement reads Made by Wade of England.

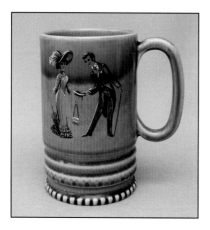

My Fair Lady Musical Tankard – shape No. I.P. 5. The tankard is ink stamped: Made in Ireland. Most of the My Fair Lady musical tankards play the tune "On the Street Where You Live," one of the most popular tunes from the musical ($65, £35).

Left: My Fair Lady One Pint Tankard – shape No. I.P. 2 with Mark Type 28. This picture illustrates the GBS decal at the front of the tankard. Right: My Fair Lady One Pint Tankard. The side decal of the tankard ($45, £24).

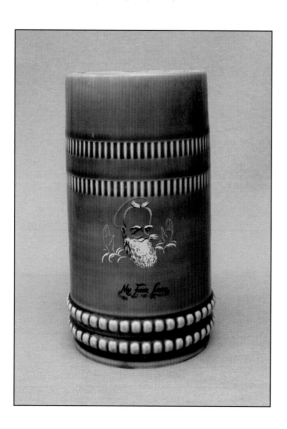

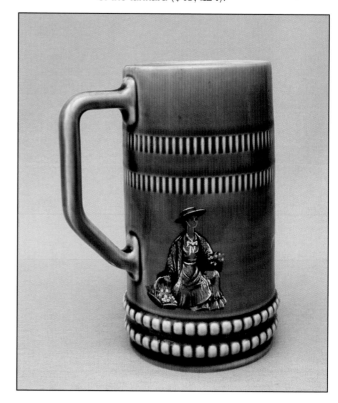

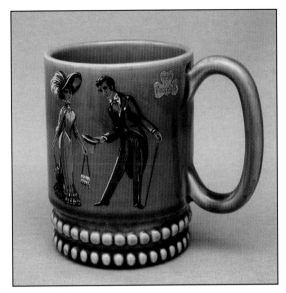

My Fair Lady Half Pint Tankard – shape No. I.P. 1 with two rows of knurls at the base and Mark Type 29 ($35, £19).

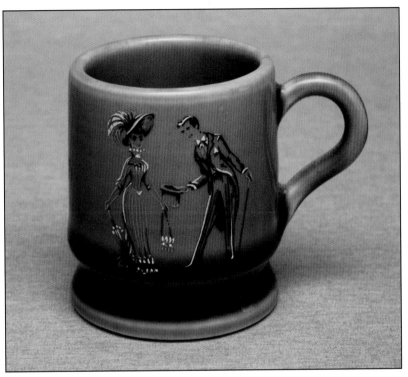

My Fair Lady Miniature Tankard – shape No. I.P. 614 with Mark Type 28 on the base ($18, £10).

My Fair Lady Self Standing Plaque. The plaque measures 4-7/8" by 4-7/8" and has Mark Type 30 ($70, £36).

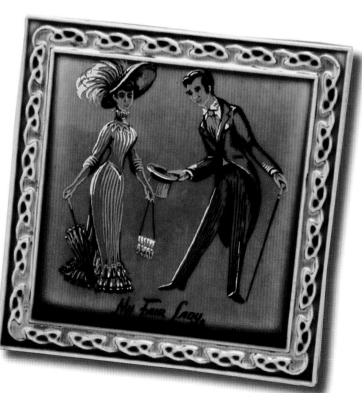

MUGS and BEAKERS

Between the early 1960s and 1986, the Irish pottery manufactured a popular line of coffee mugs, usually with the inscription: Irish Coffee. Beakers and knurled tankards were also popular items in the gift ware line.

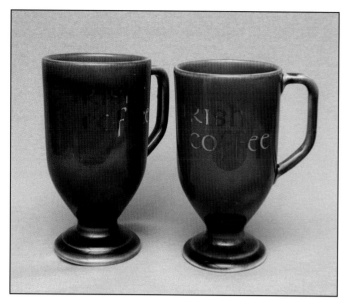

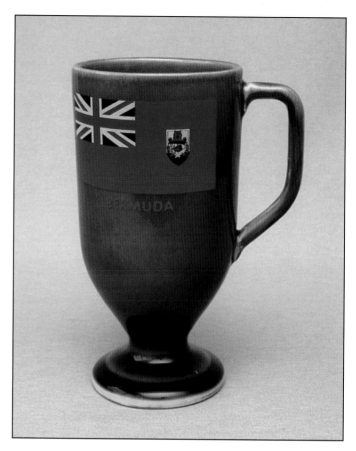

Irish Coffee Mugs – shape No. I.P. 44. Left: Irish coffee mug with Mark Type 28 measures 5-1/4" high. Right: Irish coffee mug with Mark Type 28 measures 5" high ($12 each, £7 each). The difference in height illustrates how molds differed when worn molds were replaced.

Irish Coffee Mug with Bermuda decal. The mug measures 5-1/4" high and has Mark Type 28 ($15, £8).

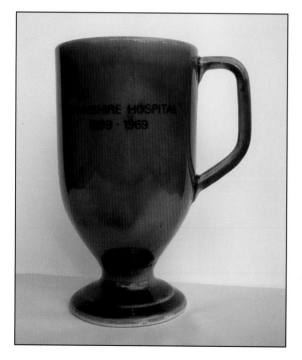

Irish Coffee Mug with a "Downshire Hospital" decal. The mug measures 5" high and has Mark Type 28 with the letter 'C' under the mark and 'H' in the center of the leaf ($15, £8).

Irish Coffee Mug with The Houses of Parliament decal. The mug measures 5" high and has Mark Type 28 with the letter 'C' under the mark and 'H' in the center of the leaf ($15, £8).

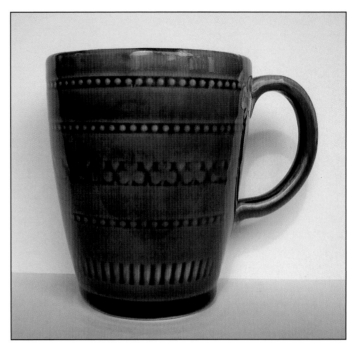

Irish Coffee Mug with Life Guard decal. The mug measures 5" high and has Mark Type 28 ($15, £8).

Beaker – shape No. I.P. 7. The beaker measures 4" high and has Mark Type 41 ($30, £16). The beakers were discontinued from the line in the early 1970s.

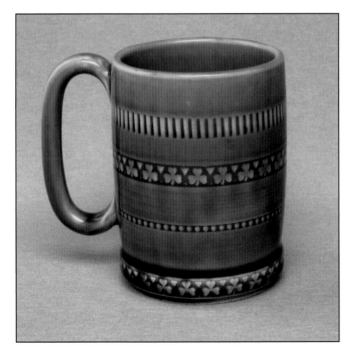

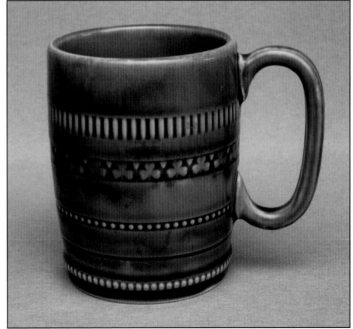

Left: Half Pint Knurled Tankard with a row of shamrock leafs at the base. The tankard measures 4" high and has Mark Type 28. Right: Half Pint Knurled Tankard with a row of knurls at the base – shape No. I.P. 6. The tankard measures 4" high and has Mark Type 29 ($38 each, £20 each).

AMBER TANKARD RANGE

When Wade Heath & Company Ltd. ceased production of tankards in the early 1960s, all tankard molds were transferred to the Irish pottery. It is therefore possible to find the amber tankards with similar applied designs with both an English or Irish backstamp.

For the continuation of the Veteran Car Range, Wade (Ireland) Limited carried on to manufacture the "Traditional" style amber tankards with the molded leaf design at the top of the handle. With the addition of various decals, the tankards were also incorporated into the regular gift ware line.

The "Traditional" style tankard was made in a variety of sizes including the 4-3/4" high one pint size, 4" high half pint size, and 2" high miniature size. Other popular shapes in the amber tankard line were the "Barrel" and "Plymouth" tankards, the latter shape being introduced to the line in October 1962. Both of these shapes were produced in three sizes. The "Barrel" one pint tankard is 5" high, the half pint tankard 3-1/2" high, and the miniature tankard is 2" high. The tapered "Plymouth" one pint tankard is 4-3/4" high, the half pint tankard is 3-3/4" high, and the miniature tankard is 2" high. These sizes are approximate, as slight variations in actual size occur.

The following pictures illustrate a variety of amber glaze tankards. Many other varieties are to be found.

Traditional Half Pint Tankard (shape No. WH.2) with a 1925 M.G. decal from the Veteran and Vintage Car Series, No. 20 from Series 7. The tankard has Mark Type 32A ($12, £6).

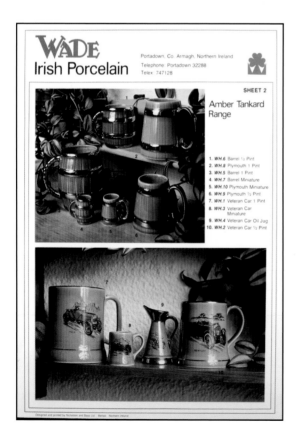

Amber Tankard Range. Trade literature, circa early 1980s - mid 1980s.

Traditional One Pint Tankard (shape No. WH.1) with a Model T Ford decal from the Veteran and Vintage Car Series, No. 27 from Series 9. The tankard has Mark Type 32A ($22, £10).

Traditional One Pint Tankard with a White Steam Car decal from the Veteran and Vintage Car Series, No. 12 from Series 4. The tankard has Mark Type 32B ($22, £10).

Traditional One Pint Tankard with a Cadillac decal from the Veteran and Vintage Car Series, No. 11 from Series 4. The tankard has Mark Type 32B ($22, £10).

Traditional One Pint Tankard with Bugatti decal from the Veteran and Vintage Car Series, No. 14 from Series 5. The tankard has Mark Type 32B ($22, £10).

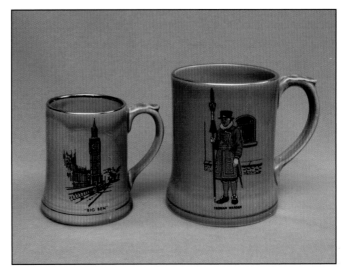

Left: Traditional Half Pint Souvenir Tankard with Big Ben decal. The tankard has Mark Type 37 ($9, £5). Right: Traditional One Pint Tankard with Yeoman Warder decal. The tankard has Mark Type 37 ($12, £6).

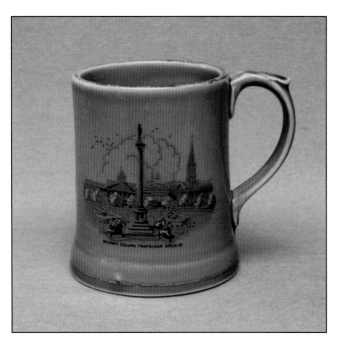

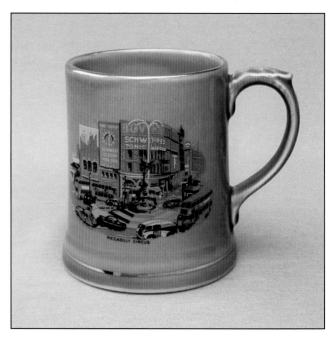

Traditional Half Pint Souvenir Tankard with Nelson's Column, Trafalgar Square decal No. 1. The tankard has Mark Type 37 ($12, £6).

Traditional Half Pint Souvenir Tankard with Piccadilly Circus decal No. 2. The tankard has Mark Type 37 ($12, £6).

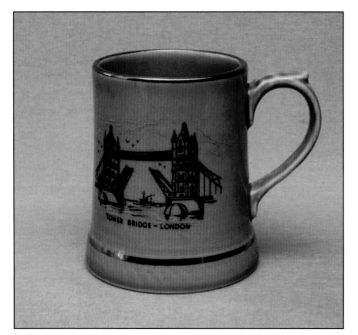

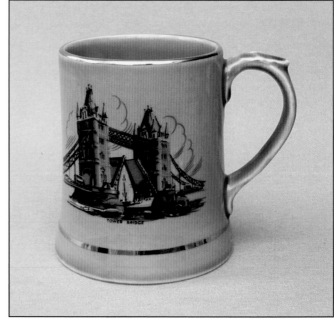

Left: Traditional Half Pint Souvenir Tankard with Tower Bridge decal No. 1.
Right: Traditional Half Pint Souvenir Tankard with Tower Bridge decal No. 2.
Both tankards have Mark Type 37 ($12 each, £6 each).

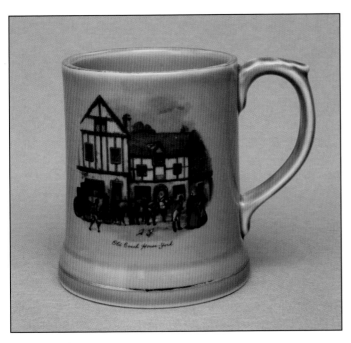

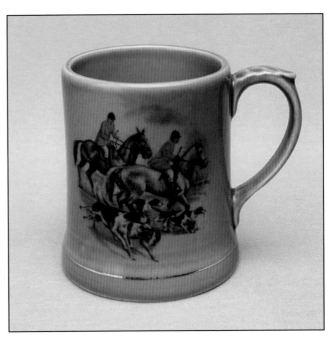

Traditional Half Pint Tankard with Old Coach House, York decal. The tankard has Mark Type 37 ($12, £6).

Traditional Half Pint Tankard with Fox Hunting Scene decal No. 4. The tankard has Mark Type 37 ($12, £6).

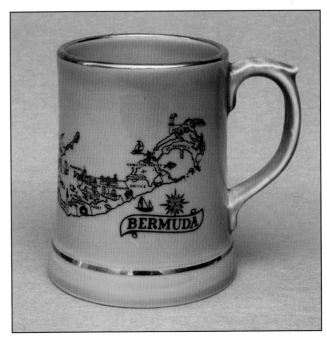

Traditional One Pint Tankard with "Same Again Please" decal. The tankard has Mark Type 37 ($15, £8).

Traditional Half Pint Souvenir Tankard with Bermuda decal. The tankard has Mark Type 37 ($12, £6).

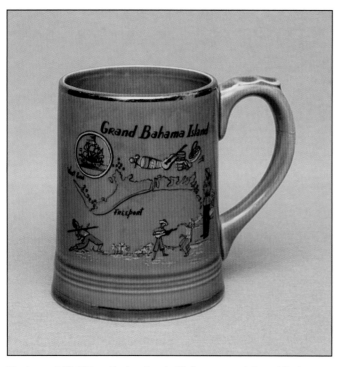

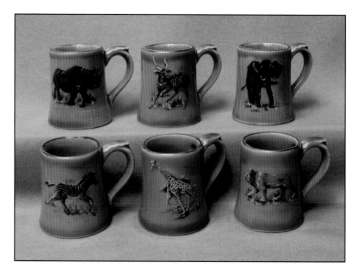

Traditional Half Pint Tankard with "A Souvenir of Grand Bahama Island" decal. The tankard has Mark Type 37 ($12, £6).

Miniature Traditional Tankards – Animal series. Top row. Left: Miniature Tankard with Rhinoceros decal. Center: Miniature Tankard with Gazelle decal. Right: Miniature Tankard with Elephant decal. Bottom row. Left: Miniature Tankard with Zebra decal. Center: Miniature Tankard with Giraffe decal. Right: Miniature Tankard with Lion decal. All miniature tankards measure 2" high and are marked: Made in Ireland ($20 each, £12 each).

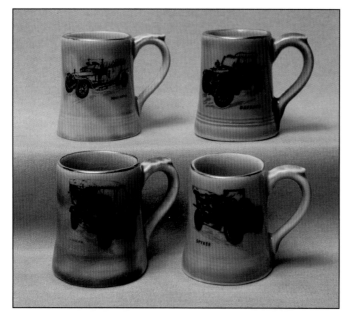

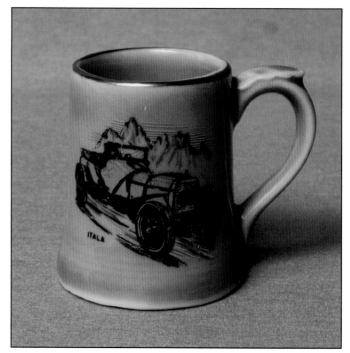

Miniature Traditional Tankards – Veteran Car series. Top row. Left: Miniature Tankard with Rolls Royce decal and Mark Type 32B. Right: Miniature Tankard with Darraco decal and Mark Type 32A. Bottom row. Left: Miniature Tankard with Sunbeam decal and Mark Type 32B. Right: Miniature Tankard with Spyker decal and Mark Type 32A. All miniature tankards measure 2" high ($18 each, £10 each).

Miniature Traditional Tankard – Veteran Car series with Italia decal and Mark Type 32A ($18, £10).

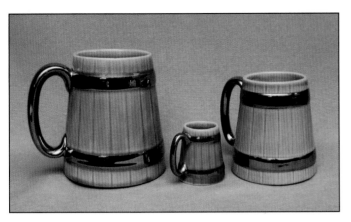

Plymouth Tankards. Left: One Pint Plymouth Tankard – shape No.WH.8 ($14, £8). Center: Miniature Plymouth Tankard – shape No.WH.10 ($9, £5). Right: Half Pint Plymouth Tankard – shape No.WH.9 ($12, £7). All three tankards have Mark Type 37.

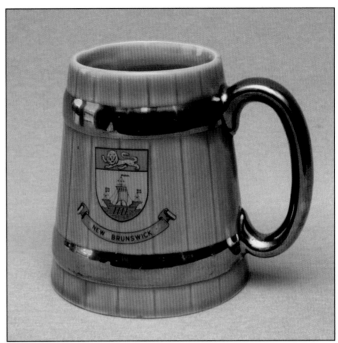

Plymouth One Pint Souvenir Tankard with New Brunswick decal. The tankard has Mark Type 37 ($18, £10).

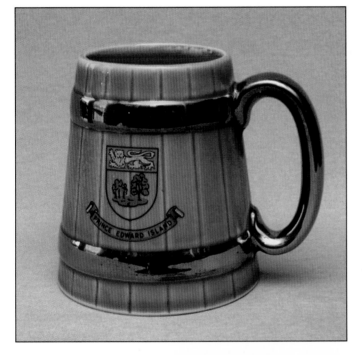

Plymouth One Pint Souvenir Tankard with Prince Edward Island decal. The tankard has Mark Type 37 ($18, £10).

Barrel Tankards. Left: One Pint Tankard measures 5" high ($18, £10). Center: Half Pint Tankard measures 3-3/4" high ($15, £6). Right: Mini Tankard measures 2" high ($10, £5). All tankards have Mark Type 37. The four pint jumbo barrel tankard was never produced in Ireland.

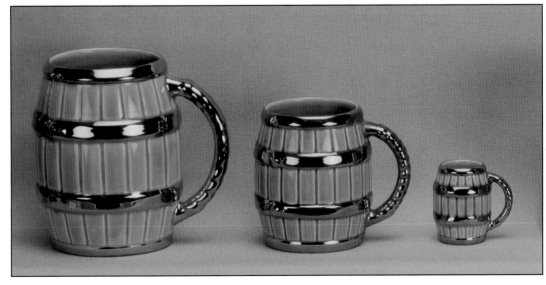

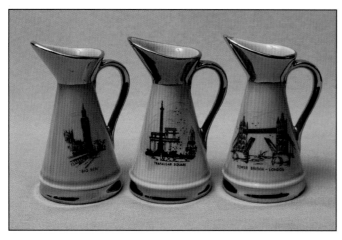

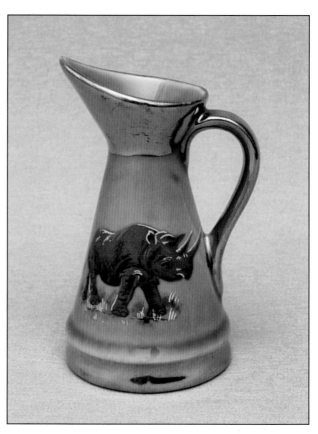

Miniature Oil Jug – London scene series. Left: Miniature Oil Jug with Big Ben decal. Center: Miniature Oil Jug with Nelson's Column, Trafalgar Square decal No. 2. Right: Miniature Oil Jug with Tower Bridge decal No. 1. The miniature oil jugs (shape No. WH.4) measure 3-3/4" high and have Mark Type 37 ($15 each, £8 each).

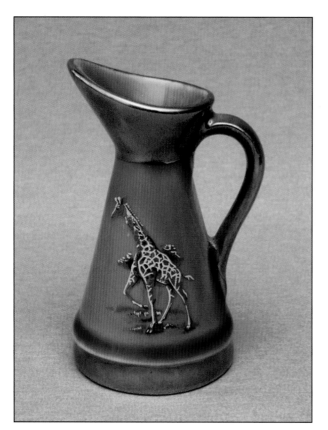

Miniature Oil Jug – Animal series. The miniature oil jug with Rhinoceros decal measures 3-3/4" high and has Mark Type 37 ($20, £11).

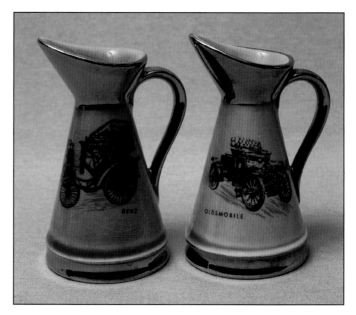

Miniature Oil Jug – Animal series. The miniature oil jug with Giraffe decal measures 3-3/4" high and has Mark Type 37 ($20, £11).

Miniature Oil Jug – Veteran Car series. Left: Miniature Oil Jug With Benz decal. Right: Miniature Oil Jug with Oldsmobile decal. Both jugs measure 3-3/4" high and have Mark Type 32B ($18 each, £10 each).

Miniature Oil Jug – Veteran Car series with Bugatti decal ($18, £10).

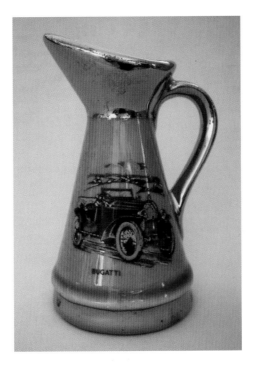

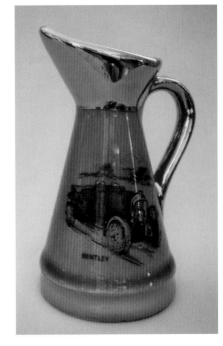

Miniature Oil Jug – Veteran Car series with Bentley decal ($18, £10).

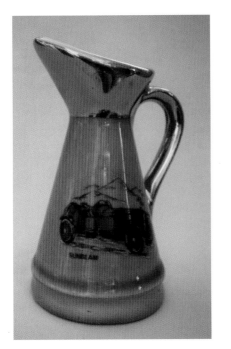

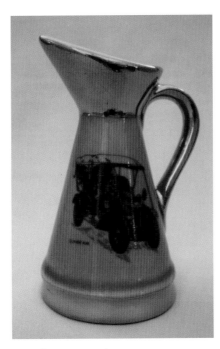

Left: Miniature Oil Jug – Veteran Car series with Sunbeam type 1 decal. Right: Miniature Oil Jug – Veteran Car series with Sunbeam type 2 decal ($18 each, £10 each).

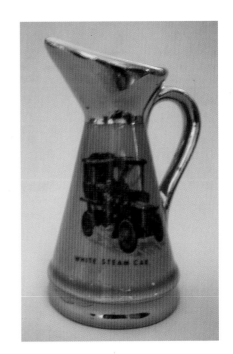

Miniature Oil Jug – Veteran Car series with White Steam Car decal ($18, £10).

MISCELLANEOUS TANKARDS

Wade (Ulster) Limited and later Wade (Ireland) Limited produced a number of tankards for various universities, colleges, and general gift ware with black or white glazes. The tankards illustrated are just a few of this type of tankard manufactured by the Irish pottery. Many other shapes with or without decals are to be found.

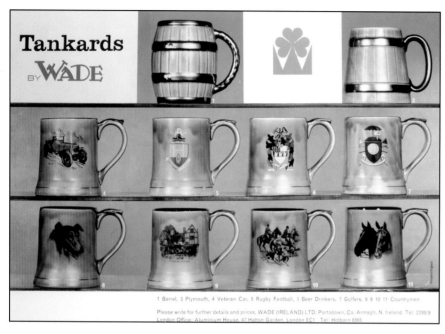

Wade (Ireland) Ltd. Tankards. Trade literature 1970.

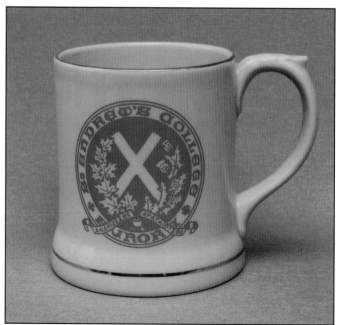

One Pint Traditional Tankard with University of Waterloo decal. The tankard has Mark Type 37 ($26, £14).

One Pint Traditional Tankard with Ryerson Polytechnical Institute decal. The tankard has Mark Type 37 ($26, £14).

One Pint Traditional Tankard with St. Andrew's College, Aurora decal. The tankard has Mark Type 37 ($26, £14).

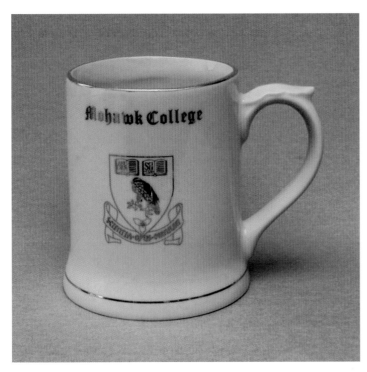

One Pint Traditional Tankard with Mohawk College decal. The tankard has Mark Type 37 ($26, £14).

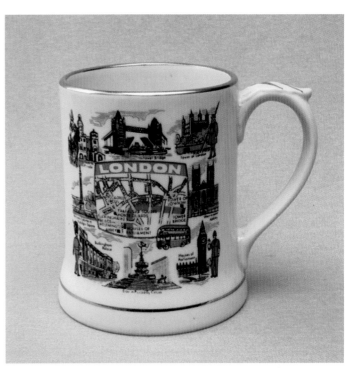

One Pint Traditional Souvenir Tankard with London scene decal. The tankard has Mark Type 37 ($22, £10).

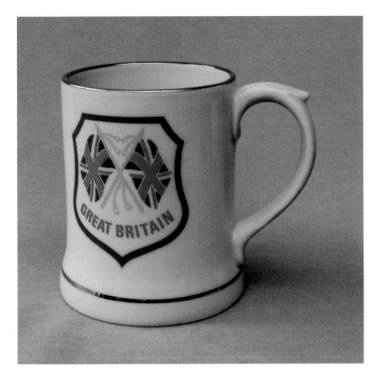

One Pint Traditional Souvenir Tankard with "Great Britain" decal. The tankard has Mark Type 37 ($14, £7).

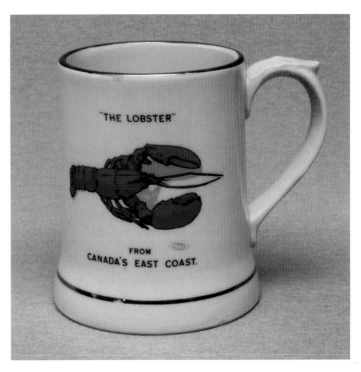

Half Pint Traditional Souvenir Tankard with "The Lobster" decal. The tankard has Mark Type 37 ($12, £6).

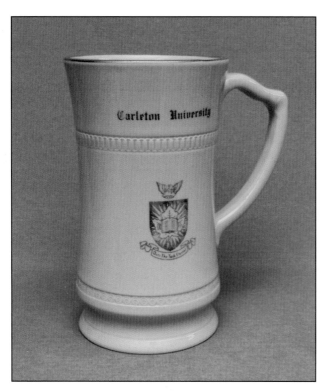

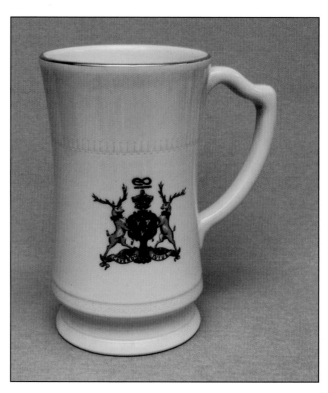

One Pint Tyrone Tankard – shape number I.P. 10 with Carleton University decal. The 6-1/2" high tankard has Mark Type 35 ($36, £20).

One Pint Tyrone Tankard – shape number I.P. 10 with unknown crest. The motto reads: Cavendo Tutus, which translated reads: Secure by caution. This is the Cavendish family motto, but the crest is not the family crest. The motto is used by a number of other organizations but Wade (Ireland) Limited personnel did not know the crest or for whom it was produced. The tankard has Mark Type 35 ($36, £20).

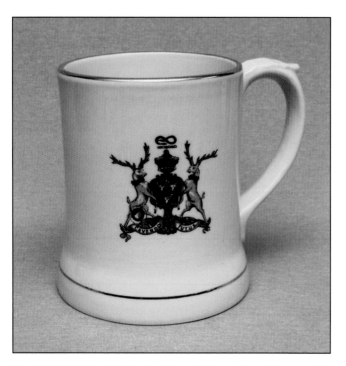

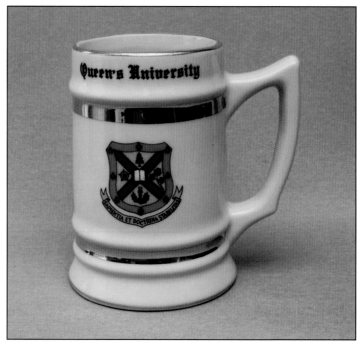

One Pint Traditional Tankard with a similar motto and crest as the previous tankard. The tankard has Mark Type 37 ($30, £16).

One Pint Tankard with "Queens University" decal. The tankard has Mark Type 37 ($28, £15).

Half Pint Tankard – shape number I.P. 1 with Country Scene decal. The tankard has Mark Type 28 ($18, £9).

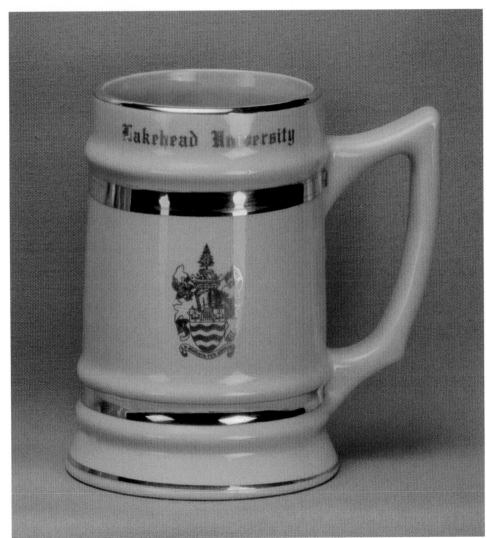

Lakehead University Tankard measures 6" high and has Mark Type 37 ($18, £9).

Chapter 3
GIFT WARE

early 1950s - 1993

Generally, just about all products of the Irish pottery were classed as "gift ware." However, for the purposes of this book, the products have been separated into different categories. This chapter, listed simply as "Gift Ware," illustrates and describes items that do not fall into definite categories.

YACHT WALL PLAQUES, *1955*

A set of three die-pressed wall plaques produced by the Irish pottery for approximately one year only. The plaques are mold-marked: Made in Ireland by Wade. Each plaque has a single hole for affixing the item to wall pins.

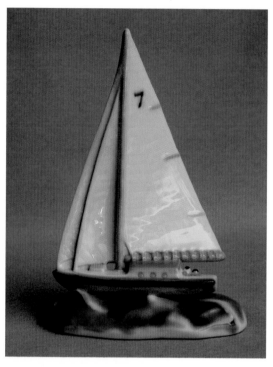

Prototype Yacht. This design was modeled by William Harper but never went into production ($250, £150).

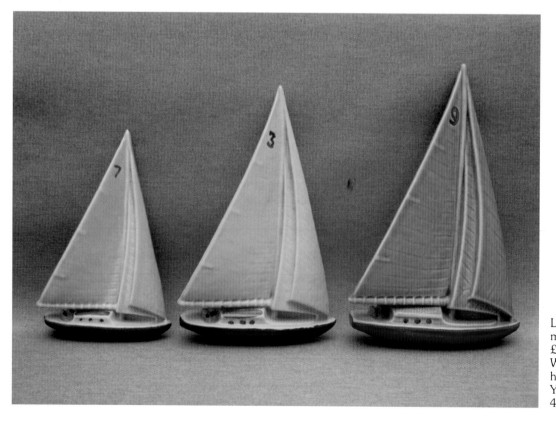

Left: Small Yacht Wall Plaque measures 3-3/8" high ($50, £38). Center: Medium Yacht Wall Plaque measures 4-1/8" high ($50, £38). Right: Large Yacht Wall Plaque measures 4-1/2" high ($50, £38).

"TREASURES" THE "ELEPHANT CHAIN,"
1957 - 1959

First appearing in the 1957 Wade catalog and again in the 1958 catalog, the "Treasures" The "Elephant Chain" was described as "...most perfectly modeled and decorated and sets a high standard for further sets in the Series..." Unfortunately, the proposed series that was to be developed over a number of years never materialized.

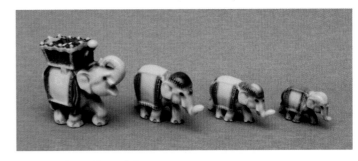

The "Elephant Chain." Prototypes.

The set comprises five elephants graduated in size, ranging from 2" high by 2-3/8" long to 3/4" high by 1-1/2" long. The figurines were modeled by William Harper and although manufactured by Wade (Ulster) Ltd. they are marked with a blue WADE ENGLAND transfer type mark. The January 1959 issue of the *Wade Wholesalers Newsletter No. 6* reported "...Last Orders Please" for the "Treasures Set."

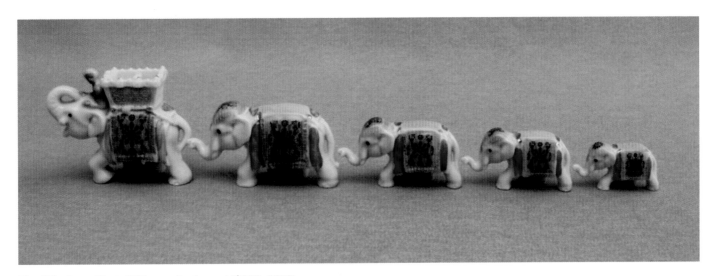

The "Elephant Chain." The production set ($900, £450).

The "Elephant Chain." The original packaging.

MISCELLANEOUS GIFT WARE ITEMS,
mid 1950s - 1986

Over the years of production at the Irish pottery, a number of items were added to the gift ware line—some with long production runs and some with only a short life. Many do not fall into a specific category. Following are illustrations of some of these items.

Reproduction of Wade (Ireland) Ltd. catalog, circa 1979.

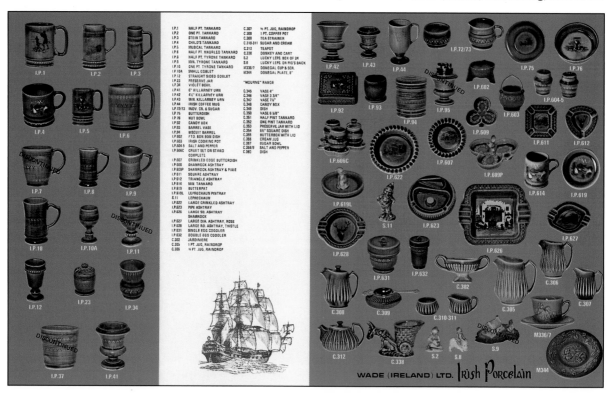

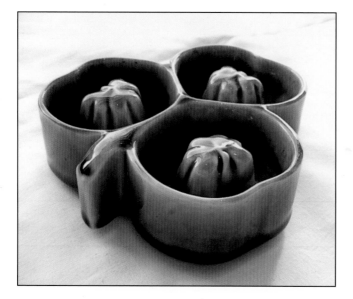 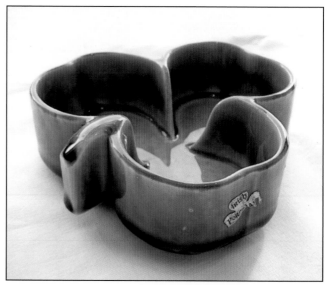

Left: Shamrock Dish Type 1. This dish measures 4-1/2" across by 4-3/4" from top to bottom and has a mark similar to Mark Type 28 but with Wade written in the center of the leaf. This dish was produced for a short time in 1954. Interestingly, no one at the Irish pottery could recall the name and use of this item ($26, £14).
Right: Shamrock Dish Type 2. This dish measures 4-1/2" across by 4-3/4" from top to bottom and has a mark similar to Mark Type 28 but with Wade written in the center of the leaf. This dish was produced for a short time in the mid 1950s ($14, £8).

Ink Well. The ink well measures 1-3/4" high by 3" wide by 3-1/2" long and has Mark Type 32. This item was in production for a short time in the mid 1950s ($60, £35).

Bowls, urns, etc. Trade literature circa early 1980s - mid 1980s.

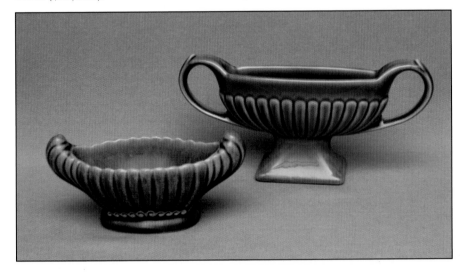

Left: Jardiniere – shape No. I.P. 620. The bowl measures 2-1/2" high at the handle by 5-3/4" overall and has Mark Type 28. The production run of this item appears to have been short, from 1957 to 1958 ($18, £10). Right: Jardiniere – shape No. C. 302. The bowl measures 4" high at the handle by 8-1/2" overall and has Mark Type 30. This jardiniere was first introduced in 1954 and again in 1962 and discontinued in the late 1970s. It is to be found with a number of different backstamps in addition to Mark Type 30 as listed above ($18, £10).

Killarney Urns. From left: Large Urn – shape No. I.P. 40 is 8" high with Mark Type 28 on the base ($70, £40). Medium Urn – shape No. I.P. 41 is 6-1/4" high with Mark Type 28 on the base ($60, £34). Small Urn – shape No. I.P. 42 is 4-1/4" high with Mark Type 28 on the base ($40, £23). Miniature Urn – shape No. I.P. 43 is 3" high with Mark Type 28 on the base ($30, £16). All urns were in production from the mid 1950s to 1986 except for Shape No I.P 40, which was discontinued circa late 1960s. As with many items from the Irish pottery, these urns are to be found with Mark Types other than those mentioned here.

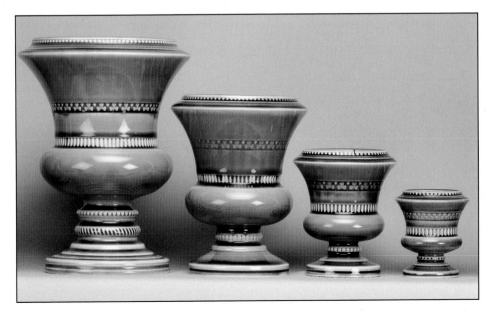

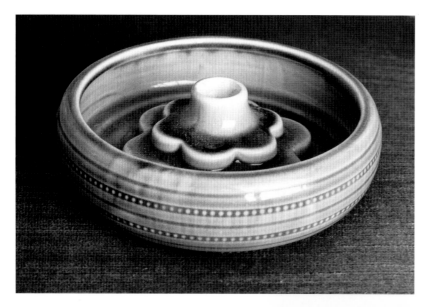

Candle Holder/Ashtray. This 6-1/2" diameter ashtray/candle holder has Mark Type 28 on the underside of the base and was produced for a short time in the mid 1950s. It is interesting to note that the applied candle holder is from the same mold as the "Everlasting Candle" base produced by George Wade & Son Ltd. in 1953 - 1954 ($60, £35).

Candle Holder/Ashtray. This 8" diameter candle holder/ashtray has Mark Type 33 on the underside of the base and was produced in the early 1960s ($50, £30).

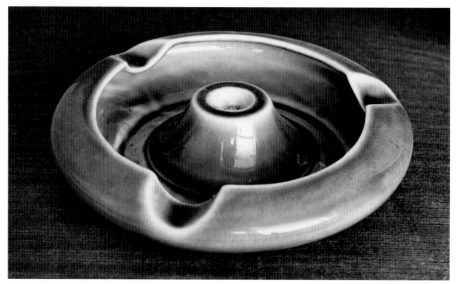

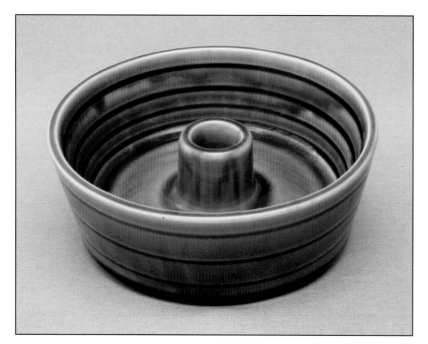

Candle Holder. This 6" diameter by 2" high candle holder has Mark Type 29 on the underside of the base and was produced in the mid 1950s ($60, £35).

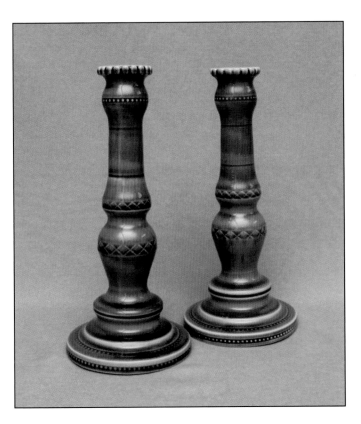

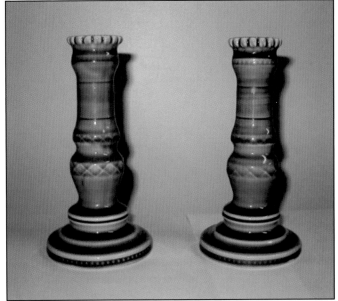

Candle Holders. Above: These tall candle holders measure 8-7/8" high by 4" diameter at the base. The candle holders are not marked but were introduced in 1954 and in production to the early 1970s ($175 pair, £105 pair). Above right: Short candle holders measure 6" high by 3-1/8" diameter and are unmarked ($225, £130). Bottom right: Short and tall candle holders shown for comparison.

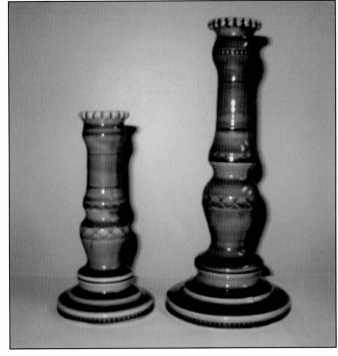

Candle holders, etc. Trade literature circa early 1980s - mid 1980s.

Rose Dish – shape No. I.P. 625. The dish is 5-1/2" long and has Mark Type 29. It was produced in the late 1950s to the early 1960s ($30, £17).

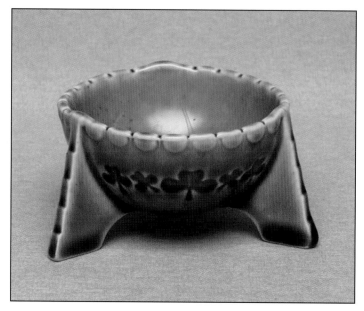

Footed Bon Bon Dish – shape No. I.P. 602. The dish has Mark Type 28, measures 1-1/2" high by 2-5/8" in diameter, and was produced circa mid 1950s to mid 1970s ($12, £7).

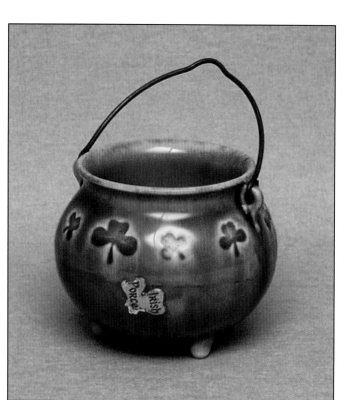

Irish Cooking Pot – shape No. I.P. 603. The pot has Mark Type 28, measures 2-1/4" high, and had a long production run from circa mid 1950s to 1986 ($12, £7).

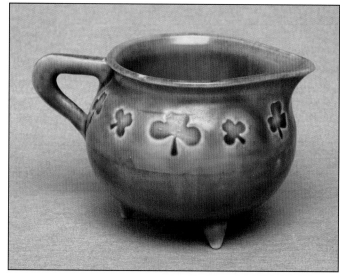

Irish Cooking Pot Creamer. This unusual variation on the Irish cooking pot is 2-1/4" high by 3-1/2" overall. The creamer is mold marked: Irish Porcelain Made in Ireland ($85, £48).

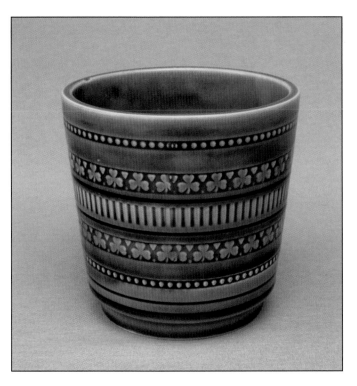

Flower Pot Holder – shape No. I.P. 37. The pot measures 4" high, has Mark Type 28 on the base, and was in production from the late 1960s through to the mid 1970s ($30, £18).

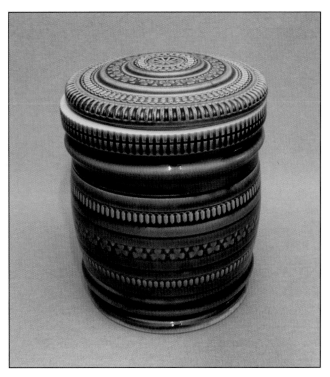

Biscuit Barrel – shape No. I.P. 94. The biscuit barrel has Mark Type 28 on the underside of the base. It measures 6" high by 5" diameter and was in production for a long time, circa late 1950s to 1986 ($60, £35).

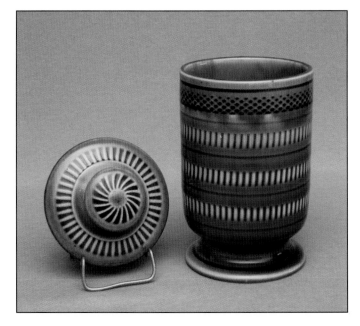

Covered Storage Jar. The storage jar measures 5-3/4" to top of finial by 3" diameter and has Mark Type 28 ($70, £40).

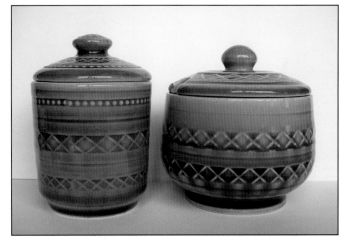

Covered Jam Dishes. Left: The dish measures 3-3/4" high to top of finial by 3-1/2" diameter and has Mark Type 29 with the letter 'N' below the mark ($40, £25). Right: The dish measures 3-5/8" high to top of finial and has Mark Type 29 with the letter 'C' below the mark. This is an example of an early product from Wade (Ulster) Ltd. and was in production for a short time in the early to mid 1950s ($40, £25).

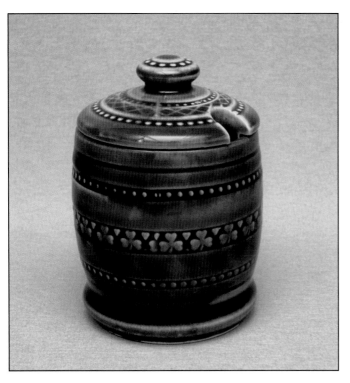

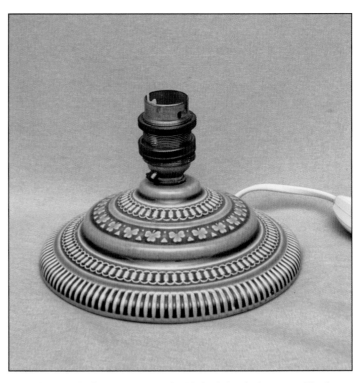

Preserve Jar – shape No. I.P. 23. The preserve jar measures 4" high to top of finial and has Mark Type 28 on the base. This item was shown in the December 1963 issue of *Tableware* but was in production from the mid 1950s to 1986 ($30, £18).

Lamp Base. The base measures 2-1/4" high by 6" diameter. The lamp base has an impressed mark: Irish Porcelain Made in Ireland by Wade County Armagh. According to Wade personnel, the lamp base was in production around 1965 and it was also on the general price list at that time. It was not in production in the 1970s ($60, £35).

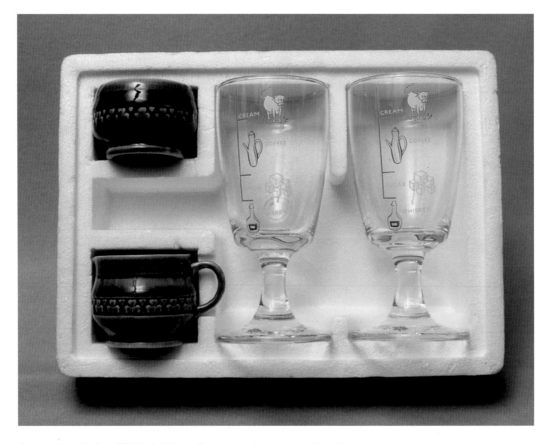

Boxed Irish Coffee Gift Pack. The coffee glasses included in the gift pack were not manufactured by the Irish pottery ($25, £15).

MISCELLANEOUS VASES and POSY BOWLS, *mid 1950s - 1986*

Wade (Ulster) Ltd. and later Wade (Ireland) Ltd. produced a number of different vases over the years, many of which had short production runs. As with many of the products of the Irish pottery, dates of production are estimates only.

Tapered Vases. The vases measure 4" high by 2-1/4" diameter at the base and have a 2-3/8" diameter opening at the top. Both have Mark Type 30 and are believed to have had a short production run, circa mid 1950s to early 1960s. Left: Tapered Vase with Pheasants decal. Right: Tapered Vase with Irish Colleen decal ($40 each, £25 each).

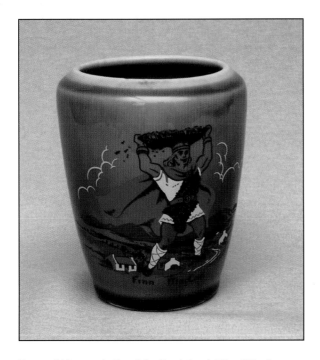

Tapered Vase with Finn MacCoul decal. The 4" high vase has Mark Type 30 on the base ($40, £25).

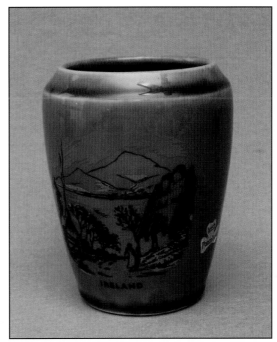

Tapered Vase with Irish Landscape decal. The 4" high vase has Mark Type 30 on the base ($40, £25).

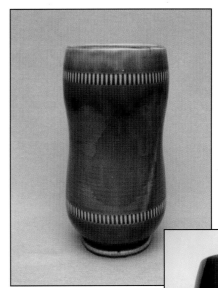

Left: Bulbous Vase Type 1. The vase measures 7-1/2" high and has Mark Type 28. It was produced circa late 1950s to mid 1960s. Below: Bulbous Vase Type 2. The vase measures 7-1/2" high and is unmarked. It was produced circa late 1950s to mid 1960s ($35 each, £20 each).

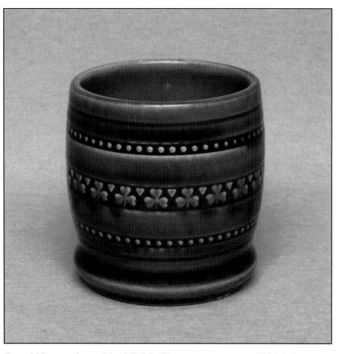

Barrel Vase – shape No. I.P. 93. The vase measures 3" high by 2-3/4" diameter and has Mark Type 28 ($15, £9).

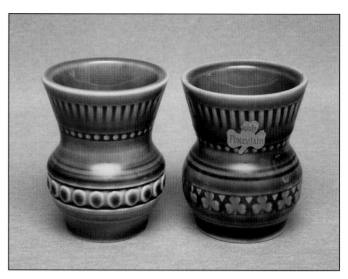

Violet Posy Bowls. Left: This 2-5/8" high violet posy bowl has an unusual molded decoration and is unmarked ($15, £8). Right: Violet Posy Bowl – shape No. I.P. 34. The bowl has Mark Type 28 on the base, measures 2-5/8" high, and was in production from the late 1950s to 1986 ($12, £6).

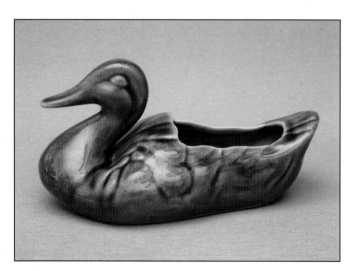

Open Duck Posy Bowl. This bowl was introduced in 1962 and first advertised in the March 1962 edition of *Pottery and Glass*. The bowl measures 4-1/2" high by 7-1/2" long and has Mark Type 30 on the base. A second, 7-1/4" long mold was produced for this duck posy bowl. Production of this item ceased in the late 1960s ($120, £65).

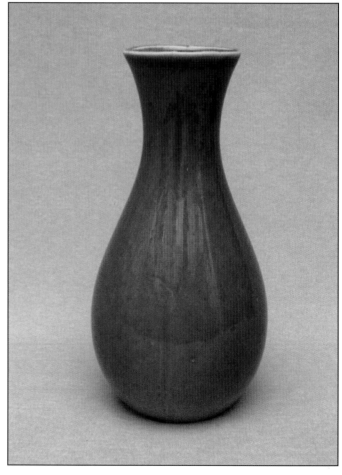

Tall Necked Vase. The vase measures 6-3/4" high and has Mark Type 40A on the base. This vase was in production from the late 1970s to the early 1980s ($40, £25).

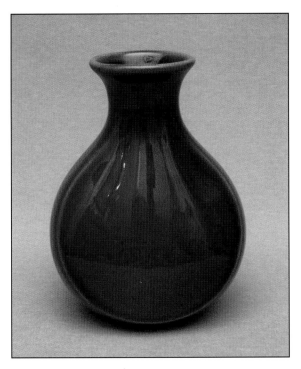

Low Necked Vase. The vase measures 4-3/4" high and has Mark Type 40B on the base. This vase was in production from the late 1970s to the early 1980s ($40, £25).

Round vase – shape No. KD.14. This 4-3/4" high vase with Mark Type 40B was designed by Kilkenny Design Workshop and was in production from the late 1970s to the early 1980s ($40, £25).

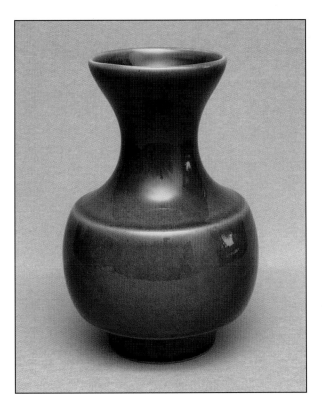

Tall Necked Bulbous Vase. The vase measures 7" high and has Mark Type 39A on the base. This vase was in production from the late 1970s to the early 1980s ($40, £25).

Donkey and Side Panniers Posy Bowl. This 4" high bowl is transfer marked: Made in Ireland. The posy bowl was in production for approximately one year only, circa 1965. This bowl has also been found customized with various town names and sold as souvenirs ($65, £45).

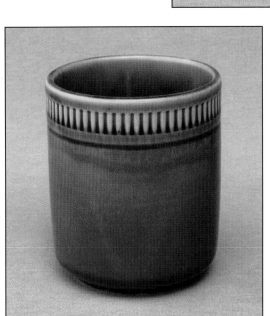

This straight sided open container is 3-3/8" high by 3" diameter. The container is unmarked and was used as a pencil holder ($15, £9).

GEODE TRAYS, *circa 1963 - 1964*

In the early 1960s, Wade (Ulster) Ltd. produced a range of porcelain "cladding" or "wall facing" to resemble genuine stone. This line evolved out of an idea from Iris Carryer, who was looking for some stonework to face some of the fireplaces in her new home. Together with James Borsey, chief designer at Wade (Ulster) Ltd., new stone-like porcelain was designed and was out of the ovens within weeks—a new line for the Irish pottery was born.

An article in the 1963 January edition of *Tableware* reports that the new stone-like porcelain was used by the local gas company for the outside walls of their new showroom. This showroom of the Portadown Gas Light and Electricity Co. Ltd. was constructed by Mr. Alex Prudell and opened by the Mayor of Portadown, Controller Harry McCourt, on November 5, 1962. Along with the new ceramic wall facings, the showroom also had new interior vitreous porcelain floor tiles, another product of the Irish pottery. Unfortunately neither Straker nor Iris Carryer could be present at the opening of the new showroom so the Irish pottery was represented by Alec McCullough, Director of Wade (Ulster) Ltd.

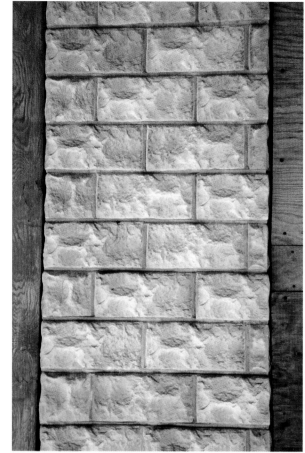

A close-up of Porcelain Stone Wall Facings on Portadown Gas Company showroom.

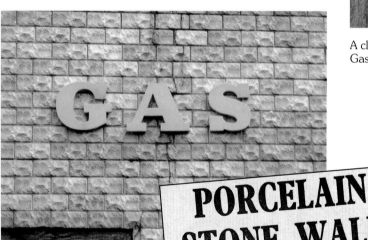

Porcelain Stone Wall Facings on the exterior of the Portadown Gas Company showroom.

A Wade (Ulster) Ltd. advertisement for the Porcelain Stone Wall Facings.

PORCELAIN STONE WALL FACINGS

THESE NEW AND REVOLUTIONARY WALL FACINGS HAVE BEEN CHOSEN FOR THE EXTERIOR DECORATION OF THE

NEW GAS SHOWROOM

☆ All the charm of real stone
☆ Frost proof
☆ Easily cleaned
☆ Available in an ever increasing range of textures and a variety of delicate colourings.
☆ Carefully designed in shape and size to ensure easy erection

MADE IN PORTADOWN BY

WADE (ULSTER) LIMITED

WADE (ULSTER) LTD., PORTADOWN, CO. ARMAGH

"New Ulster 5 Star" VITREOUS PORCELAIN FLOOR TILES

AS USED THROUGHOUT THE NEW GAS SHOWROOM

Samples on request

MADE IN PORTADOWN BY

★ Dimensionally Accurate
★ Special grip-fast key
★ Colour fast
★ Acid and stain proof.
★ Supplied in handy cartons containing one square yard

WADE (ULSTER) LIMITED

WADE (ULSTER) LTD., PORTADOWN, CO. ARMAGH

A Wade (Ulster) Ltd. advertisement for the Vitreous Porcelain Floor Tiles.

The new line of porcelain wall facings proved costly to manufacture and was soon discontinued. It is from this line of stone-like porcelain that the geode trays were developed. According to Wade Ireland personnel, these trays were manufactured in the mid 1960s and a brown centered tray lay about the offices of Wade (Ulster) Ltd. for years.

According to Alec McCullough, works manager and later director of the Irish pottery during the 1950s and 1960s, experimental trays were produced that incorporated ashtrays and designs similar to those used for the wall plaques. These trays were later given the name "geode" trays.

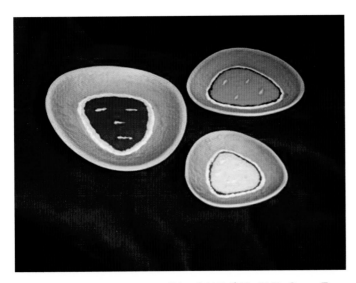

Brown Tray measures approx. 6" by 6-1/4" ($28, £15). Green Tray measures approx. 5" by 5-1/2" ($22, £12). Yellow Tray measures approx. 4" by 3-3/4" ($17, £9). All have Mark Type 32C reading: Made in Ireland by Wade Co. Armagh.

Robert Alec McCullough, circa 1956.

CELTIC PORCELAIN, *circa mid 1960s*

As legend has it, there are no snakes in Ireland because they were banished by St. Patrick, the patron saint of Ireland. However, in pre-Christian Ireland, it is possible that snake worship was the origin of the elaborate Celtic art shown in the *Book of Kells*, a very beautiful manuscript book hand written by Irish monks a long time ago. This art form is reproduced on the panels of the six canisters and dishes that form the range of "Celtic Porcelain" produced by Wade (Ulster) Ltd. in the early to mid 1960s. Interestingly, no one at the Irish pottery could recall for what purpose these items were made. Each item in the range was given a mold number of Celtic Kells or C.K.1 to C.K.6. All jars and urns have Mark Type 34 on the underside of the base.

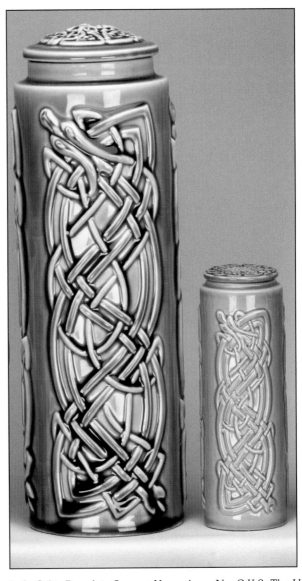

Left: Celtic Porcelain Serpent Urn – shape No. C.K.3. The Urn measures 11-1/2" high ($95, £55). This urn has been found converted into a table lamp. Right: Celtic Porcelain Serpent Urn – shape No. C.K.5. The Urn measures 5-3/4" high ($75, £45).

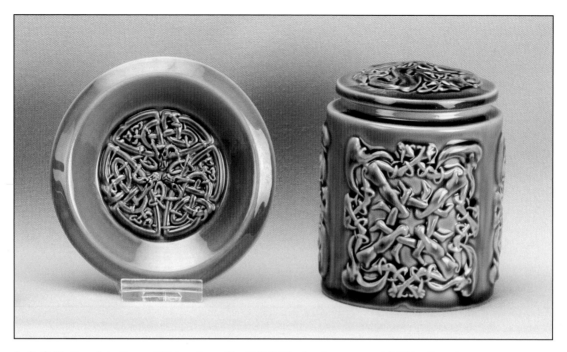

Left: Celtic Porcelain Serpent Dish – shape No. C.K.2. The bowl measures 4-1/2" in diameter ($40, £25). Right: Celtic Porcelain Beard Pullers Jar – shape No. C.K.4. The jar measures 4-1/2" high ($85, £50). The Beard Pullers Jar was also used as a cigarette lighter but with a different, molded backstamp. See Chapter 4 for illustration.

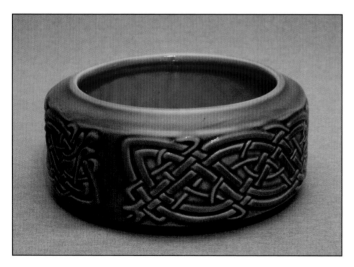

Celtic Porcelain Serpent Jar – shape No. C.K.1. The jar measures 4-1/2" high by 3-1/2" in diameter ($85, £50).

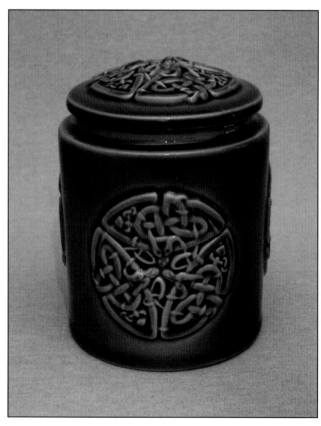

Celtic Porcelain Serpent Bowl – shape No. C.K.6. The bowl measures 2-1/8" high by 4-7/8" in diameter ($50, £30).

PADDY McGREDY FLORIBUNDA SET,
circa mid 1960s

In the mid 1960s, Wade (Ireland) Ltd. produced their Gift Pack No.1 comprising cigarette box, tankard, and ashtray. A number of these sets were specially decorated to be used as a special order by the Samuel McGredy Nursery, famous for their roses.

One nursery garden was located in Portadown, with a second nursery and store located in Derriaghy, near Belfast. The nurseries closed in 1975 when Sam McGredy, Jr., emigrated to New Zealand. Sam McGredy had a sister named Paddy, so it is most likely this design was named after her.

Each of the items in the gift set is marked on the back: Paddy McGredy, Floribunda. Raised by Sam McGredy from Spartan x Tzigane. Awarded gold medal National Rose Society, Award of Merit, Royal Horticultural Society.

Paddy McGredy Floribunda Half Pint Tankard with Mark Type 28 ($65, £34).

Paddy McGredy Floribunda Ashtray with Mark Type 29 ($55, £28).

Paddy McGredy Floribunda Cigarette Box/Candy Box with Mark Type 29 ($80, £48).

EGG CODDLERS, *circa mid 1960s - 1986*

Egg Coddlers were introduced to the Irish Porcelain Gift Ware range between May 1965 and February 1968, and were still appearing in trade literature in 1986 when production of the gift ware lines ended.

Besides the usual blue/green egg coddlers with the shamrock decoration around the top, a white glazed double egg coddler without the shamrock decoration has been found with an embossed Wade Ireland mark on the base. In addition, a plain double egg coddler with a pale pink glaze has been found, but with a Made in England transfer type backstamp. The pink glaze is interesting, as it is similar to the pink glazed candle holder shown in the Royal Commemorative chapter.

A. S. Cooper & Sons Bermuda

A.S. Cooper & Sons was established in 1897 when Alexander Samuel Cooper bought the stock and goodwill of the Bermuda Furnishing and Supply Company. In the years since then, A.S. Cooper & Sons Ltd. have developed their stock to include fine crystal, silver, and ceramics, and in the late 1960s the company became importers and distributors of Irish porcelain made by Wade (Ireland) Ltd.

When the company ordered various lines of the Irish gift ware, they asked that their name be impressed only on the egg coddlers that were produced, in small quantities, up until the 1980s.

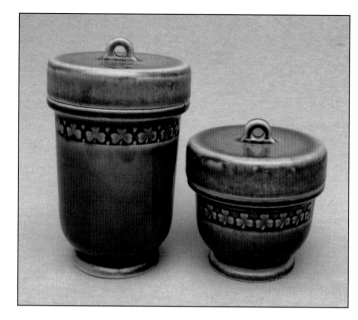

Left: Double Egg Coddler – shape No. I.P. 632. The coddler measures 4-1/4" high and has Mark Type 39 ($18, £10). Right: Single Egg Coddler – shape No. I.P. 631. The coddler measures 3" high and has Mark Type 35 ($14, £8).

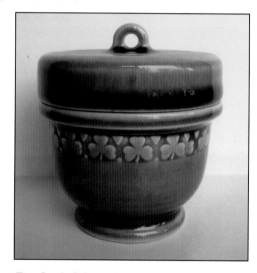

Top: Single Solomon's Mines Bahamas Egg Coddler – shape No. I.P. 631 ($25, £14). Bottom: Backstamp of Solomon's Mines egg coddler.

Single Egg Coddler – shape No. I.P. 631. The coddler measures 3" high and has Mark Type 35 ($25, £14).

WALL PLAQUES, *circa mid 1960s*

In the 1960s, Iris Carryer became friendly with Maxine Renaker, the then president of Hagen-Renaker. Through this friendship, Iris had a number of Hagen-Renaker molds sent over from the U.S.A. to be used at the Irish pottery to produce porcelain wall plaques. Unfortunately, the porcelain plaques were not a success as they tended to crack during the cooling process after being fired in the kiln.

As very few porcelain plaques made it through the cooling process they never went into production and were sampled only. Those that did make it to the final stage are eagerly sought after by collectors. All plaques made at the Irish pottery have Mark Type 32C reading: Made in Ireland by Wade Co. Armagh.

Wall Plaque "Fish." The plaque measures 12" long by 7-1/2" high ($575, £325).

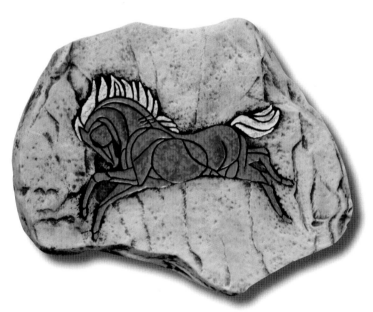

Wall Plaque "Horse." The plaque measures 11" long by 8" high ($575, £325).

Wall Plaque "Abstract Bottles." The plaque measures 15" high by 9-1/2" wide ($475, £265).

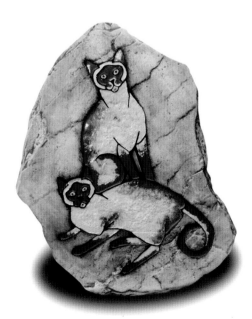

Wall Plaque "Siamese Cats." The plaque measures 16-1/4" high by 12-1/4" wide ($575, £325).

SELF STANDING ADVERTISING PLAQUES,
circa 1960s - 1986

During the years of gift ware production, Wade (Ulster) Ltd. and later Wade (Ireland) Limited produced self standing plaques to advertise their products. These plaques were not part of any retail line.

Rectangular Advertising Plaque. The plaque is in the traditional Irish glaze and measures 4" wide by 5-1/2" high. This was in use for many years from the 1960s through to 1986 ($62, £35).

Oval Advertising Plaque. The plaque with white glaze measures 3-3/8" wide by 4-1/4" high ($75, £40).

SELF STANDING PICTURES, *circa mid 1960s*

In the mid 1960s, the Irish pottery produced a number of self standing pictures or plaques very similar to the teapot stands. These ceramic plaques had a leg at the back of the plaque enabling the picture to stand. Decals added to the ceramic plaques were similar to those used for the tankards and ashtrays.

Self standing picture/plaque of Irish Colleen. The plaque measures 4" by 4" and has Mark Type 30 on the back ($62, £35).

SELF STANDING and HANGING PICTURES, 1990 - 1993

When Seagoe Ceramics Ltd. reintroduced the Song Figures in the 1990s, the pottery also introduced a series of "self standing" and hanging pictures. The actual pictures were decals applied to a ceramic plaque. There were 32 original picture/decals available but Seagoe trade literature mentions that individuals could order their own decals to be applied to the ceramic frame. The minimum order was 250 items.

The original 32 pictures were divided into five sets:

The Flowers Set comprised: 1. Crocus, 2. Primrose-1, 3. Clover, 4. Camellia, 5. Albertine Rose, and 6. Primrose-2.

Illustration of the original Flower Range reproduced from Seagoe Trade Literature.

We would like to thank you for your interest in our products, and if you require further details please do not hesitate to write or call. *We will gladly attend to your enquiry.*

seagoe
CERAMICS LIMITED
WATSON STREET, PORTADOWN
Co. ARMAGH, N. IRELAND BT63 5AH
Telephone (0762) 332288
Fax. (0762) 336896

The Irish Set comprised: 7. Tory Island, 8. On Horn Head, 9. The Bog Road, 10. Muchish Co. Donegal, 11. Rockport Cushendun, 12. Homeward Bound, 13. Going to the Dungloe Fair, and 14. Morning Mist Connemara.

The Dog Set comprised: 15. On Point, 16. Your Move, 17. Springer & Pheasant, 18. Winter Morning, 19. Springer & Woodcock, and 20. Away.

The Horse Set comprised: 21. Nice Morning, 22. The Farrier, 23. Clydesdale, and 24. Lippizzaner Mare.

The General Set comprised: 25. Sunrise, 26. Sunset, 27. Mussenden Temple, 28. Giant's Causeway, 29. Mellon Homestead, 30. Slemish, 31. Crawfords Burn, and 32. Tow Path.

Illustration of the original Irish scenes, Dog, Horse, and General sets reproduced from Seagoe trade literature.

Rectangular picture of Springer Spaniel and Woodcock. The ceramic plaque measures 4-1/2" wide by 3-1/2" high and has a built-in stand ($35, £20).

Left: Rectangular picture "Up and Away." Right: Rectangular picture "Shooting Scene." The ceramic plaques measure 4-1/2" wide by 3-1/2" high. Both have a molded stand on the back ($35 each, £20 each).

Rectangular picture "The Bog Road." The ceramic plaque measures 4-1/2" wide by 3-1/2" high and is a wall hanging picture ($35, £20).

Rectangular picture "The Cobbler." The ceramic plaque measures 4-1/2" wide by 3-1/2" high ($35, £20).

Rectangular picture "Open Lake Scene." The ceramic plaque measures 4-1/2" wide by 3-3/4" high ($35, £20). The picture is noted on the back as "One in a series of paintings by Irish artist June Moffatt."

Square picture "Sunrise." The ceramic plaque measures 3-3/4" by 3-3/4" ($35, £20).

Rectangular picture "Clover." The ceramic plaque measures 4-1/2" wide by 3-1/2" high. The label on the back of the picture reads: One in a series of paintings by Irish artist Elizabeth McEwan. All copyrights reserved. Manufactured by Gray Fine Arts, Belfast, Ireland ($35, £20).

Oval picture "Winter Morning." The ceramic plaque measures 4" by 3-1/2" ($35, £20).

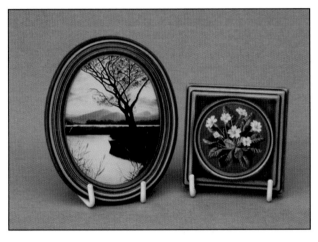

Left: Oval picture of "Sunset." The ceramic plaque measures 4" by 3-1/2" ($35, £20). Right: An unusual small square picture of "Primroses-2." The ceramic plaque measures 2-5/8" by 2-5/8" ($60, £32).

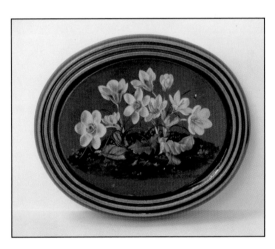

Oval picture "Crocus." The ceramic plaque measures 4" by 3-1/2" ($35, £20).

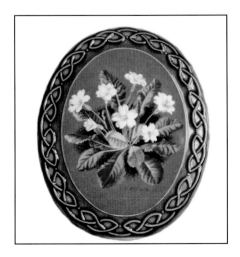

Left: Oval picture of "Primroses-2" – olive green. The ceramic plaque, with impressed ringed border, measures 4" by 3-1/2" and has a built-in stand ($35, £20). Right: Oval picture of "Primroses-2" – light green. The ceramic plaque, with molded decorated border, measures 4" by 3-1/2" and has a built-in stand ($35, £20).

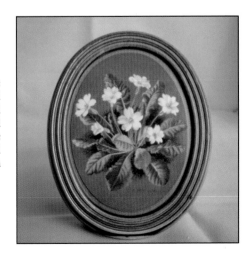

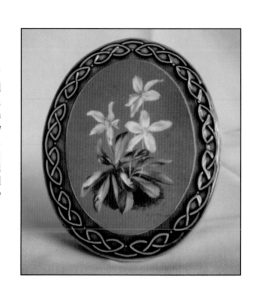

These beautiful flower studies, reproduced by Gray Fine Arts, are the work of N. Ireland artist Elizabeth McEwen S.B.A., A.R.U.A., U.W.S., U.S.W.A. Born in Belfast, where she now lives, was educated at Belfast Royal Academy, Belfast College of Art and Reading University, where she obtained a diploma in Art teaching, and taught Art afterwards in Princess Gardens and Ashleigh House School.

From her early days at Art College she was interested in painting plant and flower studies and decided to specialist in these subjects. She eventually gave up teaching to devote all her time to painting and is now recognised as one of the foremost plant and flower painters in Ireland.

Gray Fine Arts would like to thank you for the interest you have shown, and hope that you will find pleasure with your purchase. They also look forward to bringing you the work of other gifted contemporary artists in the years to come.

To care for your ceramic, do not scratch or scrape the surface, keep out of direct sunlight, wash gently in clear water or a light dusting with a soft cloth will suffice.

Left: Ceramic plaque "Crocus" presentation box. Right: Back of presentation box.

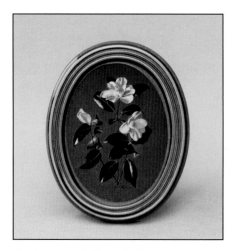

Oval picture of "Camellia." The ceramic plaque measures 4" by 3-1/2" ($35, £20).

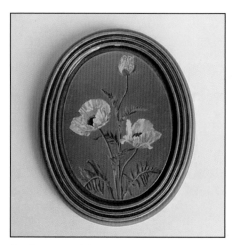

Oval picture of "Poppies." The ceramic plaque measures 4" by 3-1/2" ($35, £20).

Oval picture without decal. The ceramic plaque measures 4" by 3-1/2" ($10, £6).

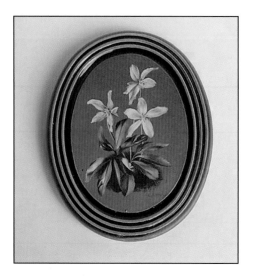

Oval picture of "Wood Sorrel / Oxalis." Left: The ceramic plaque, with impressed ringed border, measures 4" by 3-1/2" ($35, £20). Right: The ceramic plaque, with molded decorated border, measures 4" by 3-1/2" and has a built-in stand ($35, £20). The label on the back of the picture reads: One in a series of paintings by N. Ireland artists, reproduced on Irish porcelain, all copyrights reserved, Manufactured by Gray Fine Arts, Belfast.

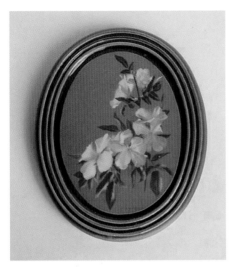

Oval picture of white flowers. The ceramic plaque measures 4" by 3-1/2" ($35, £20).

Oval picture of "Great Tits." The ceramic plaque measures 4" by 3-1/2" and is a wall hanging picture ($65, £35).

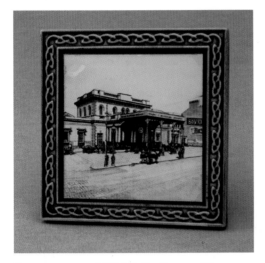

Square picture of "Old Belfast" scene. The ceramic plaque measures 3-7/8" by 3-7/8". The label on the back of the picture reads: Manufactured by Gray Fine Arts, Belfast "Old Belfast Scene" ($35 £20).

Rectangular picture of "Old Belfast" church scene. The ceramic plaque measures 4-1/2" high by 3-1/2" wide and has a built-in stand ($35 £20).

Square picture of "Old Belfast" tram scene. The ceramic plaque measures 3-7/8" by 3-7/8" and has a built-in stand ($45 £25).

Rectangular picture of "Old Castle on the Hill." The ceramic plaque measures 4-1/2" wide by 3-1/2" high and has a built-in stand ($35 £20).

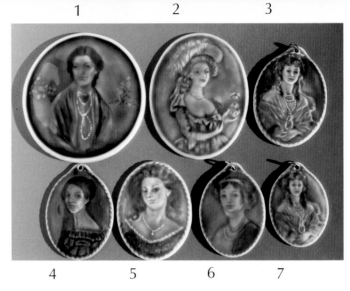

PLAQUES AND MEDALLIONS, *early 1960s*

There are conflicting reports as to production dates for the medallions that were made by Wade (Ireland) Ltd. The medallions were produced for an outside company, which subsequently applied them to various shaped pin boxes. A number of these plaques were amended, at the time of firing, to be used as pendants. All are unmarked.

1. Plaque measures 3-1/4" in dia. ($45, £20). 2. Plaque measures 3-3/8" by 2-3/4" ($45, £20). 3. Medallion measures 2-3/4" by 2" ($30, £15). 4. Medallion measures 2-3/8" by 1-3/4" ($30, £15). 5. Plaque measures 2-1/2" by 2" ($30, £15). 6. Medallion measures 2-3/8" by 1-3/4" ($30, £15). 7. Medallion measures 2-1/8" by 1-1/2" ($30, £15).

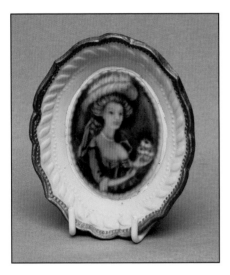

Cameo Plaque Pin Tray. The pin tray measure 3-3/8" wide by 4". The frame has an impressed mark: English Porcelain ($20, £12).

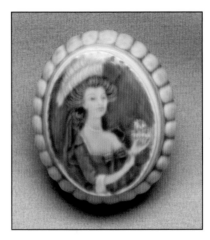

Oval Covered Cameo Dish. The dish measures 1-1/4" high by 2-3/8" overall and is unmarked ($75, £45).

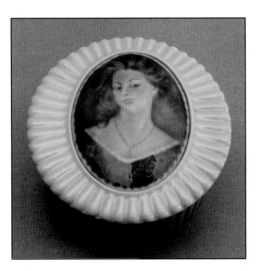

Round Covered Cameo Dish. The dish measures 1-1/2" high by 3" diameter and is unmarked ($75, £45).

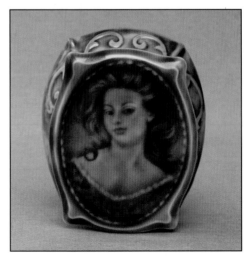

Covered Cameo Dish. The dish measures 3" long by 2-1/2" wide by 1-1/2" high and is unmarked ($75, £45).

MISCELLANEOUS PIN TRAYS

During the 1950s and 1960s, the Wade Pottery in Burslem produced a number of pin trays in the shape of leaves, fish, and pet faces. All these trays were modeled by William Harper, probably the most prolific modeler for Wade at that time.

After the run ended for the English made pin trays and dishes, and following a lapse of a few years, production of some of these pin trays and dishes was moved to Ireland with remade tools and Irish backstamps.

Cameo Plaque and Stand. Top: The stand and plaque measure 3" high and are unmarked ($70 complete, £40 complete). Bottom: Medallion Stand. The stand measures 1" high by 4" long and is unmarked ($15, £9).

Horse Chestnut Leaf Dish. After the English run between 1957 and 1959, the dishes were reintroduced by the Irish pottery circa mid 1970s to 1984. The leaf dishes were retailed in pairs and with attractive presentation boxes. The leaves were available in green or beige glazes and measured 3-1/4" long by 2-3/4" wide. The leaves illustrated have Mark Type 41 on the base ($12 each, $30 boxed set; £7 each, £18 boxed set).

Starfish Tray. After the English run between 1959 and 1960, the dishes were reintroduced by the Irish pottery between 1973 and 1984. The Starfish measures 4-1/2" overall by 7/8" high. The illustrated Starfish has Mark Type 41 on the base. The Irish made Starfish has a blue edging all around the outside as shown in the illustration. The English made Starfish does not have the blue edging ($30, £18).

Aqua Dishes. After the English run between 1958 and 1960, the dishes were reintroduced by the Irish pottery between 1973 and 1984. The Aqua dishes measure 4" across the fins by 3-1/8" from nose to tail. The Aqua dish is marked: Wade Porcelain Made in Ireland ($12 each, $30 boxed set; £7 each, £18 boxed set).

SHAMROCK RANGE of GIFT WARE BELLS, GOBLETS and VASES, *1982 - 1986*

A new line of gift ware featuring a white glaze with shamrock decoration was introduced to the retail lines in 1982. The range of the white glazed gift ware was quite extensive, comprising bells, goblets, candle holders, ashtrays, and table ware.

When production of all gift ware was discontinued in 1986 to concentrate on industrial ceramics, the Shamrock range came to an early end. To use up excess stock of the colorful decals, many were applied to flagons.

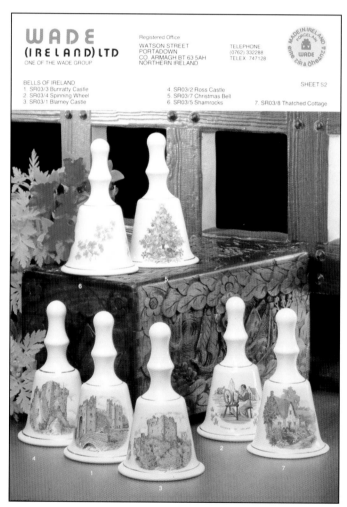

"Bells of Ireland" Shamrock Range. Trade literature circa early 1980s - mid 1980s.

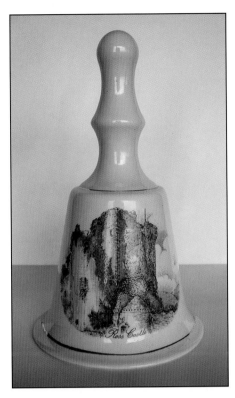

"Bells of Ireland" with Ross Castle decal. The bell measures 5-1/2" high and has Mark Type 41B on the inside wall of the bell ($45, £25). The decal on the back of the bell reads: "Ross Castle is situated on Ross Island in Lough Leane lakes of Killarney. From its 15th century tower one of the world's best loved beauty spots can be seen."

"Bells of Ireland" with Blarney Castle decal. The bell measures 5-1/2" high and Has Mark Type 41B on the inside wall of the bell ($45, £25). The decal on the back of the bell reads: "Blarney Castle. In 1446 the McCarthys of Muskerry built the great castle of Blarney with its enormous machicolated 85 ft. keep. Below the battlements is the Blarney Stone, the stone of eloquence."

"Bells of Ireland" with Thatched Cottage decal. The bell measures 5-1/2" high and has Mark Type 41B ($45, £25).

"Bells of Ireland" with Shamrock decal and original box. The bell measures 5-1/2" high and has Mark Type 41B ($50, £28).

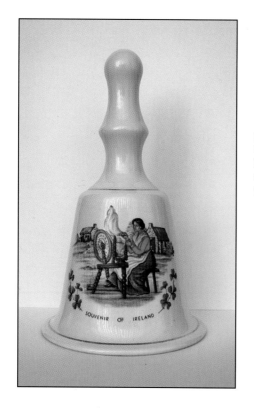

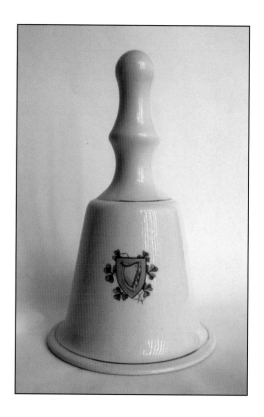

Left: "Bells of Ireland" with Spinning Wheel decal. The bell measures 5-1/2" high and has Mark Type 41B ($45, £25). Right: Harp decal on the back of the bell.

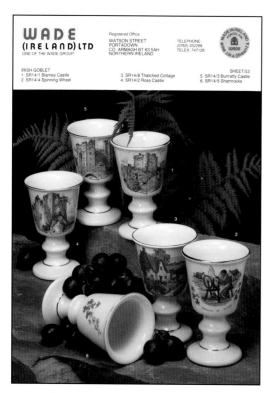

Goblets in the Shamrock Range. Trade literature circa early 1980s - mid 1980s.

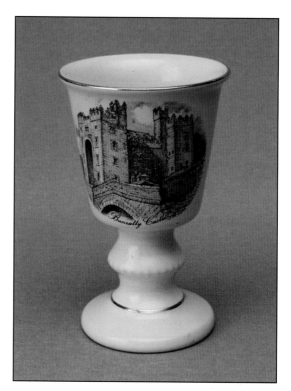

Goblet with Bunratty Castle decal. The goblet measures 4-1/2" high and has Mark Type 41B ($45, £25).

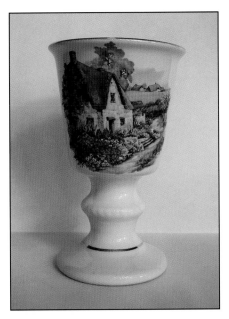

Goblet with Thatched Cottage decal. The goblet measures 4-1/2" high and has Mark Type 41B ($45, £25).

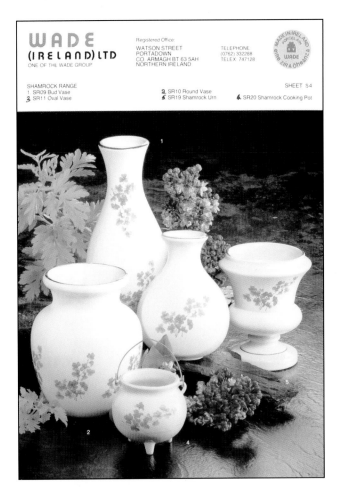

WADE (IRELAND) LTD
ONE OF THE WADE GROUP

Registered Office:
WATSON STREET
PORTADOWN
CO. ARMAGH BT 63 5AH
NORTHERN IRELAND

TELEPHONE
(0762) 332288
TELEX 747128

MADE IN IRELAND PORCELAIN éire cré a dhéantar á WADE

SHAMROCK RANGE
1. SR09 Bud Vase
3. SR11 Oval Vase
2. SR10 Round Vase
5. SR19 Shamrock Urn
6. SR20 Shamrock Cooking Pot

SHEET S4

Vases in the Shamrock Range. Trade literature circa early 1980s - mid 1980s.

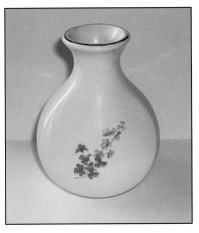

Shamrock Oval Vase – shape No. SR.11. The vase measures 4-5/8" high and has Mark Type 41B on the base ($50, £28).

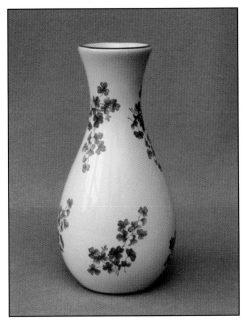

Shamrock Bud Vase – shape No. SR.09. The vase measures 6-3/4" high and has Mark Type 41B on the base ($40, £22).

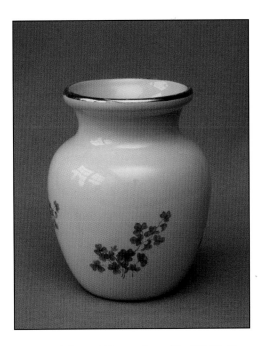

Shamrock Round Vase – shape No. SR.10. The vase measures 5-1/8" high and has Mark Type 41B on the base ($50, £28).

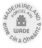

WADE
(IRELAND) LTD
ONE OF THE WADE GROUP

Registered Office
WATSON STREET
PORTADOWN
CO. ARMAGH BT 63 5AH
NORTHERN IRELAND

TELEPHONE
(0762) 332288
TELEX 747128

SHAMROCK RANGE
1. SR01 Half Pint Tankard
2. SR02 One Pint Tankard
3. SR17 Large Ashtray with Gold Rim
4. SR18 Small Ashtray without Gold Rim 5. SR12 Candlestick

SHEET S6

WADE
(IRELAND) LTD
ONE OF THE WADE GROUP

Registered Office
WATSON STREET
PORTADOWN
CO. ARMAGH BT 63 5AH
NORTHERN IRELAND

TELEPHONE
(0762) 332288
TELEX 747128

SHAMROCK RANGE
1. SR16 Irish Coffee Goblets Gift Pack of Two
2. SR15 Single Irish Coffee Goblet 3. SR13 Decanter

SHEET S5

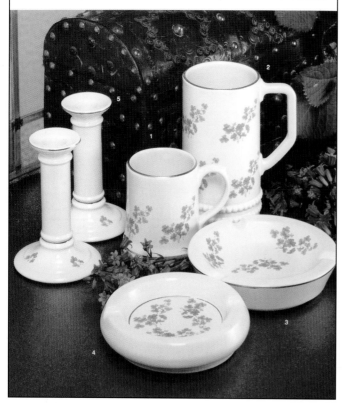

Candle Holders, Ashtrays and Tankards in the Shamrock Range. Trade literature circa early 1980s - mid 1980s.

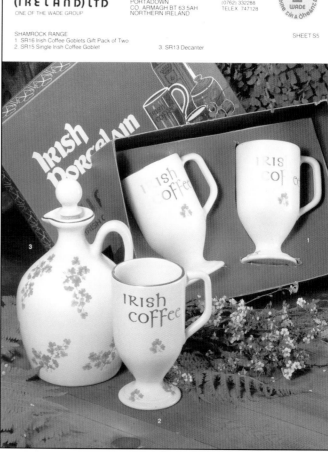

Decanter and Coffee Mugs in the Shamrock Range. Trade literature circa early 1980s - mid 1980s.

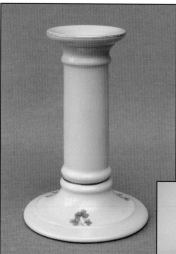

Shamrock Candle Holder – shape No. SR.12. The candle holder measures 5-1/4" high and has Mark Type 41B on the base ($30 pair, £18 pair).

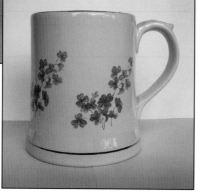

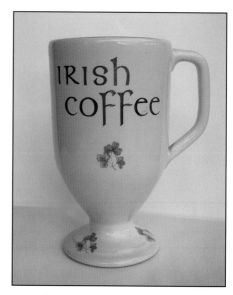

Shamrock Traditional Half Pint Tankard – shape No. SR. 01. The tankard is 3-3/4" high and has Mark Type 41B on the base ($20, £12).

Shamrock Irish Coffee Mug – shape No. SR. 15. The mug measures 5" high and has Mark Type 41B ($20, £12).

WALL PLATES, *1984 - 1986*

In the mid 1980s, the Irish pottery used up remaining stocks of decals by applying them to various plates and then selling the items in the Factory Shop.

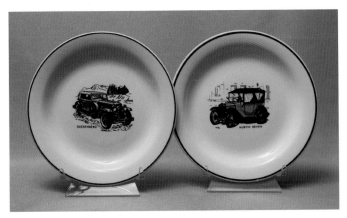

Left: "Duesenberg" Veteran Car wall plate measures 7-1/8" in diameter and has Mark Type 19C on the base. The wall plate illustrates the 1933 Duesenberg, SJ, No. 22 from series 8 of the Veteran Car series ($35, £20). Right: "Austin Seven" veteran car wall plate measures 7-1/8" in diameter and has Mark Type 32A on the base. This wall plate illustrates the 1925 Austin Seven, No. 26 from series 9 of the Veteran Car series ($35, £20).

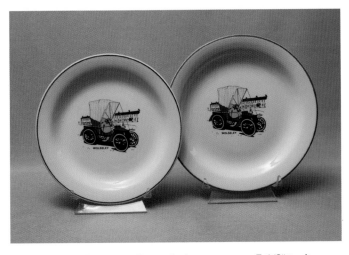

Left: "Wolseley" Veteran Car wall plate measures 7-1/8" in diameter and has Mark Type 32A on the base. This plate illustrates the 1904 6hp Wolseley, No. 25 from series 9 of the Veteran Car series ($35, £20). Right: "Wolseley" Veteran Car wall plate measures 7-3/4" in diameter and has Mark Type 32A on the base. This plate also illustrates the 1904 6hp Wolseley, No. 25 from series 9 of the Veteran Car series ($35, £20).

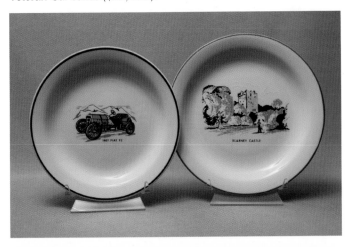

Left: "Fiat" Veteran Car wall plate measures 7-1/8" in diameter and has Mark Type 32A on the base. The wall plate illustrates the 1907 Fiat F2, No. 21 from series 7 of the Veteran Car series ($35, £20). Right: "Blarney Castle" wall plate measures 7-3/4" in diameter and has Mark Type 37 ($35, £20).

MISCELLANEOUS PROMOTIONAL ITEMS

The Irish pottery was commissioned to produce a number of promotional items by various companies in the medical and food supply fields. This section does not include the decanters and liquor bottles also produced in Ireland.

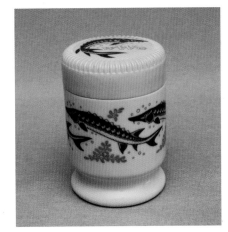

Caviar Pot. The pot is 4" high by 2-5/8" diameter (4oz. size) and marked on the base: W. G. White London, Wade Porcelain Co. Armagh. Production dates for this jar are thought to have been in the mid 1960s - 1970 ($35, £20). This jar was produced in 3 sizes: 2oz., 4oz., and 8oz. W. G. White was founded in 1895 by William George White. For over a hundred years the company has been one of the world's major suppliers of caviar and gourmet foods to the catering and retail trade.

Unguentum Jar. The jar measures 4-1/2" high by 3-1/8" diameter and is marked: Made in Ireland by Wade Co. Armagh. Production dates for this jar are thought to have been in the mid 1960s. The jars were used as pencil holders ($45, £26).

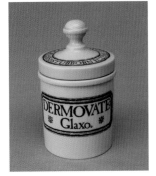

Glaxo Ointment Jar. This jar measures 7" high and has Mark Type 37 on the base. The jar was produced circa 1976 and was a single run item specifically manufactured for Glaxo Laboratories. The wording around the lid reads: Dermovate Psoriasis and Stubborn Eczema ($35, £20).

Bath Salts Jar. (not shown). Wade (Ireland) Ltd. manufactured a jar for bath salts in the 1970s. The jar was 5" high and with the lid in place measured 7-1/2" high. Bath Salts was written in black across the front of the jar, which was surrounded by an oval, gold colored decoration. There was also a gold line around the top and the bottom of the jar. Wade did not have a picture of this jar, only a description.

Chapter 4
ASHTRAYS AND CIGARETTE LIGHTERS
mid 1950s - 1986

Ashtrays for cigarettes and pipes were first manufactured by Wade (Ulster) Limited in the mid 1950s and remained as part of the gift ware lines until 1986. Numerous shapes of ashtrays were made, many with applied decals similar to those used on the tankards.

As the ashtrays were manufactured over a long period and molds were replaced due to wear, it is possible to find examples with Mark Types other than those mentioned in the illustrations. All Mark Types mentioned here are on the underside of the base unless noted otherwise.

The ashtrays, tankards, and candy boxes manufactured in the early 1960s were often packaged in Presentation or Gift Boxes. Presumably the candy boxes were to be used as cigarette containers in the Presentation Boxes.

CANDY/CIGARETTE BOXES,
circa mid 1950s - 1980

From the mid 1950s to 1980, the Irish pottery manufactured a large number of covered containers given the shape No. IP. 92. It is interesting to note that when marketed in presentation boxes along with ashtrays, the boxes were presumably used for cigarettes but when sold separately they were retailed as candy boxes. However, Wade literature refers to these double duty containers only as candy boxes. The boxes measure 1-3/4" high by 5" long and 4" wide. Those illustrated have Mark Type 29 on the base.

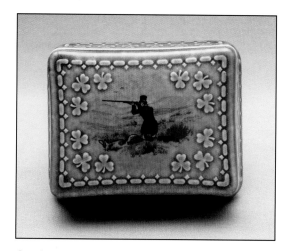

Candy Box with Shooting scene decal ($35, £18).

Boxed Gift Packs from a trade brochure circa mid 1960s.

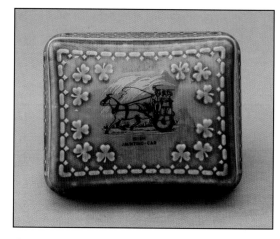

Candy Box with Irish Jaunting Car scene decal ($35, £18).

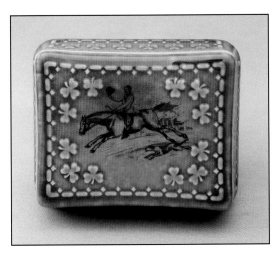

Candy Box with Fox Hunting scene No. 1 decal ($35, £18).

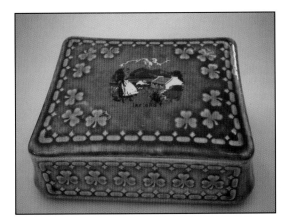

Candy Box with Irish Colleen decal ($35, £18).

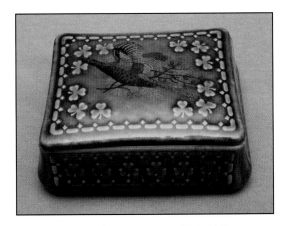

Candy Box with Pheasant decal ($35, £18).

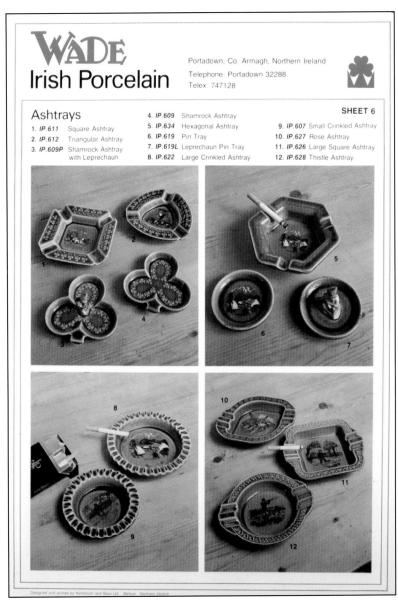

Irish glaze ashtrays. Trade literature circa early 1980s - mid 1980s.

ROSE ASHTRAYS

This offset rectangular ashtray was in production from the mid 1950s until all gift ware was discontinued in 1986. The style of ashtray gets its name from the two bands of roses molded into the design at the rim of the tray.

This style ashtray was given the mold number I.P. 627 and measures approximately 1-1/4" high by 6-1/2" overall.

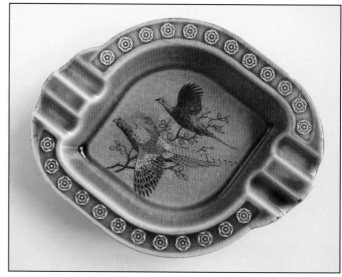

Rose Ashtray with Pheasant decal. The tray has Mark Type 29 ($26, £14).

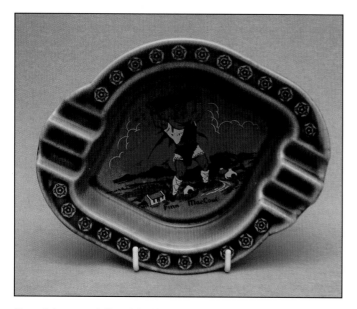

Rose Ashtray with Finn MacCoul decal. The tray has Mark Type 29 ($26, £14).

SHAMROCK ASHTRAYS

This large square ashtray was in production from the mid 1950s until all gift ware was discontinued in 1986. The style of ashtray gets its name from the bands of shamrock leaves molded into the design at the rim of the tray.

This style ashtray was given the mold number I.P. 626 and measures approximately 5-1/8" by 6-1/8".

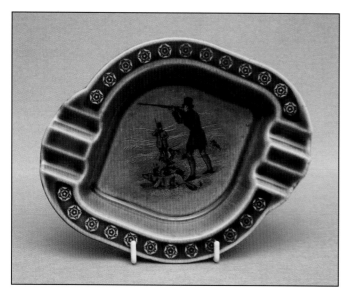

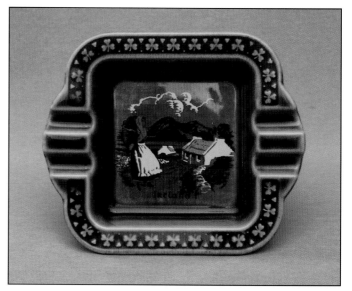

Rose Ashtray with Shooting scene decal. The tray has Mark Type 41 ($26, £14).

Shamrock Ashtray with Irish Colleen decal. The tray has Mark Type 29 on the base ($26, £14).

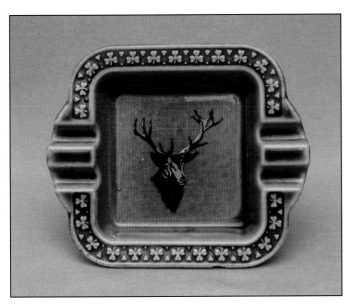

Shamrock Ashtray with Stag Head decal. The tray has Mark Type 29 ($26, £14).

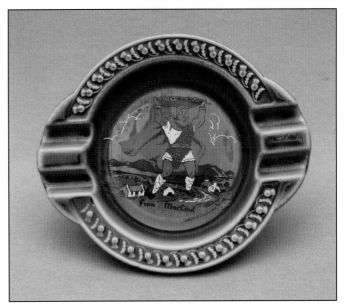

Thistle Ashtray with Finn MacCoul decal. The tray has Mark Type 29 ($26, £14).

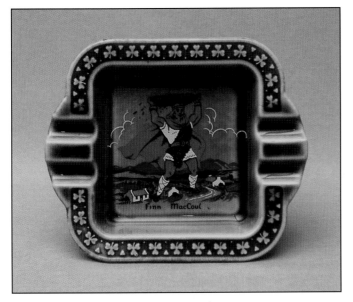

Shamrock Ashtray with Finn MacCoul decal. The tray has Mark Type 29 ($26, £14).

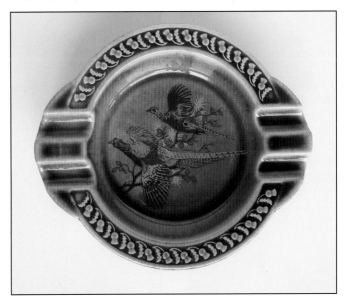

Thistle Ashtray with Pheasant decal. The tray has Mark Type 29 ($26, £14).

THISTLE ASHTRAYS

This large round ashtray was in production from the mid 1950s until all gift ware was discontinued in 1986. The style of ashtray gets its name from the bands of thistles molded into the design at the rim of the tray.

This style ashtray was given the mold number I.P. 628 and measures approximately 1-1/4" high by 5-1/4" by 6-1/8".

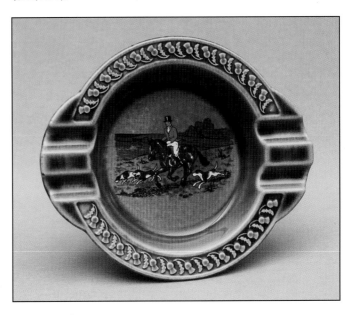

Thistle Ashtray with Fox Hunting scene No. 3 decal. The tray has Mark Type 41 ($26, £14).

CRINKLED ASHTRAYS

There were two sizes of the Crinkled ashtrays. The large size measures 6" in diameter, was given the mold number I.P. 622, and has 36 indents around the rim of the tray.

The small size measures 4-3/4" in diameter, was given the mold number I.P. 607, and has 30 indents around the rim of the tray. In some catalogs this small round ashtray was also referred to as a butter dish.

Small Crinkled Ashtray with Fishing scene decal. The tray has Mark Type 32 ($18, £9.50).

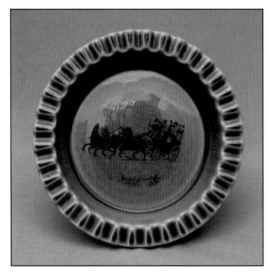

Large Crinkled Ashtray with Stage Coach No. 1 decal. The tray has Mark Type 29 ($22, £11.75).

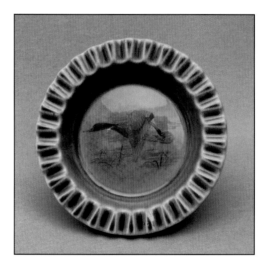

Small Crinkled Ashtray with Flying Ducks decal. The tray has Mark Type 32 ($18, £9.50).

Large Crinkled Ashtray with Pheasant decal. The tray has Mark Type 29 ($22, £11.75).

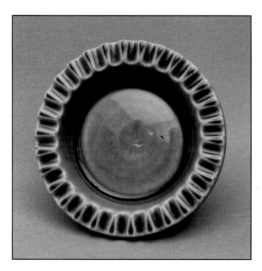

Small Crinkled Ashtray without decal. The tray has Mark Type 32 ($18, £9.50).

Small Crinkled Ashtray with Irish Jaunting Car decal. The tray has Mark Type 29 ($18, £9.50).

Small Crinkled Ashtray with Irish Football Association decal. The tray has Mark Type 32 ($18, £9.50).

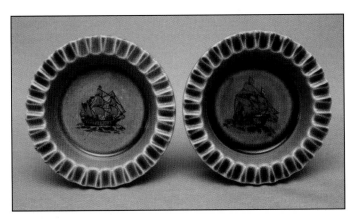

Left: Small Crinkled Ashtray with sailing ship "Revenge" decal. Right: Small Crinkled Ashtray with sailing ship "Santa Maria" decal. Both trays have Mark Type 32 ($18 each, £9.50 each).

SQUARE ASHTRAYS

This small square ashtray was in production from the mid 1950s until all gift ware was discontinued in 1986. The ashtray has bands of shamrock leaves molded into the design at the rim of the tray.

This style ashtray was given the mold number I.P. 611 and measures 4" by 4".

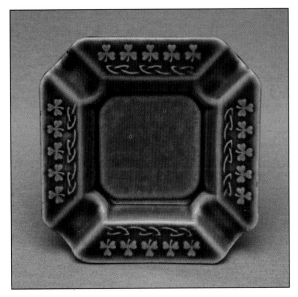

Small Square Ashtray without decal. The tray has Mark Type 32 ($12, £6).

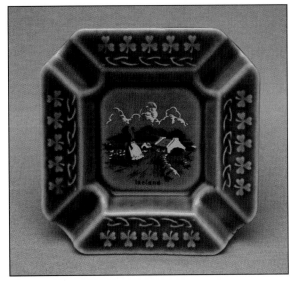

Small Square Ashtray with Irish Colleen decal. The tray has Mark Type 32 ($15, £8).

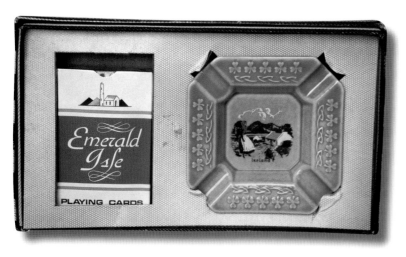

Presentation Box of small square ashtray and a pack of playing cards ($26, £14).

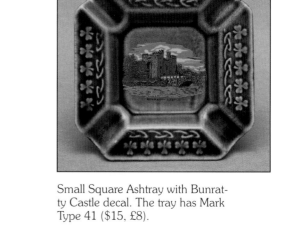

Small Square Ashtray with Bunratty Castle decal. The tray has Mark Type 41 ($15, £8).

Small Square Ashtray with cartoon decal. The tray has Mark Type 32 ($15, £8).

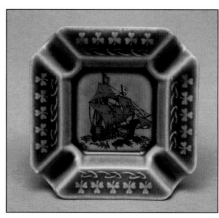

Small Square Ashtray with sailing ship "Santa Maria" decal. The tray has Mark Type 41 ($15, £8).

HEXAGONAL ASHTRAYS

This six sided ashtray was in production from the mid 1950s until all gift ware was discontinued in 1986. The ashtray has no impressed decoration around the rim and relied on the applied decals for decoration.

This style ashtray was given the mold number I.P. 634 and measures 1-1/4" high by 5" overall.

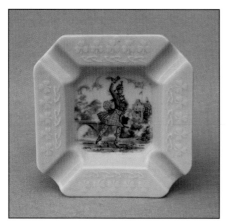

Small Square Ashtray with Scottish Dancer decal. This unusual white glaze ashtray has Mark Type 32 ($26, £14).

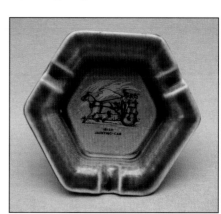

Hexagonal Ashtray with Irish Jaunting Car decal. This ashtray has Mark Type 29 ($15, £8).

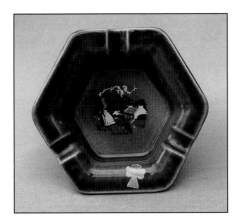

Hexagonal Ashtray with Irish Colleen decal.
This ashtray has Mark Type 29 ($15, £8).

TRIANGULAR ASHTRAYS

This triangular ashtray was in production from the mid 1950s until all gift ware was discontinued in 1986.

This style ashtray was given the mold number I.P. 612 and measures 7/8" high by 4" by 4".

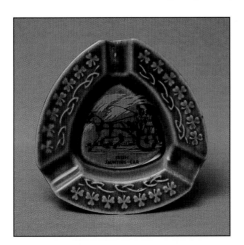

Triangular Ashtray with Irish Jaunting Car decal.
This ashtray has Mark Type 41 ($12, £6).

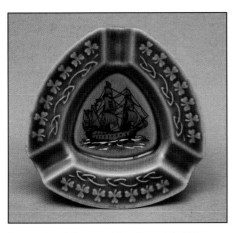

Triangular Ashtray with sailing ship "Revenge" decal. The tray has Mark Type 41 ($12, £6).

SMALL SHAMROCK ASHTRAYS

This shamrock leaf shaped ashtray was in production from the mid 1950s until all gift ware was discontinued in 1986. This shape ashtray did not have applied decals as decoration.

This style ashtray was given the mold number I.P. 609 and measures 3-1/2" by 3-3/8". The same style ashtray with the addition of a pixie was given the mold number I.P. 609P.

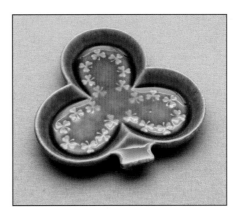

Shamrock Ashtray. This ashtray has Mark Type 29 ($14, £7).

MISCELLANEOUS ASHTRAYS

During the years of gift ware production at the Irish pottery a number of short run items were manufactured, some of which were ashtrays.

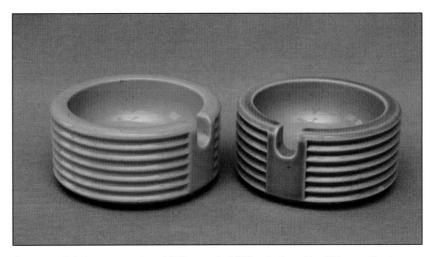

Occasional Ashtrays circa late 1970s - early 1980s, designed by Kilkenny Design Ireland and given the mold number KD. 25. The ashtrays measure 1-1/2" high by 3-1/4" diameter ($16 each, £9 each).

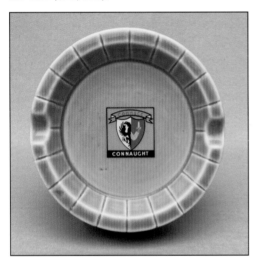

Sirocco Ashtray, circa late 1950s. The ashtray measures 4" diameter and is stamped Made in Ireland by Wade on the underside of the base ($30, £16).

Connaught Ashtray, circa 1970. The ashtray measures 1-1/2" high by 5-1/2" diameter at the top and has Mark Type 38 ($34, £18).

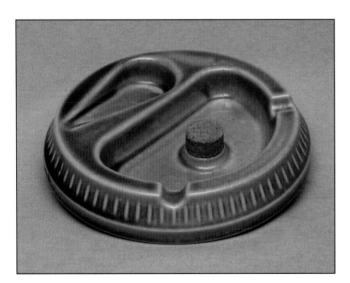

Pipe Ashtray – shape number I.P. 623, circa 1960 - early 1970s. The ashtray measures 1" high by 6" diameter and has Mark Type 29 ($24, £12).

CIGARETTE LIGHTERS

From the late 1950s to the mid 1970s, Wade (Ulster) Limited, later Wade (Ireland) Limited, manufactured a number of cigarette lighters. There is little information available to give actual dates of production or the size of production runs. A cigarette lighter does appear in early trade literature but not in literature of the 1970s.

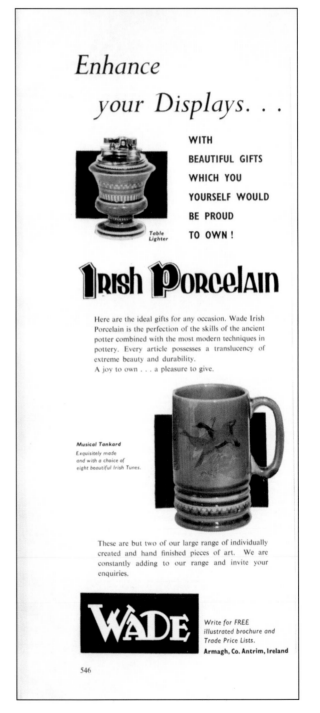

Enhance your Displays. . .

WITH BEAUTIFUL GIFTS WHICH YOU YOURSELF WOULD BE PROUD TO OWN !

Table Lighter

Irish Porcelain

Here are the ideal gifts for any occasion. Wade Irish Porcelain is the perfection of the skills of the ancient potter combined with the most modern techniques in pottery. Every article possesses a translucency of extreme beauty and durability.
A joy to own . . . a pleasure to give.

Musical Tankard
Exquisitely made and with a choice of eight beautiful Irish Tunes.

These are but two of our large range of individually created and hand finished pieces of art. We are constantly adding to our range and invite your enquiries.

WADE

Write for FREE illustrated brochure and Trade Price Lists.
Armagh, Co. Antrim, Ireland

546

An advertisement from the July 1961 issue of *Pottery and Glass*.

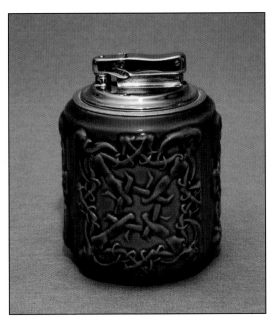

Celtic Cigarette Lighter. This lighter measures 3-1/4" high by 2-1/2" diameter and is marked on the underside of the base: Irish Porcelain Made in UK Colibri ($60, £32).

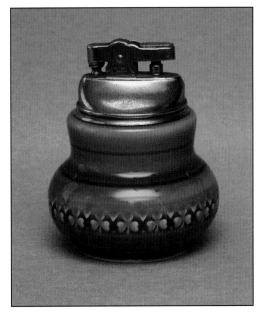

This Cigarette Lighter measures 3-3/8" high and has Mark Type 28 ($55, £28).

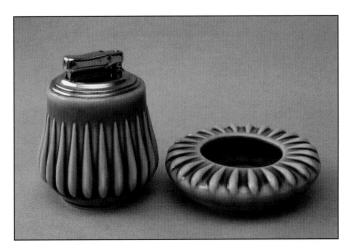

The design of the lighter and ashtray is similar to the Raindrops tableware design. The lighter measures 3-1/4" high and the ashtray is approximately 1-1/2" high. The ashtray is mold marked: Colibri Irish Porcelain Made in U.K. ($60, £32).

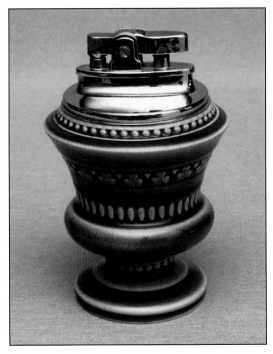

Cigarette Lighter – shape number I.P. 95, measures 4" high and has Mark Type 28. This, the longest production run of Irish made lighters, was produced from approximately the late 1950s to the mid 1970s ($55, £28).

This unfinished item is believed to be the base of a cigarette lighter. The piece is unmarked and has a small hole in the base.

Chapter 5
TABLEWARE
mid 1950s - 1993

From the mid 1950s, the Irish pottery produced butter dishes and fruit bowls and later, in the early 1960s, tableware items in various size ranges and patterns. Some patterns included teapots, coffee pots, and cups and saucers but few included plates. Occasional pieces with their own patterns were also produced, such as a cup and saucer or a plate. It wasn't until the 1990s that full ranges of tableware were manufactured and then, for a short time only.

MISCELLANEOUS TABLEWARE, *1950s - 1986*

Following are illustrations of products from Wade (Ulster) Ltd. and Wade (Ireland) Ltd. that are not part of any particular set or issue. In many cases the dates of issue are approximate only.

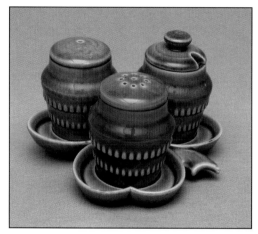

Cruet Set and Stand. The cruet stand (I.P. 629) measures 5-1/4" across and has Mark Type 29. The pepper shaker (I.P. 604) and salt shaker (I.P. 605) measure 2-5/8" high. The covered mustard (I.P. 606) is 3" high. The shakers and mustard are mold marked: Irish Porcelain. As a complete set, the cruet was given the shape No. I.P. 606C ($60, £30). The cruets were also sold as a set of three without the stand and also as a two piece set of pepper and salt shakers only.

Egg Cup. The egg cup measures 2-1/4" high and has Mark Type 28 on the base ($12, £7).

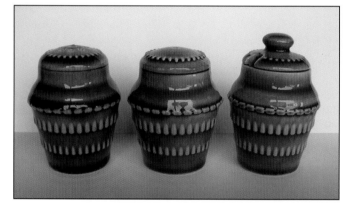

Three Piece Cruet Set. Mold variation with extra knurls. The three piece set is similar in size and marking to the cruet set and stand ($40 set, £25 set).

Cruet Set. The salt and pepper shakers measure 2-3/8" high and are marked: Wade Irish Porcelain. The mustard pot is 2-7/8" to top of finial and has Mark Type 29 on the base. This set is believed to have had a short production run in the 1950s and can also be found without the decals ($40 set, £24 set).

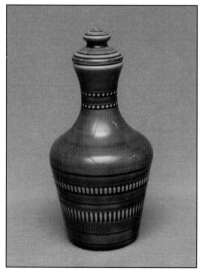

Vinegar Bottle – shape No. I.P. 112. The bottle measures 6-3/4" high and has Mark Type 28 on the base ($60, £35). Not shown is the Oil Jar (I.P. 111), which is similar to the vinegar bottle but without the pouring spout. These bottles appeared in catalogs of the 1960s and were discontinued in the 1970s.

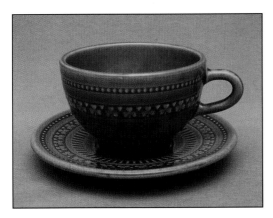

Tea Cup and Saucer. The cup is 2-1/2" high by 4" diameter with Mark Type 28 and the saucer is 5-3/4" diameter with Mark Type 29. This was advertised in the December 1963 issue of *Tableware* but had been in production for some time prior to this date ($45, £26).

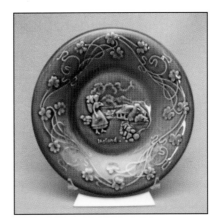

Donegal Plate – shape No. M.334. The plate measures 6" in diameter, has Mark Type 40 and was in production from the late 1970s to circa 1980 ($45, £26).

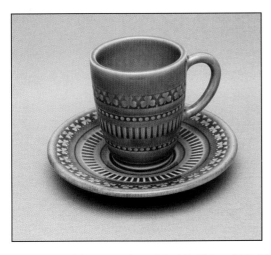

Tea Cup and Saucer – shape No. I.P. 100 and I.P. 101. This occasional cup and saucer was first advertised in the December 1963 issue of *Tableware* but had been in production for some time prior to this date. The cup measures 2-7/8" high by 2-3/8" diameter at the rim and has Mark Type 28 on the base. The saucer is 5" diameter and has an embossed mold Mark Type 29 ($45, £26).

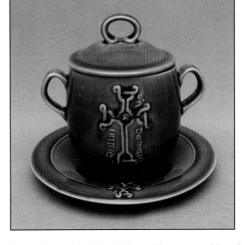

Onion Soup Bowl and Plate. The covered bowl is 5" high by 5-1/4" diameter overall and has Mark Type 39A. The plate is 6-1/2" in diameter and has Mark Type 39A ($75, £45).

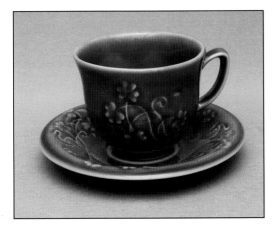

Donegal Tea Cup and Saucer – shape No. M.336 and M.337. The cup measures 2-3/4" high by 3-1/4" diameter and has an embossed Mark Type 40. The saucer is 5-1/2" in diameter and has an impressed Mark Type 40. This set was in production from the late 1970s to circa 1980 ($50, £30).

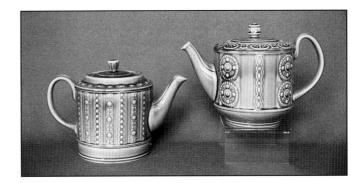

Prototype Teapots.
Two 6-1/2" high teapots modeled by William Harper. This was a departure for William Harper, as he is best known for modeling figurines. We photographed these teapots at Bill's house during one of our visits there. We recently asked Bill about these teapots and in a letter dated March 23, 2005, Bill wrote: "...I designed and modeled two teapots with embossed Celtic patterns all over in the grey/green translucent glazes but I do not know if they were ever produced..." It appears that at least one of these teapots went into production in the early 1960s.

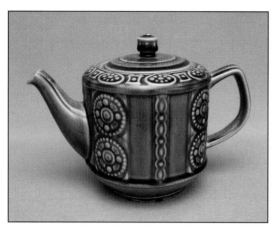

Teapot. The teapot measures 6-1/2" high by 9-1/2" overall handle and spout and has Mark Type 33 on the base ($65, £38). This teapot is from a design modeled by William Harper. See also the previous illustration of prototype teapots.

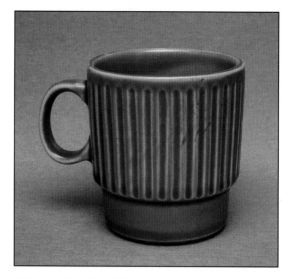

Ribbed Coffee Mug. The mug measures 3" high and has Mark Type 39A on the base ($15, £9).

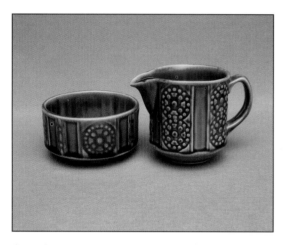

Open Sugar and Creamer. The sugar bowl measures 2" high by 4" diameter with Mark Type 33A ($20, £12). The creamer measures 3-1/2" high by 4" overall handle and spout and has Mark Type 33A on the base ($25, £15).

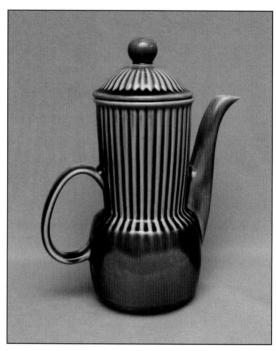

Ribbed Coffee Pot. The pot measures 10-1/2" high and has Mark Type 41 on the base. This coffee pot was produced circa 1980 ($75, £45).

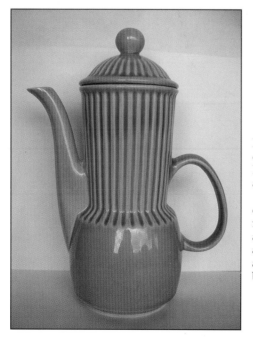

Ribbed Coffee Pot. The coffee pot measures 10-1/2" high, has Mark Type 39A, and was produced in the late 1970s ($75, £45). This tall coffee pot is part of a full coffee set of coffee pot, cream and covered sugar, and cups and saucers. This set was also made in a dark, almost black glaze.

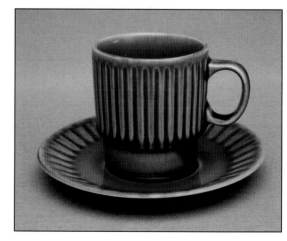

Ribbed Coffee Mug and Saucer. The mug is 3" high by 2-3/4" diameter at top and has Mark Type 40. The saucer is 5-3/4" in diameter and has Mark Type 40 ($20, £12).

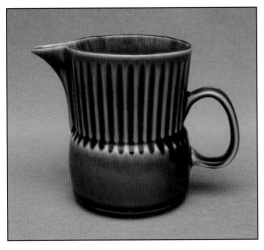

Ribbed Milk Jug. The jug is 4-1/8" high and is mold marked: Irish Porcelain by Wade Ireland Design by D.S. Nelson ($25, £15).

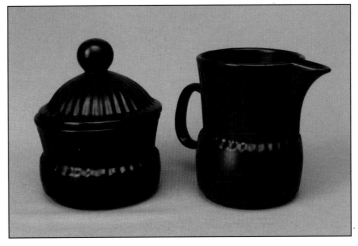

Ribbed Covered Sugar and Milk Jug. This unusual dark, almost black, glaze sugar bowl measures 4-3/4" high by 4" diameter. The milk jug measures 4-1/4" high. Both pieces are mold marked: Made by Wade Ireland. Design by D.S. Nelson ($55 set, £35 set). This color glaze was also used for the full coffee set including the tall coffee pot, cups, and saucers.

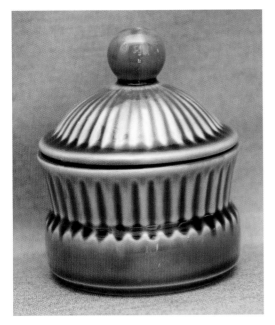

Ribbed Covered Sugar. The sugar bowl measures 4-3/4" to top of finial and is mold marked: Irish Porcelain, Wade Ireland, Design by D.S. Nelson ($35, £20).

BUTTER DISHES

Butter dishes (shape No. I.P. 75) were in production for quite some time circa mid 1950s to circa 1980. The butter dishes measure 1" high at the rim by 5" in diameter.

Butter Dish with Irish Jaunting Car decal. The dish is transfer marked: Made in Ireland ($18, £10).

Ribbed Plate. The plate is 7" in diameter and has Mark Type 40 on the base ($18, £10).

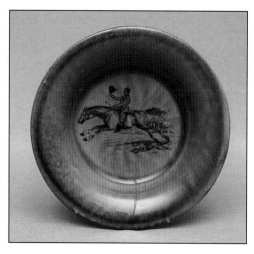

Butter Dish with Fox Hunting decal No. 1. The dish has Mark Type 38 on the underside of the base ($18, £10).

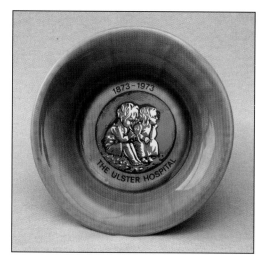

Butter Dish with Ulster Hospital 1873-1973 decal. The dish is marked Made in Ireland on the underside of the base ($25, £15).

Butter Dish with Irish Landscape decal. The dish has Mark Type 30 on the underside of the base ($18, £10).

NUT BOWLS and FRUIT BOWLS

The nut bowls (shape No. I.P. 76) measure 2" high by 6-3/4" diameter. The bowl, which has a row of impressed shamrock leaves between two rows of knurled dots, is sometimes referred to as a cereal bowl and was in production from the 1950s to circa 1980.

The fruit bowls (shape No. I.P. 74) measure 2-1/4" high by 4-3/4" diameter. The fruit bowl was first produced in the mid 1950s and appeared in an early 1960s catalog but was not in production in the late 1970s.

Butter Dish with Irish Colleen decal. The dish has Mark Type 38 on the underside of the base ($18, £10).

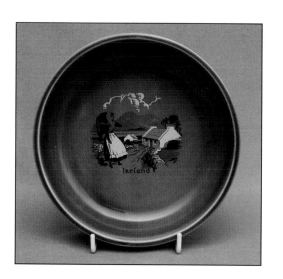

Nut Bowl with Irish Colleen decal. The bowl has Mark Type 28 on the base ($20, £12).

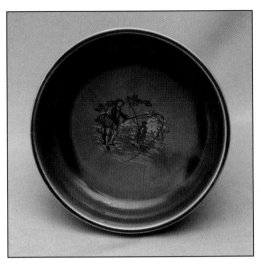

Nut Bowl with Fishing Scene decal. The bowl has Mark Type 28 on the base ($20, £12).

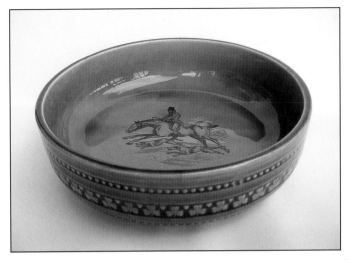

Nut Bowl with Fox Hunting decal No. 2. The bowl has Mark Type 28 with the letter 'J' in the leaf ($20, £12).

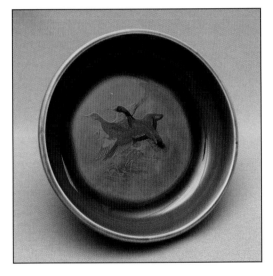

Nut Bowl with Flying Ducks decal. The bowl has Mark Type 28 on the base ($20, £12).

Low Fruit Bowl. The bowl measures 6-1/2" dia. by 2" high and has Mark Type 29 on the underside of the base. This bowl is similar to the candle holder/ashtray illustrated in Chapter 3. This bowl is heavier and thicker than I.P. 76 and without the shamrock decoration ($14, £8).

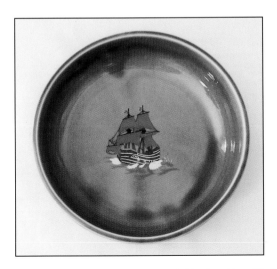

Nut Bowl with Sailing Ship decal. The bowl has Mark Type 28 on the base ($20, £12).

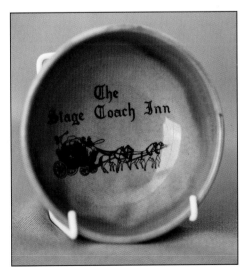

Fruit Bowl with "Stage Coach Inn" decal. The bowl has Mark Type 30 on the base ($20, £12).

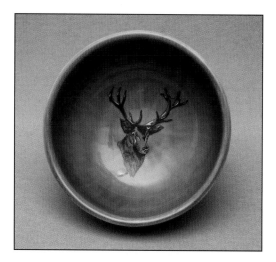

Fruit Bowl with a Stag Head decal. The bowl has Mark Type 30 on the base ($20, £12).

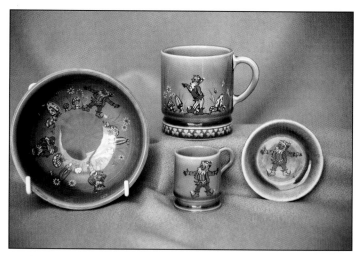

Leprechaun and Mushroom decal. Left: Fruit Bowl – shape No. I.P. 74. The bowl has Mark Type 30 on the underside of the base ($25, £15). Center Top: Child's Tankard – shape No. I.P. 4. The tankard has Mark Type 29 on the underside of the base ($20, £12). Center Bottom: Miniature Tankard – shape No. I.P. 614 with Mark Type 28 on the underside of the base ($14, £8). Right: Pin Tray – shape No. I.P. 619 with Mark Type 32 on the underside of the base ($12, £7).

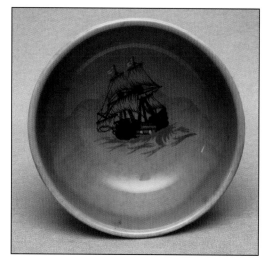

Fruit Bowl with Sailing Ship decal. The bowl has Mark Type 30 on the base ($20, £12).

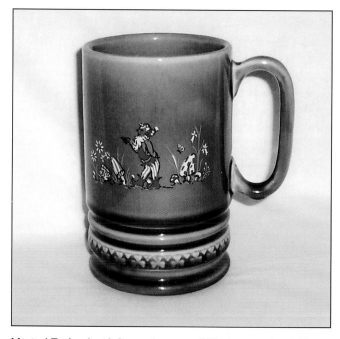

Musical Tankard with Leprechauns and Mushrooms decal. The tankard is ink stamped: Made in Ireland and plays the tune "Galway Bay" ($65, £35).

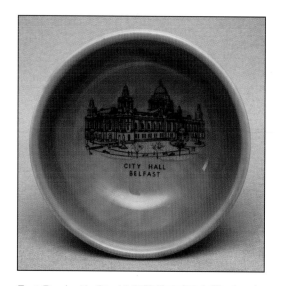

Fruit Bowl with City Hall, Belfast decal. The bowl has mark Type 30 on the base ($20, £12).

PIN TRAYS

These 3" diameter Pin Trays (shape No. I.P. 619) are sometimes referred to as Butter Pats. The pin trays were manufactured in large quantities from the mid 1950s through to 1986 and are found with a variety of backstamps.

Pin Tray with Primrose decal and Mark Type 41 on the base ($20, £12).

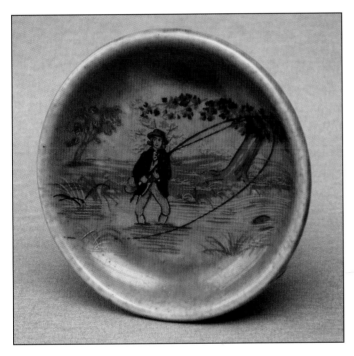

Pin Tray with Fishing decal and Mark Type 32 on the base ($10, £6).

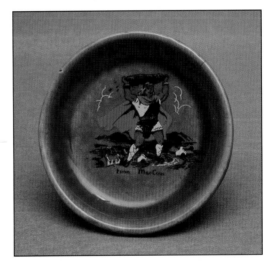

Pin Tray with Finn MacCoul decal and Mark Type 41 on the base ($10, £6).

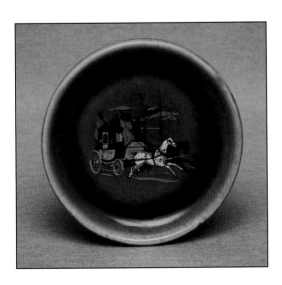

Pin Tray with Stage Coach No. 2 decal and Mark Type 41 on the base ($10, £6).

Pin Tray with Flying Ducks decal and Mark Type 41 on the base ($10, £6).

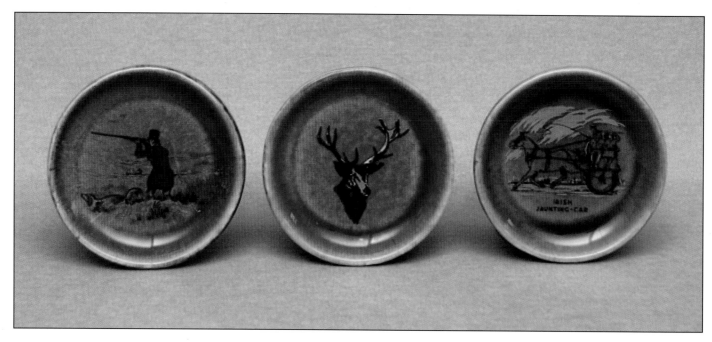

Left: Pin Tray with Shooting Scene decal. Center: Pin Tray with Stag Head decal. Right: Pin Tray with Irish Jaunting Car decal. Each pin tray has Mark Type 41 on the base ($10 each, £6 each).

Pin Tray with Wood Sorrel / Oxalis decal and Mark Type 41 on the base ($20, £12).

Pin Tray with "Founders' Day Belfast 1960" decal and Mark Type 32 on the base ($20, £12).

Pin Tray with Horse Head decal and Mark Type 41 on the base ($20, £12).

TEA POT STANDS

Tea Pot Stands (shape No. I.P. 624) are sometimes referred to as Hot Plate Stands. This item appears once only in Wade literature and was probably produced in the early 1950s through the mid 1960s. All Tea Pot Stands illustrated measure 5-1/2" by 5-1/2" unless noted otherwise.

Tea Pot Stand with Fox Hunting decal No. 2 and with molded Mark Type 29 on the underside ($35, £18).

Tea Pot Stand with Fireside decal. The plate is mold marked: Made in Ireland by Wade ($35, £18).

Tea Pot Stand with Shooting scene decal and with molded Mark Type 29 on the underside ($35, £18).

Tea Pot Stand with Irish Colleen decal and with molded Mark Type 29 on the underside ($35, £18).

Tea Pot Stand with Fishing Scene decal, mold marked: Made in Ireland by Wade ($35, £18).

Tea Pot Stand with Yellow Roses decal, mold marked: Made in Ireland by Wade. This tea pot stand with a white glaze is not often seen ($45, £26).

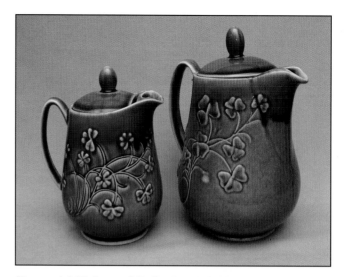

Shamrock Milk Jug and Coffee Pot. Left: Hot Milk Jug – shape No. C.317. The jug measures 7" high to top of finial and has Mark Type 33 on the base ($50, £30). Right: Coffee Pot – shape No. C.313. The coffee pot measures 8-3/8" high to top of finial and has Mark Type 33 on the base ($90, £54).

Tea Pot Stand with Carnations decal, mold marked: Made in Ireland by Wade ($45, £26).

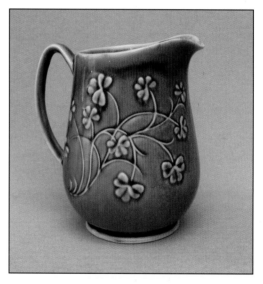

Shamrock One Pint Jug – shape No. C.320. The jug measures 5-3/4" high and has Mark Type 33 on the base ($40, £24).

EARLY SHAMROCK TABLEWARE,
circa 1962 - 1966

The Shamrock range of tableware was modeled by James Borsey, a longtime employee of Wade. Borsey, with much encouragement from Iris Carryer, was responsible for most of the tableware produced by the Irish pottery. The Early Shamrock tableware was in production for only a short time, from circa 1962 to around 1966. We refer to this first, molded shamrock range as Early Shamrock. The later, white glazed range with a shamrock pattern is referred to simply as Shamrock.

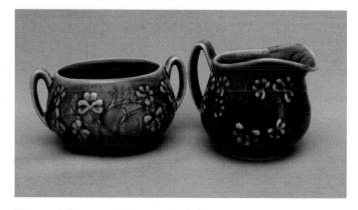

Shamrock Sugar and Creamer. Left: Sugar Bowl – shape No. C.314. The bowl measures 2" high and has Mark Type 33 ($25, £14). Right: Cream Jug – shape No. C.315. The jug measures 3" high and has Mark Type 33 ($25, £14).

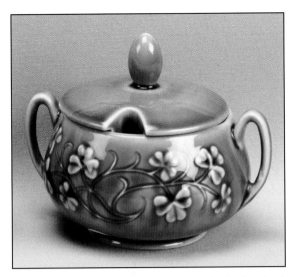

Covered Preserve Jar – shape No. C.316. The bowl is from the same mold as the sugar bowl but with the added lid. The bowl has Mark Type 33 on the base ($40, £24).

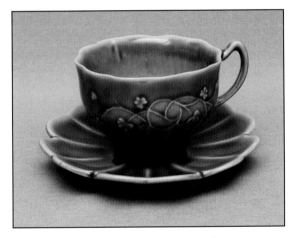

Shamrock Cup and Saucer. The cup is 2-3/8" high by 3-1/2" diameter and the saucer is 5-1/4" in diameter. Both items have Mark Type 33 ($35, £20).

RAINDROPS TABLEWARE, *circa 1962 - 1986*

The Raindrops range, also modeled by James Borsey, was in production from circa 1962 until 1986. In the later years, the Raindrops range was considerably reduced in size to Teapot, Coffee Pot, Creamer, and Sugar.

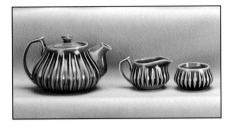 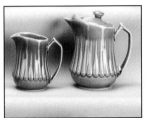

Raindrops Tableware. From left: Teapot – shape No. C.312 with Mark Type 41 on the base. The teapot measures 4-3/4" high ($80, £48). Creamer – shape No. C.311 with Mark Type 33 on the base. The creamer is 2-3/4" high ($28, £16). Sugar – shape No. C.310 with Mark Type 33 on the base. The sugar is 2" high ($20, £12). One Pint Jug – shape No. C.305 with Mark Type 33 on the base. The jug is 5-1/2" high ($48, £28). Coffee Pot – shape No. C.308 with Mark Type 33 on the base. The coffee pot is 6-1/4" high ($90, £54). There were two other open jugs in the range. Three Quarter Pint Jug – shape No. C.306 and a Half Pint Open Jug – shape No. C.307.

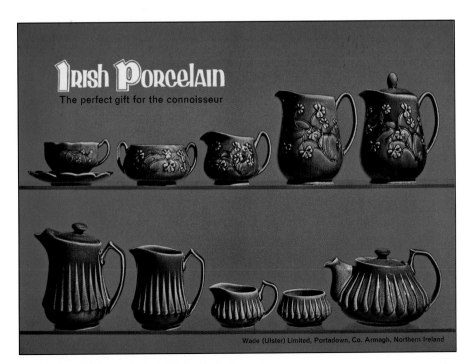

Irish Porcelain. Shamrock and Raindrops Tableware. Trade literature circa 1960s.

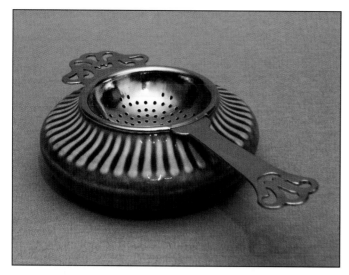

Tea Strainer and Dish. The dish measures 1-1/2" high by 4" diameter and has Mark Type 33A ($28, £16).

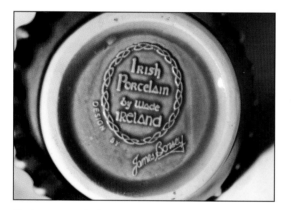

Backstamp with the James Borsey signature.

MOURNE RANGE, *1971 - circa mid 1970s*

A limited range of fifteen pieces described in Wade advertising as "…porcelain carefully nurtured into life by Irish craftsmen with coloring that reflects the tang of the hills, and a single flower motif etched deep into each design…"

Each item in the Mourne range has Mark Type 41 on the underside of the base.

Vases, Preserve Jar, and Tankards. Top row from left: Vase – shape No. C.350. The vase is 6-3/4" high ($65, £40). Cream Jug – shape No. C.356. The jug is 4-1/4" high ($35, £20). Covered Preserve Jar – shape No. C.353. The jar is 3-3/4" high ($75, £44). Half Pint Tankard – shape No. C.351. The tankard is 4" high ($50, £30). One Pint Tankard – shape No. C.352. The tankard is 5" high ($65, £38).

Bottom row from left: Footed Dish – shape No. C.349. The dish measures 7" long by 5" wide ($75, £44). Covered Candy Box – shape No. C.348. The box measures 5" long by 3-3/4" wide ($85, £50).

MOURNE

Irish porcelain at its very best

A new range of porcelain carefully nurtured into life by Irish craftsmen with a colouring that reflects the tang of the hills, and a single flower motif etched deep into each design. The Mourne range is built up of fifteen pieces each carefully designed and beautifully produced to make a series that will be in great demand. Wholesale trade enquiries to :

WADE

Wade (Ireland) Ltd.,
Watson Street, Portadown,
Co. Armagh, N. Ireland.
Telephone : Portadown 2288

Advertisement for the Mourne Range from the February 1971 issue of Tableware International.

Salt and Pepper Shakers – shape Nos. C.358/9. The shakers are 3-1/4" high and are marked: Made in Ireland ($40 pair, £24 pair).

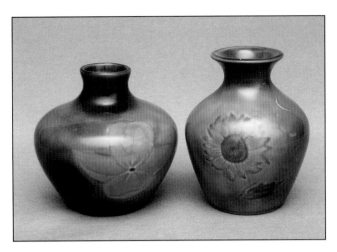

Left: Low Squat Vase – shape No. C.346. The vase is 3-1/4" high ($65, £38). Right: Tall Squat Vase – shape No. C.345. The vase is 3-3/4" high ($65, £38).

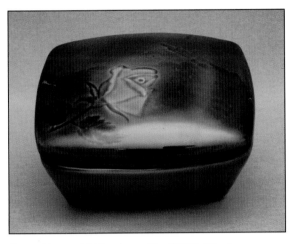

Butter Box and Lid – shape No. C.355. The box measures 3" high by 4-1/4" wide by 5-1/4" long ($85, £50).

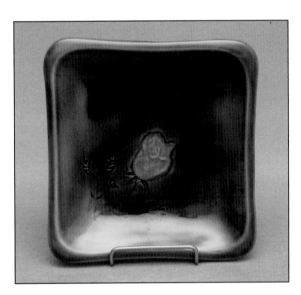

Square Dish – shape No. C.354. The dish is 1-1/4" high at rim by 5-1/2" square ($50, £30).

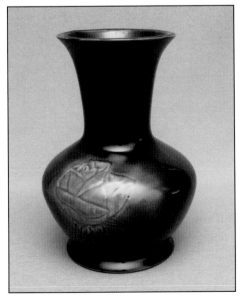

Tall Vase – shape No. C.347. The vase is 7-1/2" high ($75, £44).

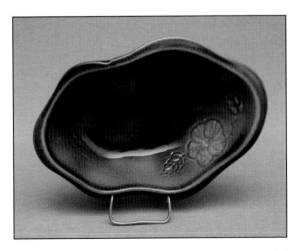

Open Bowl – shape No. C.360. The bowl is 1-3/4" high by 6-1/2" long by 4-1/4" wide ($50, £30).

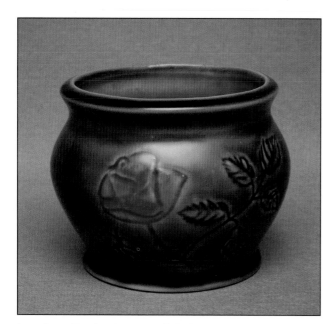

Low Open Bowl – shape No. C.357. The bowl is 3-1/8" high by 3-5/8" diameter at the top ($40, £24).

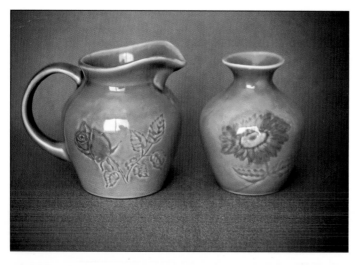

Mourne Range Color Variation.
Left: Cream Jug – shape No. C.356 ($40, £24). Right: Tall Squat Vase – shape No. C.345 ($70, £40).

KILKENNY DESIGN WORKSHOPS

The Kilkenny Design Workshops of the Kilkenny Trading Co. Ltd. were formed in 1963 and consisted of a number of adjoining buildings encircling a courtyard of eighteenth century stables opposite Kilkenny Castle.

The workshops originally comprised seven individual studios dealing with silver, gold, ceramics, pottery, textiles, glass, and woodwork. Each workshop had a head designer, with Gerald Tyler heading the ceramic and pottery workshops. The governing board of the workshops was responsible to the Irish Minister for Industry and Commerce.

Craftsmen from countries other than Ireland worked together to produce quality items to help promote a truly Irish image. To encourage this aim, designers were given a free hand to experiment with new ideas. Kilkenny Design Workshops also had offices and outlets in San Francisco, New York, and London.

Today, the organization is known as Kilkenny and is an independent entity under the directorship of sisters Marian O'Gorman and Bernadette Kelleher Nolan.

Kilkenny is now the largest outlet for Irish products and as well as producing ceramics, glass, etc. It now also produces books, stationary, clothing, and furnishings. Currently Kilkenny has outlets in Dublin, Killarney, and Galway.

Countryware, 1973 - 1984

This nine piece line of amber glazed or, as described in trade literature, "warm, rich saffron" glazed kitchenware was designed by Kilkenny Design, Ireland, a design center sponsored by the Irish government. Near the end of its production run at Wade (Ireland) Ltd., the Countryware line was also manufactured in a "cool silk white" glaze but in very limited quantities of which very little was exported. All Countryware pieces have Mark Type 36 on the base.

Pepper Shaker – shape No. KD.5. Salt Shaker – shape No. KD.4. Both shakers measure 3-1/2" high by 2" diameter ($40 pair, £22 pair).

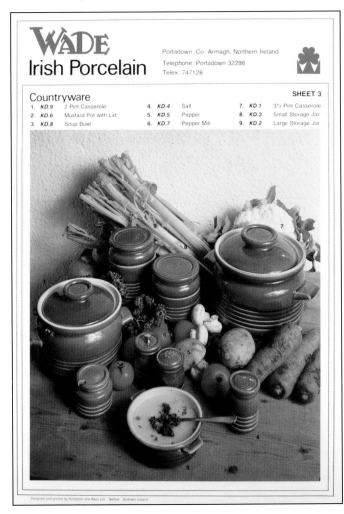

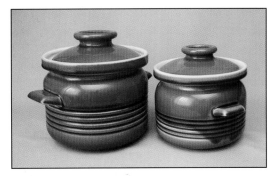

WADE
Irish Porcelain

Portadown, Co. Armagh, Northern Ireland
Telephone: Portadown 32288
Telex: 747128

Countryware

SHEET 3

1. KD.9 2 Pint Casserole 4. KD.4 Salt 7. KD.1 3½ Pint Casserole
2. KD.6 Mustard Pot with Lid 5. KD.5 Pepper 8. KD.3 Small Storage Jar
3. KD.8 Soup Bowl 6. KD.7 Pepper Mill 9. KD.2 Large Storage Jar

Designed and printed by Nicholson and Bass Ltd. Belfast. Northern Ireland

Countryware. Trade literature circa early 1980s - mid 1980s.

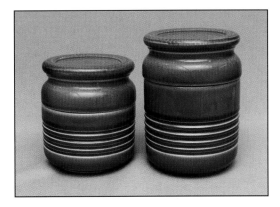

Left: 3-1/2 Pint Casserole – shape No. KD.1. The casserole measures 7-1/8" high by 9-1/4" across the handles ($65, £36). Right: 2 Pint Casserole – shape No. KD.9. The casserole measures 6" high by 7-1/2" across the handles ($55, £30).

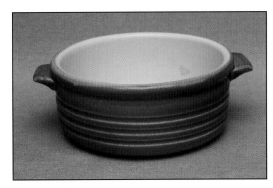

Left: Small Storage Jar – shape No. KD.3. The jar is 4-1/4" high by 4" diameter ($40, £22). Right: Large Storage Jar – shape No. KD.2. The jar is 5-1/2" high by 4" diameter ($45, £25).

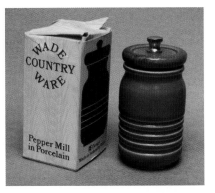

Pepper Mill – shape No. KD.7. with original box. The mill is 2-3/4" high ($15, £8).

Soup Bowl – shape No. KD.8. The bowl measures 2" high by 5" diameter ($30, £17).

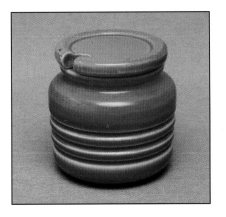

Mustard Pot – shape No. KD.6. The pot is 2-1/2" high by 2-1/2" diameter ($15, £8).

Wade (Ireland) Ltd. display at the British Industries Fair circa early 1980s.

Ballyfree Farms Pottery, 1974 - 1975

The Ballyfree Breakfast set was designed by Kilkenny Design Workshops and produced by Wade (Ireland) Ltd. The distribution of the items in the breakfast set was based on the submission of a certain number of tokens per item. The finished glaze of the pieces in the set was similar to the "amber glaze" of the "Countryware" line, which was also designed by the Kilkenny Design Workshops.

The complete set was issued over a two year period. In May 1974 came the Salt and Pepper Set, Single Egg Coddler (with a row of sitting hens around the top rather than the usual shamrocks), and the Large Mug. In May 1975 came the Mug, Plate, Cereal Bowl, Double Egg Cup, Single Egg Cup, and Jug. All pieces have Mark Type 36A on the base.

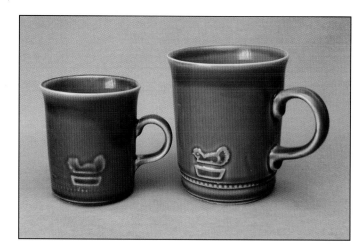

Left: Small Mug. The mug is 3-1/4" high ($30, £17). Right: Large Mug. The mug is 4" high ($45, £25).

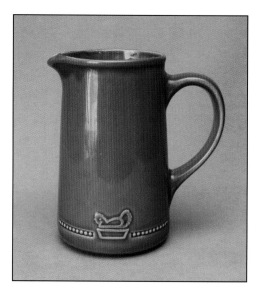

Milk Jug. The jug is 3-1/2" high by 2" diameter ($75, £42).

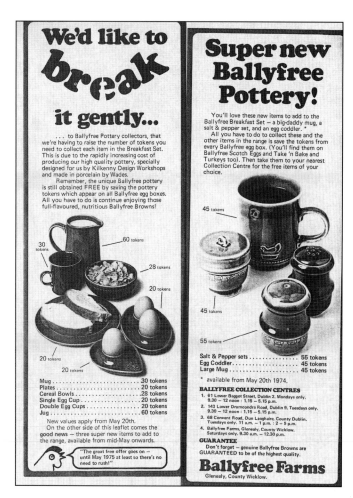

An advertisement for Bally Free Farms Breakfast Sets.

Cereal Bowl. The bowl measures 2-1/8" high by 5" diameter ($30, £18).

Single Egg Cup. The egg cup measures 3-3/4" wide by 4-3/4" long ($30, £18).

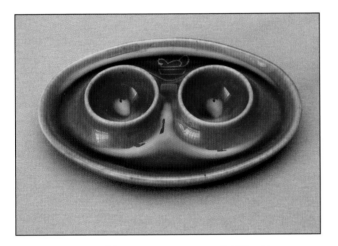

Double Egg Cup. The egg cup measures 4-1/8" wide by 6-1/8" long ($40, £22).

Dinner Plate. The plate measures 7-1/8" in diameter ($30, £18).

SHAMROCK TABLEWARE, *1982 - 1986*

In 1982, Wade (Ireland) Ltd. introduced a line of white glazed porcelain tableware and gift ware with an applied shamrock decoration. This line had a very short production run as all tableware and gift ware was discontinued in 1986.

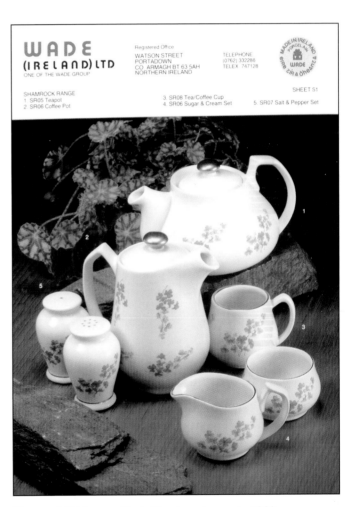

Shamrock Tableware. Trade literature circa early 1980s.

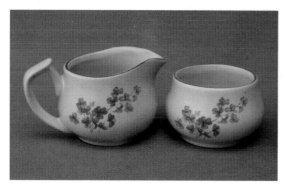

Shamrock Cream and Sugar Set – shape No. SR. 06. The cream jug measures 2-1/2" high and has Mark Type 41B on the base ($15, £9). Open sugar measures 2" high by 2-5/8" diameter at the top and has Mark Type 41B on the base ($15, £9).

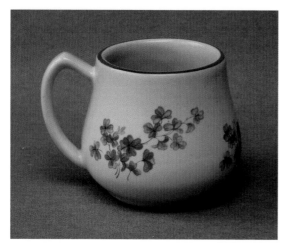

Shamrock Tea/Coffee Mug – shape No. SR. 08. The mug is 2-3/4" high and has Mark Type 41B on the base ($15, £9).

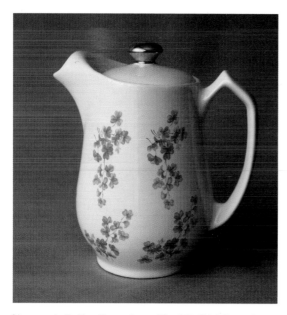

Shamrock Coffee Pot – shape No. SR. 04. The coffee pot is 6" high and has Mark Type 41B on the base ($90, £50).

FINE PORCELAIN TABLEWARE, *1989 - 1993*

When Beauford PLC acquired the Wade Potteries in late 1989, the name of the Irish Pottery was changed to Seagoe Ceramics Ltd. In 1989 - 1990, over £1,000,000 was invested in the pottery to retool the lines for the production of new tableware. New machinery for the tableware was purchased from the Swedish company Rorstrand, with an agreement that Seagoe Ceramics Ltd. would provide tableware for Rorstrand as well as producing their own tableware to be sold under the Wade brand name. Sales of the new Irish Wade tableware were initially directed to customers in the U.S.A. and United Kingdom, followed by other loyal customers in Australia and New Zealand and then Europe.

Early designs for the new lines of tableware were based on typical Irish themes such as "Nuts and Berries" and "Classic Irish Linen," which sold well in the U.S.A. Following these designs came lines of coordinated cookware and tableware with names such as "Meadowland" and "Summer Fruit." As well as the usual cups and saucers and teapots etc., the lines included: baking dishes, ramekins, flan dishes, and casserole dishes.

The designs for these new lines were done by in house designers Barbara Cooksey and Judith Wooten and free lance designers Elaine Williamson and Peter Ting.

After the initial flurry of interest in the new products, sales of the new Wade tableware declined and production of the tableware ceased in April 1993.

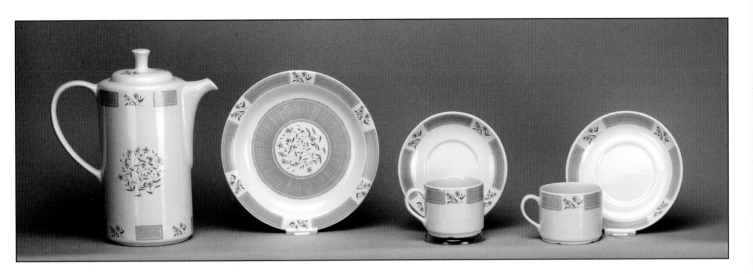

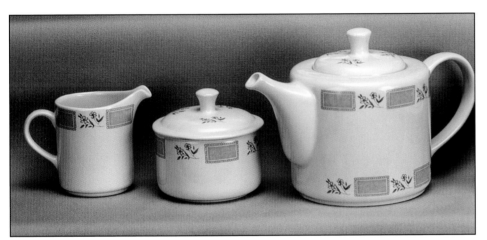

"Classic Linen" Tableware. Top row from left: Coffee Pot measures 9" high ($45, £24). Dinner Plate measures 7-3/4" in diameter ($12, £6). Coffee Cup and Saucer. The cup is 2-3/8" high by 2-7/8" diameter. The saucer is 5-1/2" in diameter ($18 set, £10 set). Tea Cup and Saucer. The cup is 2-7/16" high by 3" diameter. The saucer is 6-7/8" in diameter ($18 set, £10 set). Bottom row from left: Creamer measures 3-3/4" high ($18, £10). Covered Sugar measures 3-7/8" high ($20, £10). Teapot measures 6" high ($45, £24).

"Classic Linen" Tableware, *1990 - 1993*

"Classic Linen" was one of the most popular of the Wade/Seagoe lines of tableware but unfortunately in production for a short time only. Each piece has Mark Type 41C.

WADE INTRODUCE CLASSIC LINEN
TABLEWARE AND GIFTWARE
IN FINE QUALITY CERAMIC

'CLASSIC LINEN' DINNERWARE
A new addition to the Wade range
available as individual pieces or
as boxed sets.

'CLASSIC LINEN' GIFTWARE
Currently available:

Coaster 11cm /4.375" dia.
Trinket Tray 10cm /4" dia.
Trinket Dish 12cm /4.75" dia.
Sweet Dish 14cm /5.5" dia.
Ash Tray 10cm /4" dia.
Pot Pourri Bowl 16.5cm /6.5" dia.
Bud Vase 16cm /6.25" tall
Tankard 10cm /4" tall
All Sizes are Approximate

WADE

Wade Potteries PLC, Sales, Design & Marketing Division,
Royal Victoria Pottery, Burslem, Stoke-on-Trent,
Staffordshire, ST6 4AG, England.
Telephone: (0782) 575700 Telex: 36434 Fax: (0782) 575195

"Classic Linen" Dinnerware and Gift ware. Trade literature 1990 - 1993.

"Music" Tableware, *1990 - 1993*

This contemporary design was available in full dinner, tea, and coffee sets designed by Peter Ting. Each piece has Mark Type 41E.

"Meadowland" Tableware, *1990 - 1993*

This was a full line of tableware designed by Barbara Cooksey. Each piece is marked on the base: Meadowland Dishwasher Safe Fine Tableware.

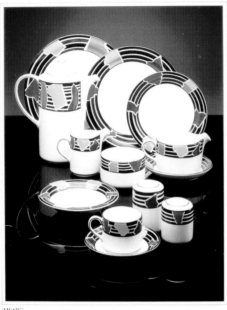

"Music" Tableware. Trade literature 1990 - 1993.

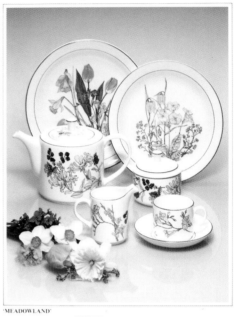

"Meadowland" Tableware. Trade literature 1990 - 1993.

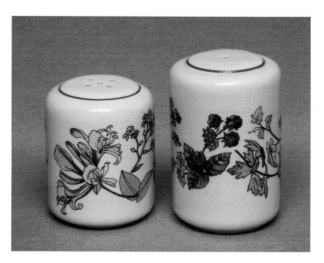

"Music" Tableware. From left: Covered Sugar measures 3-7/8" high ($20, £10). Salt and Pepper Shakers. The salt measures 3-5/8" high and the pepper is 3" high ($10 each, £6 each). Creamer measures 4" high ($18, £10).

"Meadowland" Salt and Pepper Shakers. The salt measures 3-5/8" high and the pepper measures 3" high ($10 each, £6 each).

"Summer Fruits" Tableware, *1990 - 1993*

This was a full line of tableware designed by Barbara Cooksey. Each piece is marked with Mark Type 41D. Although the backstamp reads Wade, all pieces were made in Ireland.

"Blue Chintz" Tableware, *1990 - 1993*

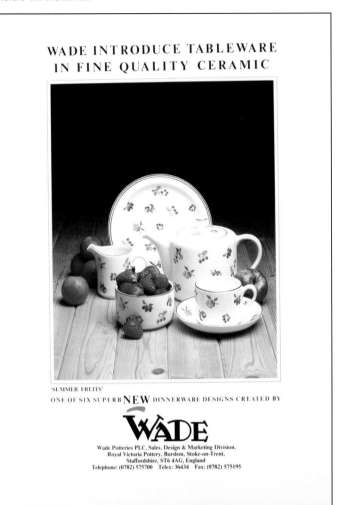

"Summer Fruits" Tableware. Trade literature 1990 - 1993.

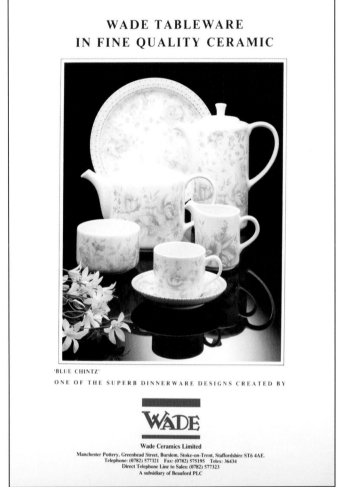

"Blue Chintz" Tableware. Trade literature 1990 - 1993.

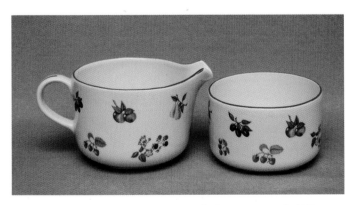

Left: "Summer Fruits" Gravy Boat / Milk Jug measures 3-1/4" high ($12, £7). Right: "Summer Fruits" Open Sugar measures 2-1/2" high ($10, £6).

MISCELLANEOUS TABLEWARE, *1989 - 1993*

Illustrated below are a number of items made by the Irish pottery during the few years of fine tableware production. During this period, the pottery produced three lines of tableware (Nordica, Gron Anna, and Fjord) for Rorstrand of Sweden, a major Swedish department store. The lines consisted of the following: teapot, coffee pot, tea cups and saucers, coffee cups and saucers, 1/4 pint creamer, covered sugar, 1-3/4 pint milk jug, gravy boat, egg cups, cereal bowl, soup bowl, round covered casserole, three size plates (7-3/4" dia., 9-1/2" dia., and 10-1/2" dia.) and a rectangular platter. The pattern on the Fjord line consisted of symmetrical dark blue lines only.

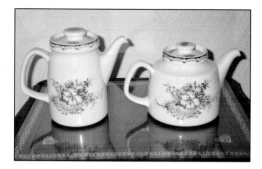

Left: "Gron Anna" Coffee pot ($30, £18). Right: "Gron Anna" Tea pot ($30, £18).

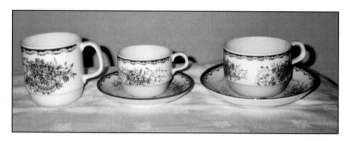

Left: "Gron Anna" Mug. The mug measures 3-1/2" high ($15, £8). Center: "Gron Anna" Tea Cup and Saucer. The cup measures 2-3/4" high and the saucer measures 6-1/4" in diameter ($15 complete, £8 complete). Right: "Gron Anna" Coffee Cup and Saucer. The cup measures 2-3/8" high and the saucer measures 5-1/4" in diameter ($15 complete, £8 complete).

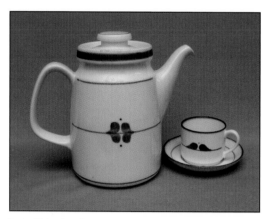

Left: "Nordica" pattern Coffee Pot. The coffee pot is 7-3/4" high ($30, £18). Right: "Nordica" Coffee Cup and Saucer. The cup is 2" high by 2-1/4" diameter and the saucer is 4-3/4" in diameter ($15 set, £8 set). All items are marked Rorstrand Sweden on the base.

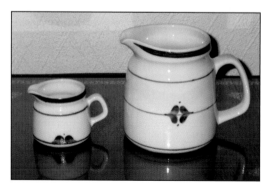

Left: "Nordica" creamer ($15, £8). Right: "Nordica" milk jug ($20, £12).

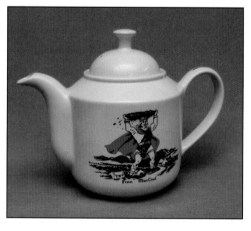

Tea Pot with Finn MacCoul decal. The teapot measures 6-1/2" high and is marked Genuine Wade Porcelain on the base. A crest decoration "Together we Progress" appears on the other side of the tea pot. Only a small number of these tea pots with this decal were produced in 1993 ($50, £28). The mark on the base was a mark used mainly in Burslem but this tea pot was produced in Ireland and sold in the Irish Factory Shop.

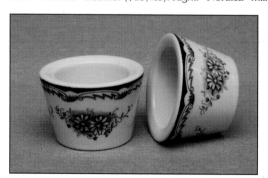

"Gron Anna" pattern Egg Cups. The egg cups measure 1-1/2" high by 2-1/4" diameter at the top. They are marked Rorstrand Sweden ($15 each, £8 each).

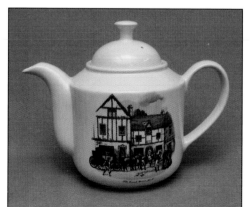

Tea Pot with Old Coach House, York decal. The teapot measures 6-1/2" high and has Mark Type 37 on the base. Only a small number of these teapots with this decal were produced in 1993 ($50, £28).

Chapter 6
DECANTERS, FLAGONS, AND LIQUOR BOTTLES

In 1965, Wade (Ireland) Ltd. started production of the Bell's "hand bell type" liquor decanters, previously produced by Spode and Royal Doulton.

In the mid 1970s, the Govancroft Pottery, who had been producing decanters and liquor bottles for numerous whisky distillers in Scotland, became part of the Wade Group of Potteries. In 1982, Govancroft was sold off by the Wade Group of Potteries and a number of the original Govancroft molds for the decanters were sent to Wade (Ireland) Ltd.

There are a number of colored trade literature sheets with the various decanters, flagons and liquor bottles from the Govancroft Pottery. Some of the containers were sent to Burslem and some to Portadown. Below are illustrations of flagons that were produced at the Portadown pottery. The Kings Ransom flagon was produced with a pink glaze when made at Portadown.

The suggested values in this chapter are for empty decanters unless noted otherwise.

BELL'S WHISKY DECANTERS, *1965 - circa mid 1970s*

The Irish pottery began production of the Bell's whisky decanters in 1965, producing the pint, quart, and quarter size decanters. Due to the huge quantities of decanters needed by the distiller, production was eventually transferred to Burslem in the mid 1970s. The Irish pottery did however produce a number of the royal commemorative Bell's whisky decanters during the 1980s in the old "hand bell" shape. The miniature Bell's decanter in the "hand bell" shape was introduced in 1979 in Burslem and was never made at the Irish pottery.

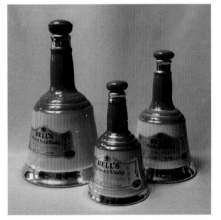

Bell's Whisky Decanters. Left: Bell's Whisky Decanter 75cl size ($95 full, sealed and boxed, $30 empty; £55 full, sealed and boxed, £18 empty). Center: Bell's Whisky Decanter 187 ml size ($125 full, sealed and boxed, $25 empty; £80 full, sealed and boxed, £20 empty). Right: Bell's Whisky Decanter 375 ml size ($120 full, sealed and boxed, $25 empty; £70 full, sealed and boxed, £15 empty). The decanters are marked: Wade, Bell's Scotch Whisky, Perth, Scotland. The Bell's whisky brand is owned by Diageo.

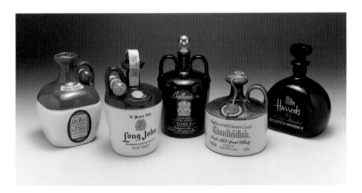

Flagons from the Govancroft Pottery which were later produced by the Irish pottery.

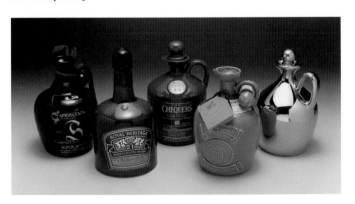

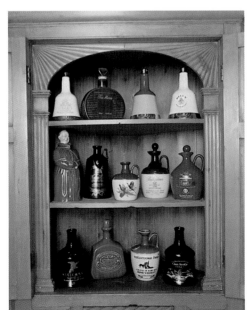

Display of liquor bottles and decanters at the Wade (Ireland) Ltd. offices circa mid 1980s.

IRISH MIST DECANTER, *1965 - 1966*

The Irish Mist decanter was made by Wade (Ireland) Ltd. between 1965 and 1966. Records indicate that Grants of Ireland International Ltd., owners of Irish Mist, bought twenty-five thousand pieces from the Irish pottery.

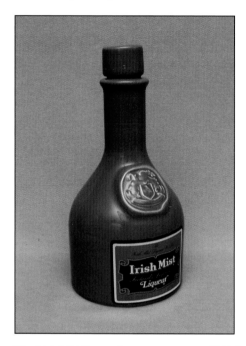

The Irish Mist liquor decanter measures 9" high and is mold marked: This is a fine piece of Irish porcelain Made by Wades. Liquor bottle – Tullamore Ireland ($55, £29). Irish Mist is owned by C&C Group PLC.

THE THISTLE AND THE ROSE CHESS SET, *1980*

Records indicate that this set of porcelain chess pieces was made for Peter Thompson (Perth) Ltd. by Wade (Ireland) Ltd. in 1980. The designs were based on historical 16th century characters from the royal houses of England (The Rose) and Scotland (The Thistle). The pieces were modeled by Frederick Mellor from designs by Ann Whittet.

The original chess pieces were unfilled and were contained in a presentation box along with a bottle of Beneagles Scotch Whisky, a copper finished chess board, and a colorful brochure. The principle pieces were also made available individually packaged and containing 50ml of whisky. A great number of these were given as free gifts to first class passengers flying British Caledonian Airways.

Toward the end of the production run, boxed sets of one Principle piece filled with whisky and one solid Pawn were distributed by Las Vegas Distributing Co. of Las Vegas, Nevada. Beneagles is owned by Waverley TBS.

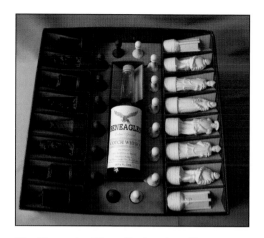

The Beneagles Chess Set in original box ($1,600 complete, £940 complete).

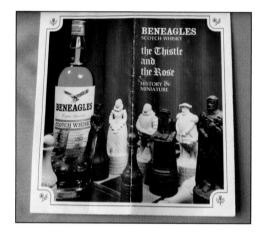

The Beneagles Chess Set brochure cover pages.

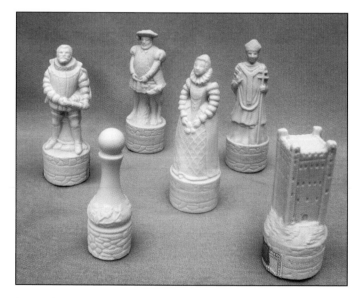

THE ROSE CHESS SET. Sir Francis Drake measures 5-1/8" high ($40, £25). Pawn "Rose" measures 3-5/8" high ($30, £18). King Henry VIII measures 5-1/4" high ($40, £25). Elizabeth I measures 5-1/4" high ($40, £25). Thomas A'Becket measures 5-1/4" high ($40, £25). Norman English Tower measures 4" high ($40, £25).

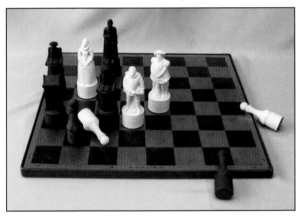

THE THISTLE CHESS SET. John Knox measures 5" high ($40, £25). Pawn "Thistle" measures 3-5/8" high ($30, £18). King Robert the Bruce measures 5-1/8" high ($40, £25). Mary Queen of Scots measures 4-7/8" high ($40, £25). Sir William Wallace measures 5-3/8" high ($40, £25). Scottish Tower House measures 4-1/8" high ($40, £25).

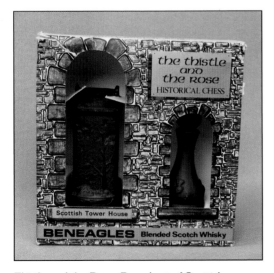

Beneagles Chess Board.

Thistle and the Rose. Boxed set of Scottish Tower House and Pawn ($75, £45).

BENEAGLES MINIATURE DECANTERS, *1974 - circa 1987*

Wade (Ireland) Ltd. produced two miniature decanters for Peter Thompson (Perth) Ltd. during the 1980s. Only the Brown Bear and Miniature Curling Stone decanters were produced by the Irish pottery.

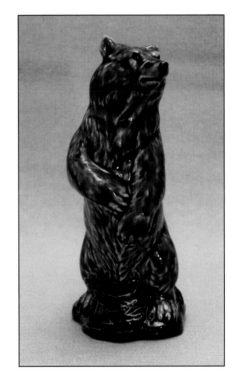

Miniature Brown Bear decanter. This 4-3/4" high decanter was first issued in 1981 for Peter Thompson (Perth) Ltd. Production ended circa 1987 ($70, £40).

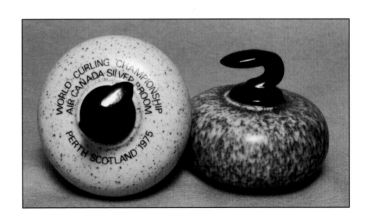

Left: Miniature Curling Stone decanter with a logo reading: World Curling Championship Air Canada Silver Broom. Perth, Scotland 1975. The Air Canada Silver Broom award ran from 1968 to 1985 and replaced the Scotch Cup award, which ran from 1959 to 1967 ($45, £26). Right: Miniature Curling Stone Decanter without logo ($40, £22). The decanters measure 2-3/4" high and are mold marked either Wade or Wade Ireland.

ABBOT'S CHOICE DECANTER, 1982 - circa 1987

The Abbot's Choice decanter was first produced by Wade (Ireland) Ltd. in 1982. A new, second mold was made in 1987 for Low Robertson, part of the Distillers Company Limited, who were then absorbed into United Distillers as part of the Guinness Group now Diageo.

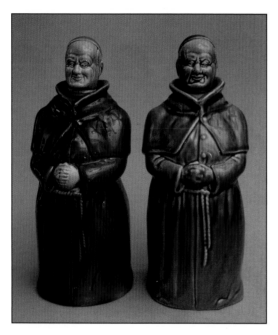

Left: This liquor bottle measures 10" high and was issued circa 1987. The decanter is mold marked on the underside of the base: M - Made Exclusively for the Abbot's Choice Scotch Whisky, John McEwan & Co. Ltd. Leith, Scotland, Liquor Bottle, Scotland ($130, £70). Right: This liquor bottle was issued circa 1982 and is mold marked on the underside of the base: 263992 Made Exclusively for Abbot's Choice Scotch Whisky, John McEwan & Co. Ltd., Leith, Scotland ($140, £75).

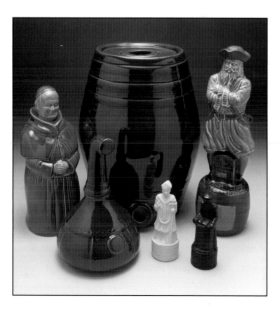

Miscellaneous liquor bottles, circa late 1980s.

JAMESON IRISH WHISKEY, 1982 - 1986

Utilizing the Decanter (shape SR.13) from the Shamrock range, Wade (Ireland) Ltd. produced a decanter for John Jameson & Son Limited of Dublin to contain their brand of Irish whiskey. Jameson Irish Whiskey is distilled in Ireland by Irish Distillers, which is owned by the Pernod Ricard Group.

Jameson Irish Whiskey decanter. The decanter measures 7-3/4" high and has Mark Type 41 on the underside of the base ($70, £37).

MISCELLANEOUS LIQUOR BOTTLES, FLAGONS and DECANTERS

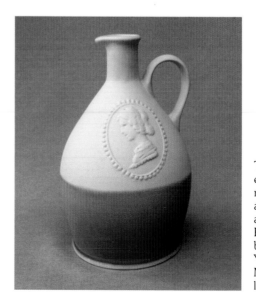

The "Bronte" Decanter Jug. The decanter measures 7-1/2" high and is marked: Created for the James B. Beam Import Corp. by Bronte Liqueur, Yorkshire, England. Made by Wade Ireland ($75, £40).

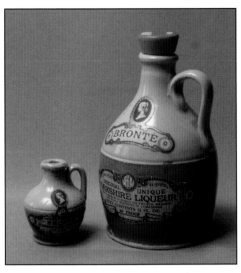

Left: Bronte Miniature Decanter measures 2-3/8" high and is un-marked ($12, £8). Right: Bronte 12 oz Decanter measures 5-1/4" high to top of lip and is unmarked ($20, £12).

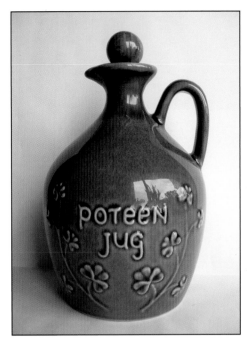

Poteen Jug. This jug, shape I.P. 60, measures 7-5/8" high and has Mark Type 40A. The jug was produced circa late 1970s - 1986 ($50, £30).

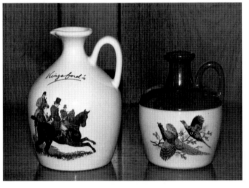

Left: Kings-ford Decanter circa late 1980s - early 1990s. The decanter measures 6-3/4" high and is marked: Wade Ireland ($75, £40). Right: Pheasant Decanter circa late 1990s. The decanter measures 5-1/2" high and is marked: Wade Ireland. This decanter is from a special order of Old Bushmills Irish Whiskey that was specially bottled for Wade (Ireland) Ltd. to be given as gifts by the pottery ($75, £40).

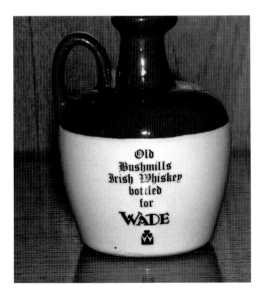

Back view of the Pheasant decanter.

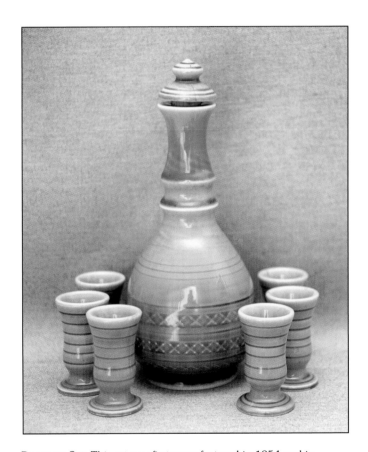

Decanter Set. This set was first manufactured in 1954 and in production for a number years. The decanter measures 8-1/2" high and has Mark Type 29 on the base. The miniature liqueur "glasses" measure 2-1/2" high and have Mark Type 28 on the base ($280 decanter/stopper and six "glasses," £150 complete).

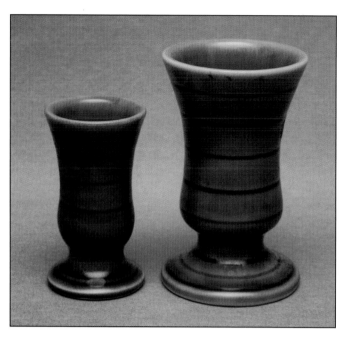

Liqueur "Glasses." Left: The "glass" is 2-1/2" high and has a similar mark as Mark Type 28 but without the wording: Made in Ireland ($15, £8). Right: Liqueur "glass" is 3-1/4" high and has an impressed mark: Irish Porcelain ($18, £10).

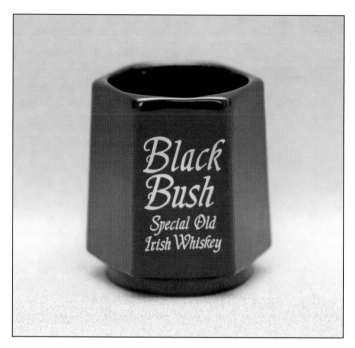

Black Bush Shot Glass 1986 - 1987. The shot glass measures 3-1/4" high and is marked Wade Ireland. The shot glass was sampled for Bushmills Distillery but never produced in quantity. Only 250 pieces were produced as specials ($25, £15).

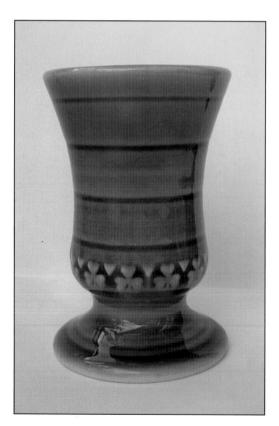

Liqueur "Glass" with shamrock decoration. The "glass" is 2-1/2" high and has a similar mark as Mark Type 28 but without the wording: Made in Ireland ($18, £10).

Chapter 7
FIGURINES

early 1950s - 1993

"PEX" FAIRY, *early 1950s*

The figurine of a fairy was produced by Wade (Ulster) Ltd. as a promotional item for Pex Stockings. At the end of the promotion, a number of surplus figurines were mounted on a posy of porcelain flowers that incorporated a candle holder behind the figurine. This combination was sold as gift ware items.

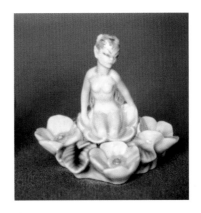

"Pex" Fairy Candle holder is 3" high and marked: Made in Ireland by Wade Co. Armagh ($600, £300).

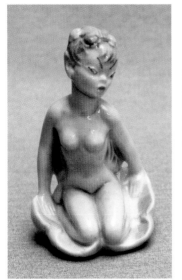

"Pex" Fairy measures 2-3/8" high and originally had a black and gold paper label reading: Made in Ireland by Wade Co. Armagh. A number of color variations of the "Pex" fairy exist ($500, £260).

POGO, *1959*

This beautiful hand-decorated, but hard to find, die-pressed figurine was modeled by William Harper from a design based on the Pogo newspaper cartoon strip.

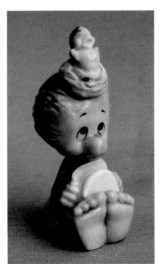

Pogo measures 3-1/4" high and is marked: "POGO" copyright Walt Kelly Made in Ireland 1959 ($650, £400).

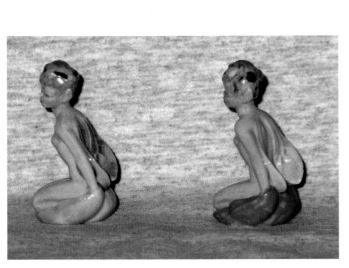

"Pex" Fairy. Color variations.

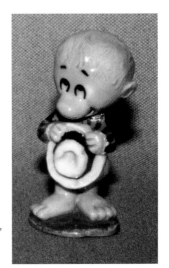

Prototype Pogo measures 2-3/4" high and is slip cast and un-marked ($650, £400).

THE RANK, HOVIS McDOUGALL FOODS COMPANY, 1977

A pair of salt and pepper shakers was modeled by Wade circa mid 1970s in the image of the "BISTO - KIDS," the popular advertising characters used for promoting "BISTO" products made by The Rank Hovis McDougall Foods Company. These two figurines were modeled at George Wade & Son Ltd. in Burslem but were manufactured by Wade (Ireland) Ltd.

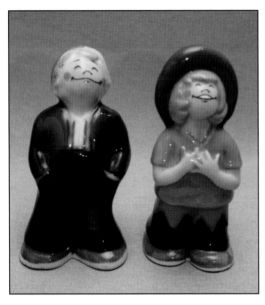

Left: Bisto Boy pepper shaker measures 4" high ($135, £85).
Right: Bisto Girl salt shaker measures 4-3/8" high ($135, £85).
Both figurines are marked on the base: "© RHM FOODS LTD. & Applied Creativity - WADE Staffordshire."

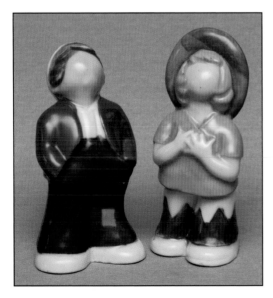

"Bisto - Kids" salt and pepper shakers with unpainted faces. Both figurines are marked on the base similarly to the regular figurines illustrated above.

IRISH SONG FIGURES, *1962 - 1986 and early 1990s - 1993*

The "Irish Porcelain Song Figures" were very much a prestige line of most carefully manufactured and hand painted figurines. Originally issued in 1962, the line comprised eleven figurines. Eight figurines measure approximately 6" high and were modeled by William Harper. The remaining three figurines measure approximately 8" high and were modeled by Raymond Piper. The eight smaller figurines are marked "Irish Porcelain Made in Ireland" along with the name of the figurine and the name of the modeler. The three larger figurines are only marked "Irish Porcelain Figurines Made in Ireland."

It is interesting to note that the first advertisements for the Song Figures featured only Dan Murphy and Mother Machree, who were, at that time, referred to as "Himself" and "Herself." These two figurines have been found marked "Himself" and "Herself" along with the signature of Raymond Piper.

Advertisement for "Himself" and "Herself" from the June 1962 issue of *Pottery and Glass.*

According to John. A. Stringer, the then Managing Director of Wade (Ireland) Ltd., the "Irish Porcelain Song Figures" were discontinued in 1986 and by January 1987 only the following figurines remained in stock: C.501 - Widda Cafferty 35 pieces, C.510 - Bard of Armagh 10 pieces, C.507 - Dan Murphy 27 pieces, C.508 - Mother Machree 36 pieces and, C.509 - Eileen Oge 4 pieces.

In the early 1990s, the "Irish Porcelain Song Figures" were reissued under the Seagoe Ceramics banner. Although the same tools were used for the reissue, there were noticeable differences in the glaze and the larger figurines now had the Irish Porcelain Figures Seagoe Ceramics mark on the underside of the base. The smaller figurines had an Irish Porcelain Seagoe Ceramics Made in Ireland mark.

The tableware and gift ware departments of Seagoe Ceramics Limited stopped manufacturing in April 1993 to concentrate on Engineering Ceramics, so once again the prestige line of the "Irish Porcelain Song Figures" came to an end.

Raymond Piper

Renowned portrait painter Raymond Piper was employed by the Irish Wade pottery to model quality figurines for the company. Piper, with his sense of humor and passion for drawing cartoons, soon became a friend to the Carryer family. It was Felicity, the daughter of Iris and Straker Carryer, who sat for Piper to do the model of Eileen Oge.

Born in London in 1923, Piper studied art at the Belfast College of Art. Before becoming a full time painter, Piper worked as a marine engineer. One of Great Britain's most sought after portrait painters, he has a passion for wild Irish orchids and is recognized internationally as a botanist of some stature. Piper had an exhibition of his research in orchids in 1974 at the Natural History department of the British Museum. In 1987, *Piper's Flowers* was published by Blackstaff Press and in September 1988, Piper was awarded the Beck's Bursary for his botanical illustrations. In 1991, he was elected honorary academician of the Royal Hibernian Academy of Arts in Dublin and in 2002 he was elected honorary academician of the Royal Ulster Academy of Art.

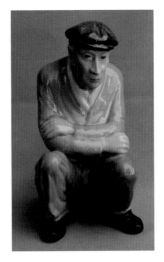 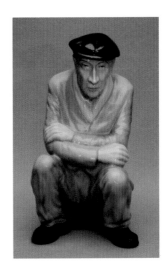

Left: Dan Murphy – shape No. C.507. This is the 1962 - 1986 issue ($345, £230). Right: Dan Murphy. This is the reissued version of the early 1990s - 1993 figurine ($300, £200).

Backstamp on the Seagoe Ceramics re-issued version of the large Irish Song Figures.

Raymond Piper.

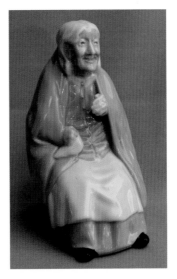 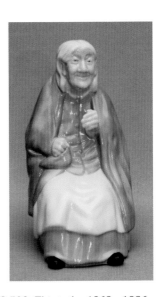

Left: Mother Machree – shape No. C.508. This is the 1962 - 1986 issue ($365, £245). Right: Mother Machree. This is the reissued version of the early 1990s - 1993 figurine ($330, £220).

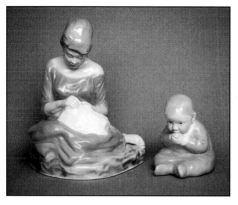

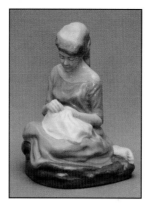

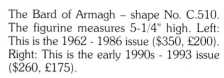

The Bard of Armagh – shape No. C.510. The figurine measures 5-1/4" high. Left: This is the 1962 - 1986 issue ($350, £200). Right: This is the early 1990s - 1993 issue ($260, £175).

Left: Eileen Oge – shape No. C.509. This is the 1962 - 1986 issue ($350, £235). Center: Baby measures 4-1/4" high and was never reissued ($700, £420). Both figurines are transfer marked: Irish Porcelain Figures Made in Ireland. Right: Eileen Oge. This is the reissued version of the early 1990s - 1993 figurine ($315, £210).

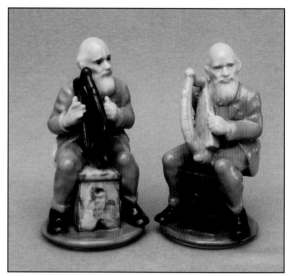

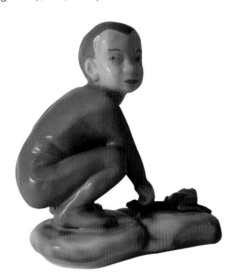

Blow-Up Pixie. The pixie measures approximately 6" high and was modeled by Raymond Piper in the early 1960s. The figurine has Mark Type 33B on the base ($1200, £800).

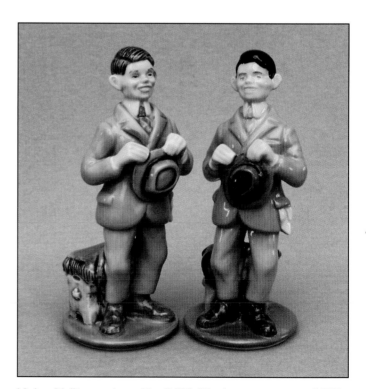

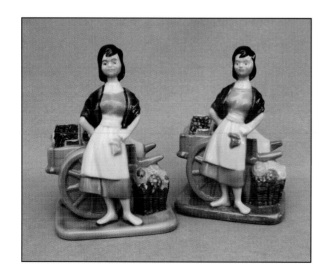

Mickey Mulligan – shape No. C.502. The figurine measures 6-3/8" high. Left: This is the 1962 - 1986 issue ($365, £245). Right: This is the early 1990s - 1993 issue ($330, £220).

Molly Malone – shape No. C.506. The figurine measures 6-1/4" high. Left: This is the 1962 - 1986 issue ($375, £250). Right: This is the early 1990s - 1993 issue ($340, £225).

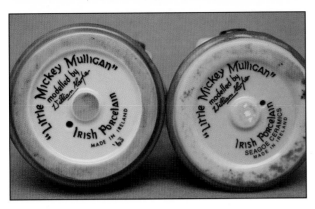

Left: Backstamp on the 1962 - 1986 figurine. Right: Backstamp on the early 1990s - 1993 figurine. The backstamps are typical of the smaller Song Figurines other than the name of the figurine.

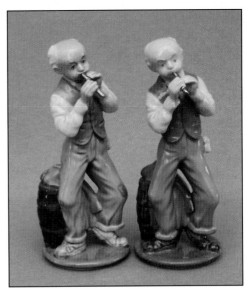

Phil the Fluter – shape No. C.500. The figurine measures 6-1/4" high. Left: This is the 1962 - 1986 issue ($350, £235). Right: This is the early 1990s - 1993 issue ($315, £210).

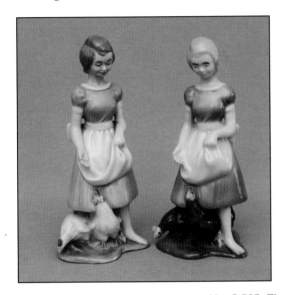

The Star of the County Down – shape No. C.505. The figurine measures 6-1/4" high. Left: This is the 1962 - 1986 issue. ($350, £235). Right: This is the early 1990s - 1993 issue. ($315, £210).

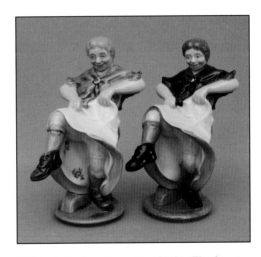

Widda Cafferty – shape No. C.501. The figurine measures 6-3/4" high. Left: This is the 1962 - 1986 issue ($320, £215). Right: This is the early 1990s - 1993 issue ($285, £190).

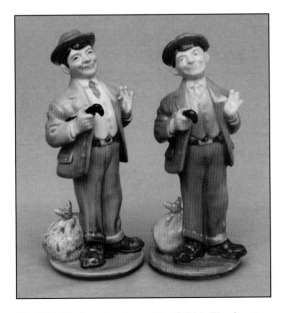

The Irish Emigrant – shape No. C.504. The figurine measures 6-1/2" high. Left: This is the 1962 - 1986 issue ($350, £235). Right: This is the early 1990s - 1993 issue ($315, £210).

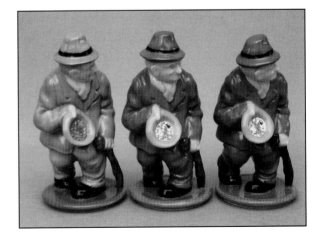

Little Crooked Paddy – shape No. C.503. The figurine measures 5-1/8" high. Left: This is the 1962 - 1986 issue ($310, £205). Center: This is the early 1990s - 1993 issue ($310, £205). Right: Variation of the early 1990s - 1993 issue. The figurine is 5-1/16" high ($270, £180).

IRISH CHARACTER FIGURES,
mid 1970s - 1986

This set of nine pressed figurines was based on characters from typical Irish folk tales and songs. Each figurine is ink stamped "Made in Ireland" on the underside of the base. Some of the figurines also have the name of the character molded into the front of the base.

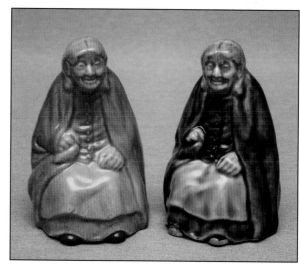

Mother Machree. Color variations ($45, £26).

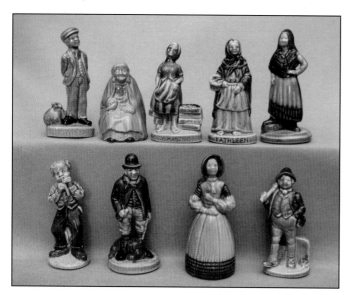

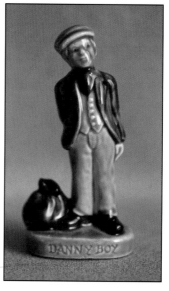

Danny Boy. Color variation sampled for Boxpak Ltd. of Belfast ($55, £30).

1. Danny Boy is shape No. S.16 and measures 4" high ($55, £30). 2. Mother Machree is shape No. S.19 and measures 2-1/2" high ($45, £26). This figurine is frequently found in a light single glaze (as illustrated) as well as a multi colored glaze. 3. Molly Malone is shape No. S.17 and measures 3-1/4" high ($45, £26). 4. Kathleen is shape No. S.18 and measures 3-1/2" high ($45, £26). 5. Eileen Oge is shape No. S.25 and measures 3-3/4" high ($45, £26). 6. Phil the Fluter is shape No. S.20 and measures 3-1/4" high ($45, £26). 7. Paddy Reilly is shape No. S.26 and measures 3-3/4" high ($45, £26). 8. Rose of Tralee is shape No. S.24 and measures 4" high ($45, £26). 9. Paddy Maginty is shape No. S.21 and measures 3-1/4" high ($55, £30).

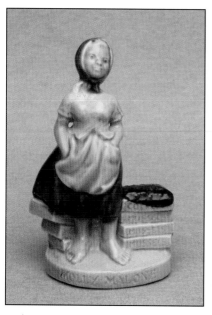

Molly Malone. Color variation ($45, £26).

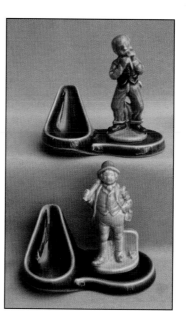

Top: Phil the Fluter Pipe Rest, late 1980s. The figurine measures 3-3/4" high and has Mark Type 40A on the base ($100, £40). Bottom: Paddy Maginty Pipe Rest, late 1980s. The figurine measures 3-5/8" high and has Mark Type 40A on the base ($100, £40).

IRISH CHARACTER FIGURES, *1991 - 1993*

The Irish Character Figures were reintroduced by Seagoe Ceramics Limited in 1991. Although the original tools were used for the reissue, the glaze was much darker with a pronounced all-over honey glaze. Each figurine had Mark Type 41A, which, in many cases, would wash off.

Production of the line was discontinued in 1993 when the pottery ceased manufacturing tableware and gift ware. Although production of the figurines ceased in 1993, existing stock was sold off over the next few years.

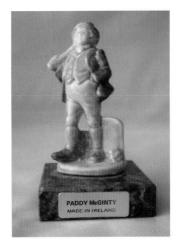

Paddy Maginty on a Marble Base ($35, £20).

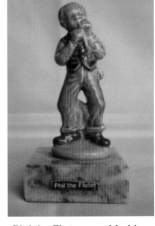

Phil the Fluter on a Marble Base ($35, £20).

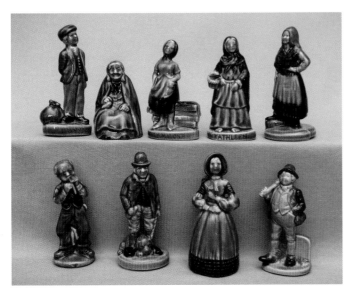

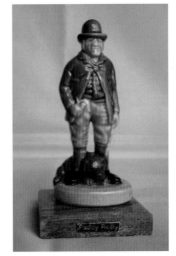

Paddy Reilly on a Marble Base ($35, £20).

1. Danny Boy is shape No. S.16 and measures 4" high ($42, £24). 2. Mother Machree is shape No. S.19 and measures 2-1/2" high ($35, £20). 3. Molly Malone is shape No. S.17 and measures 3-1/4" high ($35, £20). 4. Kathleen is shape No. S.18 and measures 3-1/2" high ($35, £20). 5. Eileen Oge is shape No. S.25 and measures 3-3/4" high ($35, £20). 6. Phil the Fluter is shape No. S.20 and measures 3-1/4" high ($40, £22). 7. Paddy Reilly is shape No. S.26 and measures 3-3/4" high ($35, £20). 8. Rose of Tralee is shape No. S.24 and measures 4" high ($35, £20). 9. Paddy Maginty is shape No. S.21 and measures 3-1/4" high ($40, £22).

A number of the Irish Character Figures are to be found affixed to small pieces of the famous Irish Connemara marble. These combination figurines were sold in gift stores but it is not known if all figures from this series appeared in this style.

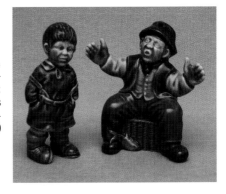

Prototype figurines. Left: Irish Boy measures 3" high. Right: Fisherman measures 3" high by 3" overall ($120 each, £70 each).

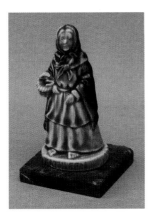

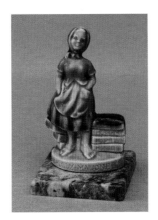

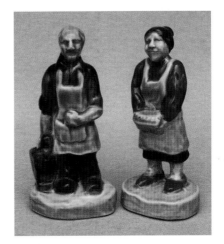

Kathleen on a Marble Base ($35, £20).

Molly Malone on a Marble Base ($35, £20).

Prototype figurines. Left: Blacksmith measures 3-1/2" high. Right: Baker measures 3-1/2" high ($120 each, £70 each).

Chapter 8
LEPRECHAUNS

LUCKY LEPRECHAUNS, *1956 - 1959 and mid 1960s - 1986*

In 1956, Wade (Ulster) Ltd. began marketing souvenirs based on the famous Irish Folk People, the Leprechauns. The three "Lucky Leprechauns" were modeled by William Harper and featured them plying various trades such as tailor and cobbler. The third leprechaun was modeled in a sitting position, holding the mythical "Crock o' Gold."

The leprechauns were supplied in boxes of 24 to the wholesalers, who then retailed them individually at one shilling and eleven pence each. Included in the box of 24 leprechauns was a porcelain shamrock leaf advertising plaque, which stated the retail selling price. This plaque had to be changed after one year as the retail price of the leprechauns was reduced by five pence.

The January 1959 issue of *The Wade Wholesalers Newsletter* announced that the Lucky Leprechauns were to be discontinued. This stoppage in production was short lived as the three Lucky Leprechauns were reintroduced to the gift ware line in the mid 1960s and stayed in production until the summer of 1986.

The leprechauns produced in the 1950s had a brownish face and were marked with a black and gold label on the bottom of the figurines. Those produced in the 1960s to 1980s had a much lighter, almost flesh colored face. Figurines produced in the 1960s did not have a backstamp or paper label but those from the 1980s had an ink stamp on the bottom reading: Made in Ireland.

In the 1960s, the three leprechauns were marketed in presentation boxes of three figurines each. The box had an attractive slip cover with an inside box divided into three windows showing the figurines. The later presentation box of three featured a plastic window showing the three figurines inside the box.

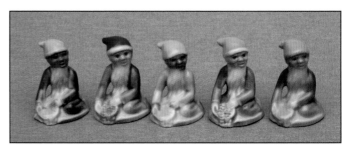

Lucky Leprechaun with Crock o' Gold. Color variations. The figurines are shape No. S. 2, measure 1-1/2" high, and may be found unmarked or ink stamped Made in Ireland ($20, £12). For the Lucky Leprechaun with Crock o' Gold on a leaf tray see Shamrock Pottery in Chapter 9.

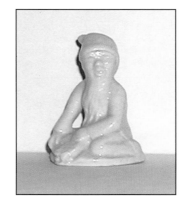

Lucky Leprechaun with Crock o' Gold. Rare, undecorated figurine ($100, £58).

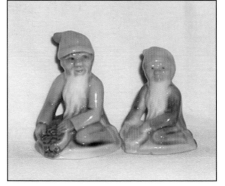

Lucky Leprechaun with Crock o' Gold. Prototype figurine. Left: Prototype figurine measures 1-3/4" high ($150, £90). Right: Production figurine shown for comparison.

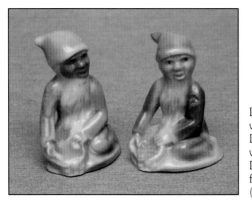

Lucky Leprechaun with Crock o' Gold. Left: Early version with dark face. Right: Later version with flesh colored face ($20, £12).

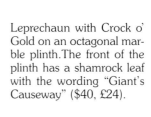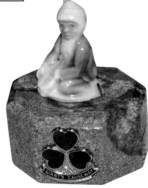

Leprechaun with Crock o' Gold on an octagonal marble plinth. The front of the plinth has a shamrock leaf with the wording "Giant's Causeway" ($40, £24).

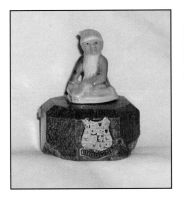

Leprechaun with Crock o' Gold on an octagonal marble plinth. Giant's Causeway plaque variation ($40, £24).

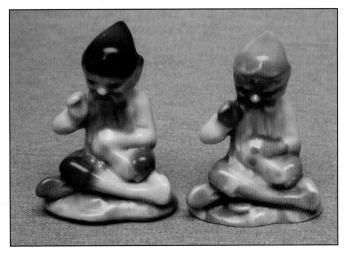

Lucky Leprechaun – Tailor. Color variations. The figurines are shape No. S. 2, measure 1-1/2" high, and may be found unmarked or ink stamped Made in Ireland ($20, £12).

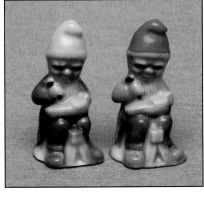

Lucky Leprechaun – Cobbler. Color variations. The figurines are shape No. S. 2, measure 1-1/2" high, and may be found unmarked or ink stamped Made in Ireland ($20, £12).

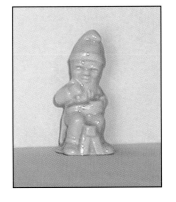

Lucky Leprechaun – Cobbler. Rare, undecorated figurine ($100, £58).

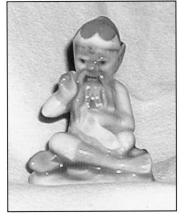

Left: Lucky Leprechaun – Tailor. Figurine with unusual orange colored hat. Right: Lucky Leprechaun – Tailor. Figurine with red colored hat ($25 each, £15 each).

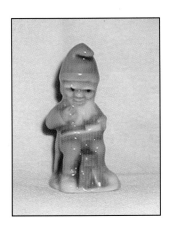

Lucky Leprechaun – Cobbler. Prototype figurine measures 1-1/2" high ($150, £90).

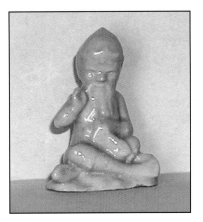

Lucky Leprechaun – Tailor. Rare, undecorated figurine ($100, £58).

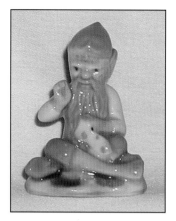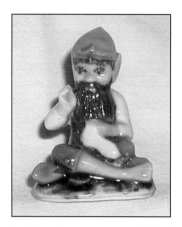

Left: Lucky Leprechaun – Tailor. Right: Lucky Leprechaun – Tailor. Both prototype figurines measures 1-1/2" high ($150 each, £90 each).

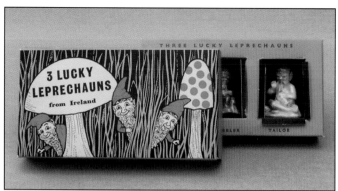

Leprechauns, early issue, in original box with slip cover ($100, £60).

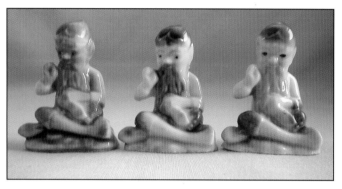

Lucky Leprechaun – Tailor. Color variations ($20 each, £12 each).

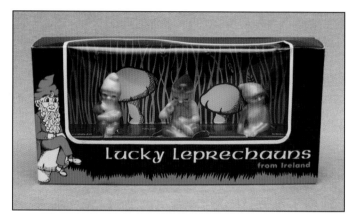

Leprechauns, later issue, in original box with open front ($90, £54).

Lucky Leprechaun. Prototype figurine. The figurine measures 1-1/2" high by 1-5/8" long and is unmarked. This figurine was modeled by William Harper but never went into production ($300, £175).

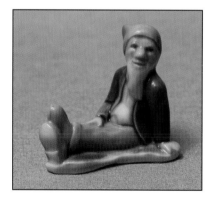

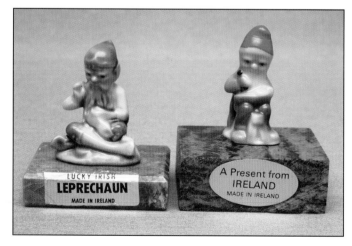

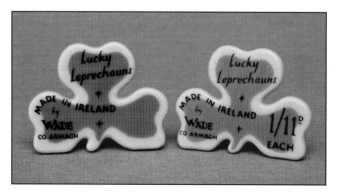

Lucky Leprechaun Display Plaques 1956 - 1959. Left: The plaque without the price was used between 1958 and 1959 ($180, £100). Right: The plaque with the original price was used between 1956 and 1957 ($200, £110). The small plaques measure 1-7/8" by 1-3/4" and are unmarked.

Left: Leprechaun Tailor on a Marble Base. This combination measures 2-1/8" high on a 2" by 1-1/2" marble base. The paper label on the underside of the base reads: Real Connemara Marble, Made in Ireland ($25, £10). Right: Leprechaun Cobbler on a Marble Base measures 2-7/16" high on a 2" by 1-1/2" marble base. The paper label on the underside of the base reads: Real Connemara Marble, Made in Ireland ($25, £10).

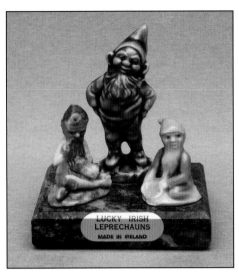

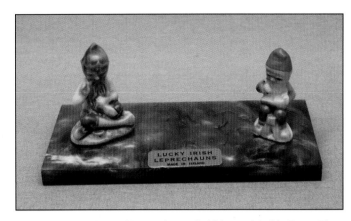

Leprechaun Tailor and Leprechaun Cobbler on Marble Base. The base is faux marble and has a label reading: Lucky Irish Leprechauns Made in Ireland ($25, £10).

Leprechauns on Marble Base. This combination measures 3-1/8" wide by 2-1/2" deep. The paper label on the underside of the base reads: Real Connemara Marble, Made in Ireland ($25, £10).

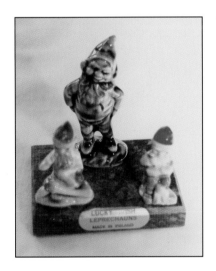

Leprechauns on Marble Base. This combination measures 3-1/8" wide by 2-1/2" deep. The paper label on the underside of the base reads: Real Connemara Marble, Made in Ireland ($25, £10).

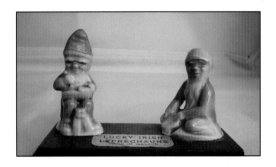

Leprechaun Cobbler and Leprechaun Crock o' Gold on a wood base ($20, £12).

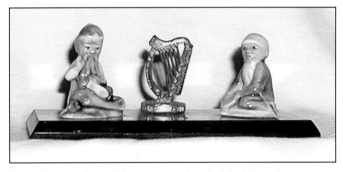

Leprechaun Tailor and Leprechaun Crock o' Gold with Harp on a 2-1/4" wide by 5" long acrylic base. ($20, £12).

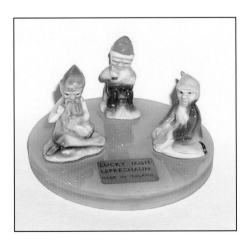

Leprechauns on Circular Acrylic Base. The circular base measures 3-1/2" in diameter ($30, £18.)

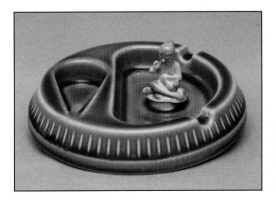

Leprechaun Tailor on Ashtray. The ashtray measures 6" in dia. and has Mark Type 29 on the base ($55, £20).

LUCKY LEPRECHAUN PIN TRAYS,
1956 - 1959 and mid 1960s - 1986

From the 1950s through to 1986, the Irish pottery produced a series of small round trays usually referred to as Pin Trays but sometimes called Butter Pats. These trays were given the shape No. I.P. 619. In addition to the Lucky Leprechauns sold in sets of three, the figurines were also applied to the Pin Trays. With the addition of the leprechauns to the Pin Trays the shape number was changed to shape No. I.P. 619L. The trays are to be found with both Mark Type 32 and Mark Type 41.

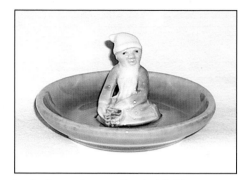

Lucky Leprechaun – Crock o'Gold on a pin tray. Color variation ($25, £14).

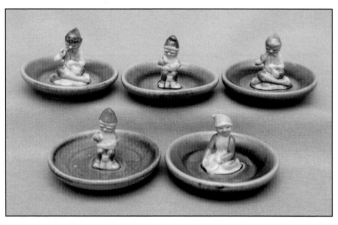

Lucky Leprechaun Pin Trays. Miniature leprechauns, Tailor, Cobbler, and Crock o' Gold, in a variety of color combinations mounted on the Pin Trays ($25 each, £14 each).

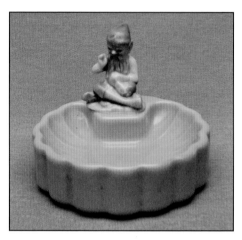

Lucky Leprechaun Butter Dish – Tailor. The dish is mold marked "Wade England." This leprechaun and dish combination is quite hard to find ($30, £18).

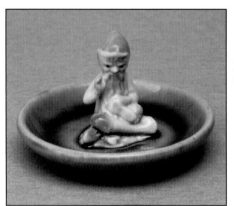

Lucky Leprechaun – Tailor on Pin Tray. Color variation ($25, £14).

Lucky Leprechaun – Crock o' Gold on a black pin tray. The tray is 2-7/8" diameter and is marked: Made in Ireland ($32, £18).

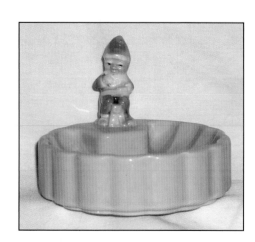

Lucky Leprechaun Butter Dish – Cobbler. The dish is mold marked "Wade England." This leprechaun and dish combination is quite hard to find ($40, £24).

"LUCKY FAIRY FOLK," 1956 - 1959

The August 1956 *Wade Wholesalers Newsletter No.1* announced the addition of three new figurines to the gift ware line. These figurines were again modeled by William Harper and were given the name "Fairy Folk." The newsletter described the new figurines as "...three entirely different models...marketed in individual acetate non-flammable boxes of intriguing shape..." The article went on to exhort people to hang the "Lucky Fairy Folk" on their Christmas trees. The November 1956 issue of *Pottery and Glass* noted that the Lucky Fairy Folk were to be exported to South Africa in January 1957. In February 1957, it was reported that the Lucky Fairy Folk were selling well in New Zealand and Australia.

The set of figurines consisted of a leprechaun riding a pig, a pixie riding a rabbit, and a pixie riding an acorn. According to the January 1959 *Wade Wholesalers Newsletter No.6*, the figurines were discontinued in 1959. The Pixies riding rabbits and acorns were never reissued but the Leprechaun Riding a Pig was reissued in the mid 1970s and stayed in the line until 1986.

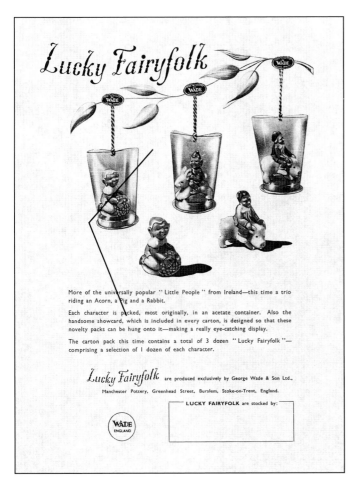

A Wade advertisement for the Lucky Fairy Folk. Note the advertisement states that the Lucky Fairy Folk are produced exclusively by George Wade & Son Ltd. This is somewhat misleading, as the figurines were all produced in Ireland then shipped to Burslem for distribution.

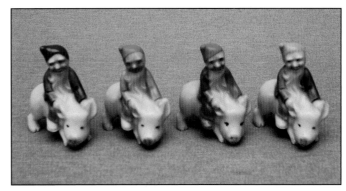

Lucky Leprechaun on a Pig. Color variations. The figurines are shape No. S. 8, measure 1-3/4" high, and may be found unmarked or ink stamped Made in Ireland ($65 each, £35 each).

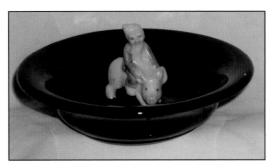

Lucky Leprechaun on a Pig dish. The unmarked dish by an unknown manufacturer measures 1-1/4" high by 4-3/4" diameter. Note the unusual shape of the dish ($40, £24).

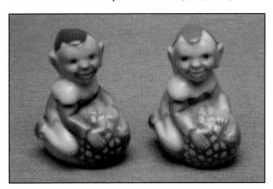

Pixie on an Acorn. Color variations. The figurines measure 1-1/2" high and may be found unmarked or ink stamped Made in Ireland ($70 each, £40 each).

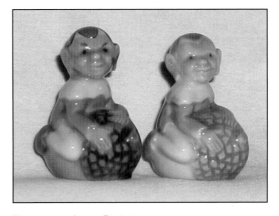

Pixie on an Acorn Prototype.
Left: Prototype figurine measures 1-5/8" high ($150, £90). Right: Production figurine shown for comparison.

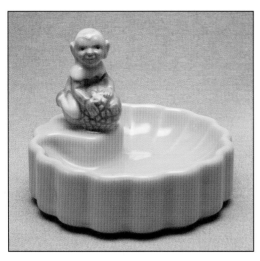

"Pixie on Acorn" Butter Dish. The figurine measures 3-1/4" in dia. by 2-1/2" high and is mold marked "Wade England." This dish combination is quite hard to find ($60, £35).

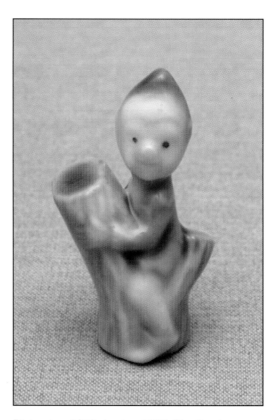

Pixie, circa 1950s to circa 1960. The figurine measures 1-3/8" high and is found with an ink stamp "Made in Ireland" or unmarked. This single pixie, modeled by William Harper, is quite hard to find ($30, £18).

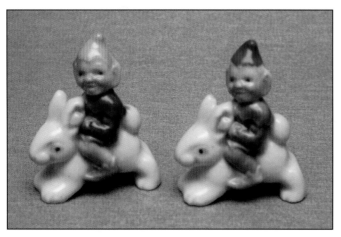

Pixie on a Rabbit. Color variations. The figurines measure 1-1/2" high and may be found unmarked or ink stamped Made in Ireland ($70 each, £40 each).

Pixie on a Rabbit in original package ($100, £58).

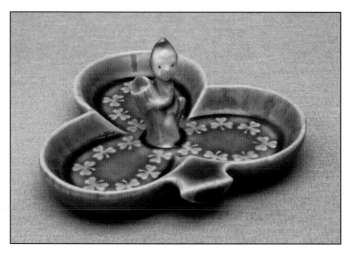

Pixie on a Shamrock Pin Tray – shape No. I.P. 609P. This tray with the pixie is much more easily found than the single pixie and was in production from the mid 1950s to 1986. The tray has Mark Type 29 on the base ($24, £14).

LARGE LUCKY LEPRECHAUNS, *mid 1970s - 1986*

The figurines are shape No. S.11 and measure 2-3/4" high. The figurines are to be found ink stamped Made in Ireland or with no marking at all.

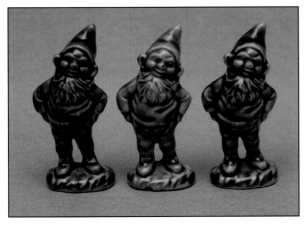

Large Lucky Leprechauns. Color variations ($30 each, £18 each).

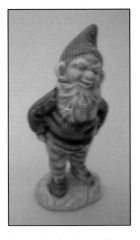 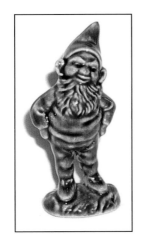

Large Lucky Leprechaun. Color Variation ($30, £18).

Large Lucky Leprechaun. Color Variation ($30, £18).

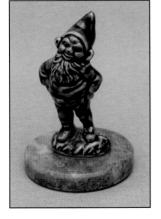

Large Leprechaun on a circular marble base ($30, £18).

LARRY and LESTER, *mid 1970s - 1986*

These large leprechaun figurines were in the gift ware line between approximately 1974 until all gift ware production ended in 1986. Both figurines were given the shape number of S.22. The only difference between Larry and Lester was the color of the glaze. Larry and Lester were also produced as book ends.

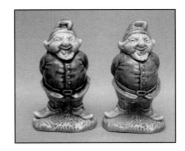

Larry and Lester.
Left: Larry measures 4" high, and is found either unmarked or with an ink stamp Made in Ireland ($75, £55). Right: Lester measures 4" high, and is found either unmarked or with an ink stamp Made in Ireland ($75, £55).

Variation of the base for Larry and Lester.

Original packaging for Larry and Lester ($15, £9).

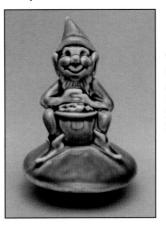

Larry and Lester Bookends. The bookends measure 4-1/2" high and may be found either unmarked or marked with an ink stamp Made in Ireland ($80 each, £65 each).

LEPRECHAUN ON A TOADSTOOL, *early 1960s*

This figurine is shape No. C340, measures 4-1/2" high, and is transfer marked: Made in Ireland. The figurine was produced for a short period in the early 1960s ($55, £45).

Chapter 9
ANIMALS, BIRDS, AND WHIMSIES

FLYING BIRDS, *1956 - 1960*

In the August 1956 issue of the *Pottery Gazette and Glass Trade Review,* an advertisement titled the "Mourne Range" of porcelain miniatures illustrated the first set of "Flying Birds" in green and blue colors. The birds were packaged in presentation boxes of three birds of similar color. In the August 1957 issue of the *Wade Wholesalers Newsletter No. 3,* it was noted as follows: "Our Irish Colleagues have made changes in their existing range: Flying Birds. In addition to the birds available at present, i.e. Blue, Green…they are also to be available in Yellow and Green, alternatively Beige and Grey." According to a notice in the January 1960 edition of the *Wade Wholesalers Newsletter No. 8,* the Flying Birds Set 1 was discontinued in 1960.

The January 1958 edition of the *Wade Wholesalers Newsletter No. 4.* reported that the Irish pottery had introduced a second set of Flying Birds known as Swifts. The Wade potteries had been well known for keeping wholesale prices down but in the 1958 *Wade Wholesalers Newsletter No. 4* a note read: "…we simply must increase the price of Flying Birds. The position has now got so bad that every time we send an order for them to our Irish factory, instead of a 'Thank you' we receive a Squawk." The newsletter also mentioned that the Irish pottery redesigned the old Swallow presentation box for the new Swifts so that the two sets of birds were "…in complete harmony." Although all the Flying Birds were produced by the Irish pottery, they were marketed by George Wade & Son, Ltd. out of Burslem. In a May 1987 letter, Straker Carryer wrote: "They [George Wade] made the tools & sent them to us & we shipped the finished products including boxes to George Wade for distribution. They did all the selling to retail etc."

In the January 1959 edition of the *Wade Wholesalers Newsletter No. 6,* it was stated that the Swifts were to be discontinued in that year. It would appear that the Flying Birds Set 2 was not as popular as Set 1.

The Flying Birds were modeled by William Harper, who modeled so many of the Wade products of the 1950s and early 1960s.

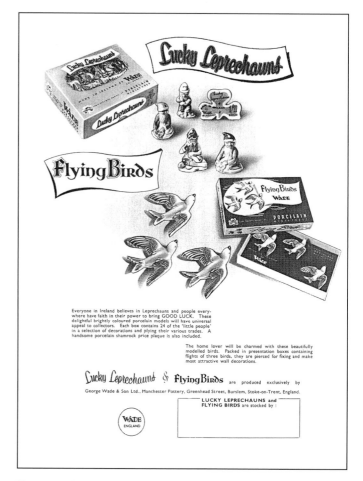

Illustration from a 1959 Wade Price List. It is interesting that the advertisement notes the Lucky Leprechauns and Flying Birds "…are produced exclusively by George Wade & Son Ltd…." This actually was not the case. The figurines were manufactured in Ireland then shipped to Burslem and marketed by the George Wade pottery. (Ref. the January 1958 *Wade Wholesalers Newsletter No. 4*).

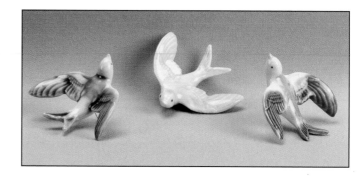

Swallows 1956 - 1960. Left: Green Flying Bird ($20, £10). Center: Yellow Flying Bird ($24, £14). Right: Blue Flying Bird ($20, £10). The birds measure 1" high by 2-3/4" across the wings and are unmarked.

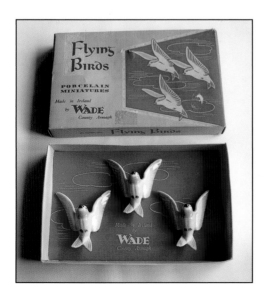

Presentation Box for Flying Birds Set 1.

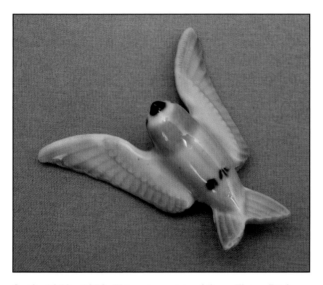

Swifts 1958 - 1959. This set consists of three Flying Birds. The birds were unmarked and each had three small holes in the back for affixing the item to the wall. The birds measure 1-1/4" high by 3" across the wingspan ($30 each, £22 each).

Presentation Box for Flying Birds Set 2.

SHAMROCK POTTERY, *1957 - early 1960s*

First advertised as Shamrock Pottery "Gifts From Old Ireland," this series comprised five gift ware figurines: Pig, Elephant, and Cottage, followed later in the run by the Pixie Dish, which was announced in the 1957 edition of *The Wade Wholesalers Newsletter No. 3* and subsequently in the May 1958 *Wade Price List*. The final piece in the series was the Donkey and Cart posy vase.

Some of the Pigs, Elephants, and Cottages made by Wade (Ulster) Ltd. were customized with names of popular holiday resorts and distributed exclusively by Desmond Cooper & Co. of Birmingham, England.

A Desmond Cooper & Co. advertisement from the May 1957 issue of *The Pottery Gazette and Glass Trade Review.*

Pigs, *1957 - early 1961*

These comic pigs were modeled by William Harper and introduced in 1957 as part of the "Gifts from Old Ireland" Shamrock Pottery series. The figurines are found with a variety of decorations and some with town names. Those with town names were sold as souvenirs. The pigs were discontinued in the early 1960s and were not reissued.

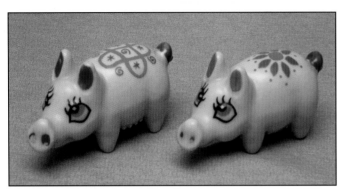

The pigs measure 1-3/4" high by 2-7/8" overall and have a transfer mark: Shamrock Pottery Made in Ireland. The mark is decorated with two green shamrock leaves ($65 each, £35 each). These pigs are to be found with various color combinations of tail and nostrils.

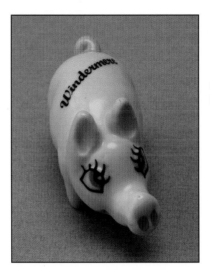

Comic Pig with a Windermere decoration ($65, £35).

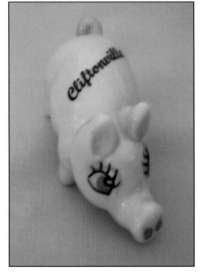

Comic Pig with a Cliftonville decoration ($65, £35).

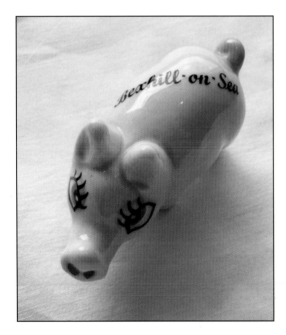

Comic Pig with a Bexhill-on-Sea decoration ($65, £35).

Black Irish Pig 1959. The pig measures 1-3/4" high by 2-7/8" long and is marked: Shamrock Pottery Made In Ireland ($95, £55).

Elephants, *1957 - early 1961*

A series of pink comic elephants, modeled by William Harper, was produced as part of the "Gifts from Old Ireland" Shamrock Pottery series with a variety of liquor-related comments printed on the figurines. Each elephant measures 1-1/2" high by 3" long. The elephants were discontinued in the early 1960s and were not reissued.

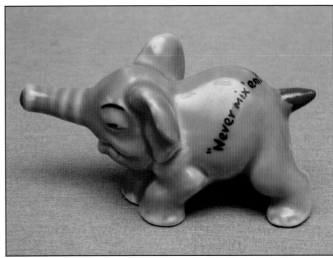

Above: "Never Mix 'em" is marked: Made in Ireland. Below: "Never Again!" is marked: Made in Ireland and is a color variation ($65 each, £35 each).

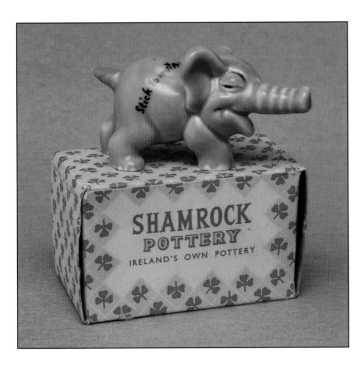

Above: Pink Elephant "Stick to Water" with original box. The figurine is marked: Shamrock Pottery Made In Ireland ($75 boxed, £44 boxed). Below left: "Oh, My Head!" is marked: Shamrock Pottery Made In Ireland ($65, £35). Below right: "Never Again!" is marked: Shamrock Pottery Made In Ireland ($65, £35).

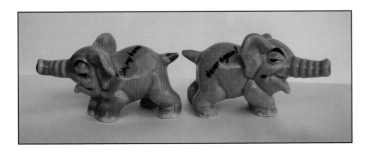

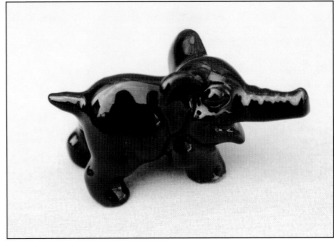

Black Irish Elephant circa 1959. The elephant measures 1-1/2" high by 3" long and is marked: Shamrock Pottery Made in Ireland ($100, £60).

Cottages, *1957 - 1961 and 1965 - 1986*

The Irish cottage, modeled by William Harper, was originally produced between 1957 and 1961 as part of the "Gifts from Old Ireland" series. This first version had a green base. The cottage was reintroduced to the gift ware line in 1965 with a green and white base and was discontinued in 1986. Over its lengthy run, the roof of the cottage was decorated in a number of shades of yellow. Various town names were sometimes added to the base of the cottage and these combinations were sold as souvenirs.

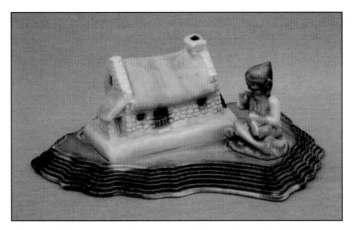

Shamrock Cottage and Leprechaun Tailor is shape No. S.9. This combination of shapes S.6 and S.2 is mounted on a base in the shape of Ireland and was in production between 1960 - 1970. The base in the shape of Ireland is marked: Shamrock Pottery Made in Ireland by Wade of Armagh ($110, £65).

Shamrock Cottage of Omagh is shape No. S.6. The cottage measures 2" high by 2-3/4" long and has an impressed mark: Shamrock Pottery Made in Ireland. This cottage was produced between 1977 and the mid 1980s ($45, £20).

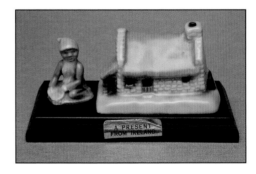

Shamrock Cottage with Leprechaun Tailor and Cobbler. This unusual combination of a cottage with two leprechauns appears to be factory applied ($150, £80).

Top: Shamrock Cottage of Dona o Hadee. The cottage has an impressed mark: Shamrock Pottery Made in Ireland. This cottage was produced between 1977 and the mid 1980s ($45, £20). Bottom: Irish Shamrock Cottage. The cottage has an impressed mark: Shamrock Pottery Made in Ireland. This cottage was produced between 1956 and 1961 ($55, £25).

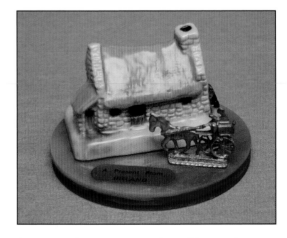

Shamrock Cottage and Leprechaun Crock o' Gold ($60, £30).

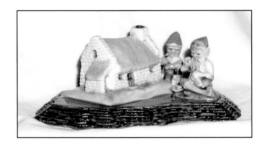

Shamrock Cottage on round base. This combination measures 2-1/8" high by 3-1/2" diameter base ($55, £25).

Pixie Dish, *1957 - 1960 and 1970s - 1986*

The Pixie Dish was the fourth item in the Shamrock Pottery range and again modeled by William Harper. The dish was introduced in the 1957 Christmas Range and first noted in the August 1957 edition of *The Wade Wholesalers Newsletter No. 3*. Although this leaf dish was described as a "Pixie Dish," it is usually found with the Leprechaun with a Crock o' Gold sitting on the leaf. As noted in the January 1960 edition of *The Wade Wholesalers Newsletter No. 8*, the Pixie Dish was discontinued in early 1960.

Wade (Ireland) Ltd. reintroduced the Pixie Dish in the 1970s under the name "Leprechaun Leaf Dish" (shape No. S.3) and it stayed in the line until 1986. During the original Irish run of the Pixie Dish, a similar Oak Leaf Dish without the leprechaun was marketed by George Wade & Son, Ltd. The English-made dish was Set 1 of the popular leaf sets and had a molded mark reading: Wade Porcelain Made in England. All leaf dishes were modeled by William Harper.

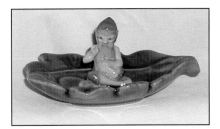

Pixie Dish with Lucky Leprechaun Tailor and Mark Type 31. This combination of Tailor and Pixie Dish is rare ($45, £25).

Donkey and Cart Vase, *circa 1962 - 1986*

The Donkey and Cart Vase was the fifth and final item in the Shamrock Pottery Range. First produced in 1962, the vase went through a number of mold changes. Two variations of this bowl exist. The earlier version has a space between the base and the underside of the cart and spaces between the end of each shaft and the donkey's neck. The later version is solid in both areas described for the earlier version. The vase was still in the gift ware line when all production ended in 1986.

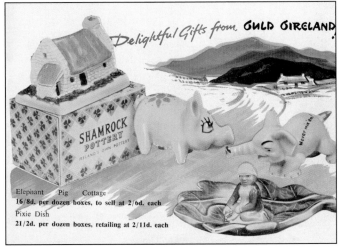

Illustration from the Autumn and Winter 1959 Wade Price List.

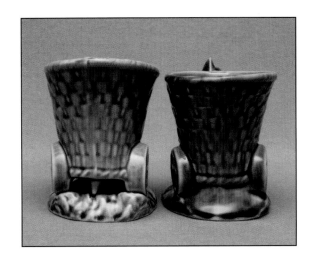

Donkey and Cart Posy Bowl – shape No. C.338. The posy bowl measures 4" high by 6-1/4" overall and has Mark Type 31 on the base ($100, £60).

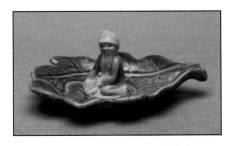

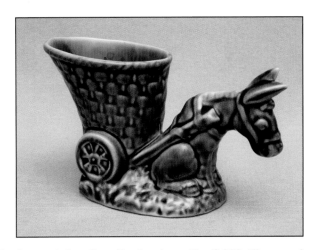

Donkey and Cart Posy Bowl – shape No. C.338. This picture illustrates the differences between the two Donkey and Cart Posy Bowls. The earlier version is 4" high and the later version is 3-5/8" high.

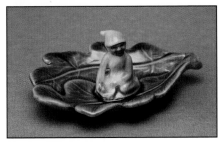

Left: Pixie Dish with Lucky Leprechaun with Crock o' Gold – shape No. S.3 and Mark Type 31 on the base. Right: Pixie Dish. Color variation ($30 each, £16 each).

WHIMSIES, *1953 - 1959*

The famous Whimsies made between 1953 and 1959 were modeled by William Harper. Production of the Whimsies was split between Burslem and Portadown. Sets Nos. 2, 4, 6, 8, and 10 were produced in Ireland and the other sets in England. Not all figurines were mold marked but those that did have a mold mark were marked Wade England. Some of the figurines without a mold mark were marked with a Wade Made in England transfer. This caused somewhat of a problem for the Irish team, as there was quite a bit of rivalry between the two potteries. However, Burslem ruled the day and the Made in England mark stayed. The last sets in the series had no marks at all. See the Introduction to this book for information on the development of the Whimsies. For sets 1, 3, 5, 7, and 9 see *The World of Wade Figurines and Miniatures.*

William Harper

William Harper was born in Newcastle-under-Lyme in 1923 and spent his early school years there. In his teens, Bill began working as an apprentice to a tinsmith, where he learned to cut, bend, and solder metal. After his apprenticeship, Bill attended The Elms Technical College in Sheldon and also started private evening classes to learn typing, shorthand, and bookkeeping.

After serving in the Royal Air Force during World War II, Bill attended art classes at the King's Palace in Naples, where he gained experience studying the human form. From Naples, Bill retuned home to enroll full time at the Burslem School of Art, where he studied oil painting and pottery.

William Harper (Spring 1990).

In 1954, Bill joined George Wade and Son Ltd., where he designed numerous figurines and gift ware and, of course, the Whimsies. Bill eventually became Head Designer and a junior director at Wade. During his stay with Wade, Bill produced an enormous amount of work—from the Whimsies to posy bowls, leprechauns and pixies, plus much, much more. After nine years at the pottery Bill left to become a free lance modeler and designer.

During his free time and vacations, Bill, as an avid adventurer, spent much of the time climbing in the Himalayas and other mountains, a pastime which he keeps up to this day.

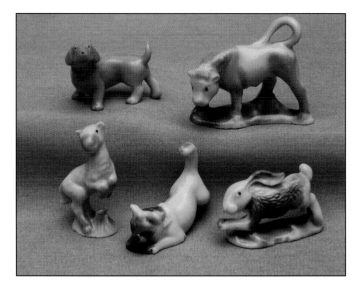

Early Whimsies Set 2, 1954. Dachshund, measures 1-1/8" high by 1-1/2" overall and is unmarked ($92, £48). Bull, measures 1-3/4" high by 2-1/8" overall and is transfer stamped Wade Made in England ($85, £60). Lamb, measures 1-7/8" high by 1-1/4" overall and is transfer stamped Wade Made in England ($57, £30). Kitten, measures 1-3/8" high by 1-3/4" overall and is unmarked ($95, £48). Hare, measures 1-1/8" high by 1-3/4" overall and is transfer marked Wade Made in England ($45, £28).

Presentation box for Whimsies Set 2. Version 1.

Presentation box for Whimsies Set 2. Version 2 closed.

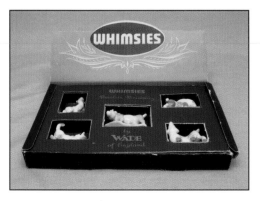

Presentation box for Whimsies Set 2. Version 2 open.

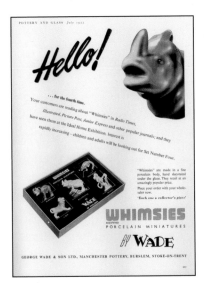

Advertisement for Whimsies Set 4 from the July 1955 issue of *Pottery and Glass*.

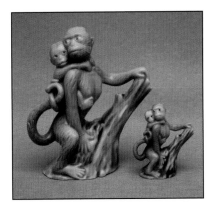

Left: Prototype Monkey and Baby. This figurine, modeled by William Harper, measures 3-1/2" high and is unmarked ($960, £550). Right: Monkey and Baby production model shown for size and color comparison.

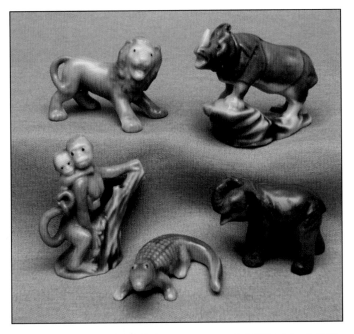

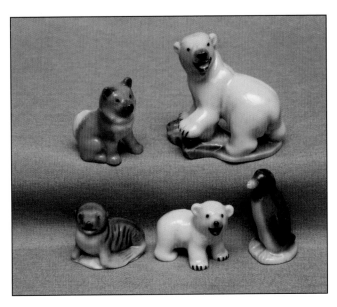

Early Whimsies Set 6, 1956 (Polar Set). Husky, measures 1-1/4" high by 1-1/8" overall and is unmarked ($50, £34). Polar Bear, measures 1-3/4" high by 1-3/4" overall and is unmarked ($47, £30). Baby Seal, measures 7/8" high by 1-1/8" overall and is unmarked ($34, £24). Baby Polar Bear, measures 7/8" high by 1-1/8" overall and is unmarked ($37, £30). King Penguin, measures 1-3/16" high by 5/8" dia. base and is unmarked ($50, £34).

Early Whimsies Set 4, 1955. Lion, measures 1-1/4" high by 1-5/8" overall and is unmarked ($54, £34). Rhinoceros, measures 1-3/4" high by 2-3/8" overall and is transfer stamped Wade Made in England ($45, £24). Monkey, measures 1-7/8" high by 1-5/8" overall and is unmarked but has been found marked with an ink stamp ($38, £24). Crocodile, measures 3/4" high by 1-5/8" overall and is ink stamped Made in England ($78, £42). Baby Elephant, measures 1-1/4" high by 1-7/8" overall and is ink stamped Made in England ($58, £34).

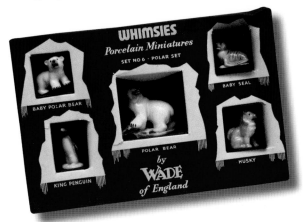

Presentation box for Whimsies Set 6, open.

Presentation box for Whimsies Set 4.

Presentation box for Whimsies Set 6.

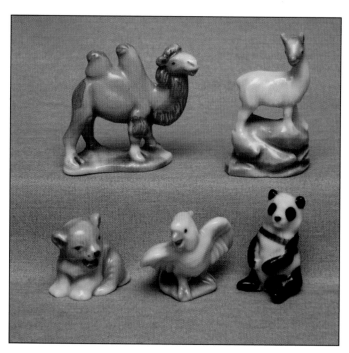

Early Whimsies Set 8, 1958 (Zoo Set). Bactrian Camel, measures 1-1/2" high by 1-5/8" overall and is unmarked ($44, £30). Llama, measures 1-3/4" high by 1-1/8" overall and is unmarked ($48, £24). Lion Cub, measures 1" high by 1" overall and is unmarked ($38, £24). Cockatoo, measures 1-1/8" high by 1-1/4" across the wings and is unmarked ($58, £30). Giant Panda, measures 1-1/4" high and is unmarked ($48, £24).

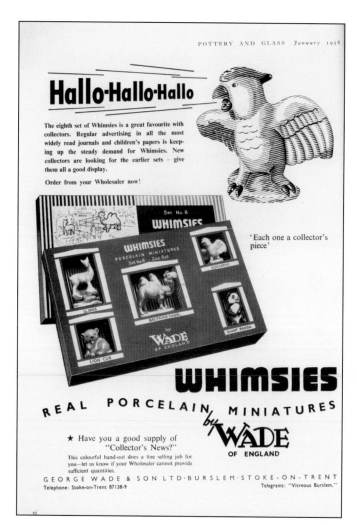

Advertisement for Whimsies Set 8 from the January 1958 issue of *Pottery and Glass*.

Presentation box for Whimsies Set 8.

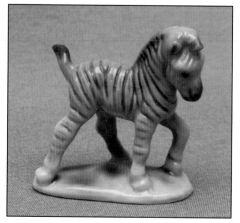

Prototype Zebra. The figurine measures 1-5/8" high and is unmarked. This figurine, modeled by William Harper, was proposed for the 1958 Whimsies Zoo Set but never went into production ($310, £175).

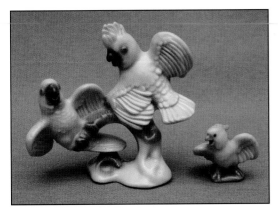

Left: Prototype Cockatoo. The figurine, modeled by William Harper, measures 2-7/8" high by 2-3/4" across and is unmarked ($420, £280). Right: Production model shown for comparison.

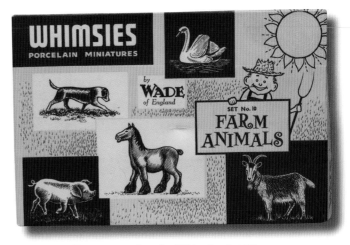

Presentation box for Whimsies Set 10.

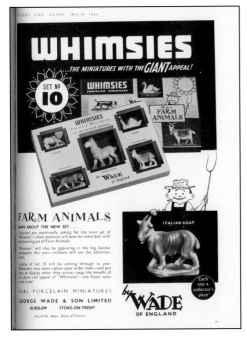

Advertisement for Whimsies Set 10 from the March 1959 issue of *Pottery and Glass.*

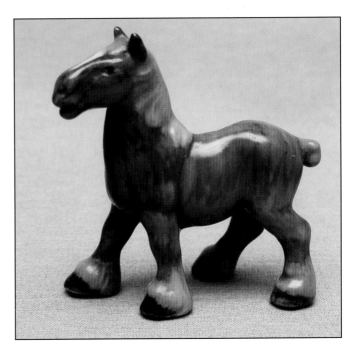

Shire Horse (Set 10). Color variation ($400, £250).

Swan and Shire Horse Reproductions, *1992*

In 1992, a reproduction of the early Whimsie Swan appeared on the market. The reproduction Swan has a shorter, thicker, and straighter neck with a smooth transition from head to beak. The wings are more rounded and lumpier than the original and the reproduction has shorter, more rounded tail feathers plus a lack of detail between the wings.

In the same year, a reproduction of the Shire Horse also appeared on the market. The reproduction horse is crude and is taller than the original, measuring 2-1/16" high. The reproduction has a decidedly backward slant and appears as if the horse were about to fall backwards. It also has large, clumsy, and poorly formed hooves.

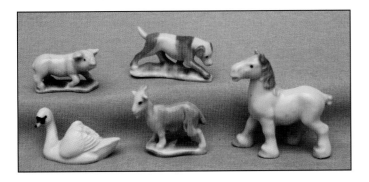

Early Whimsies Set 10, 1959 (Farm Animals). Piglet, measures 7/8" high by 1-1/2" overall and is unmarked ($76, £45). Fox Hound, measures 1" high by 1-3/4" overall and is unmarked ($77, £45). Swan, measures 7/8" high by 1-1/2" overall and is unmarked ($190, £110). Italian Goat, measures 1-3/8" high by 1-1/2" overall and is unmarked ($77, £45). Shire Horse, measures 2" high by 2-1/8" overall and is unmarked ($235, £140).

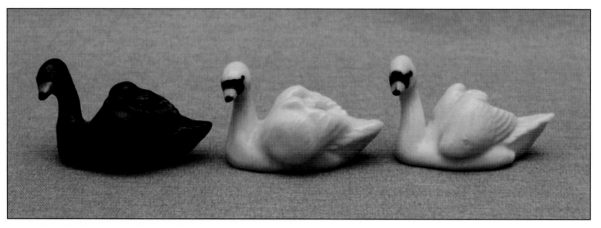

Swan (Set 10). Left: Swan. A black version of the unauthorized reproduction. Center: Swan. The white version of the unauthorized reproduction. Right: Swan. The production model.

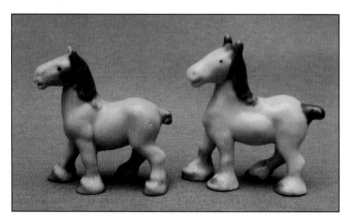

Shire Horse (Set 10). Left: Shire Horse. Production model. Right: Shire Horse. Unauthorized reproduction.

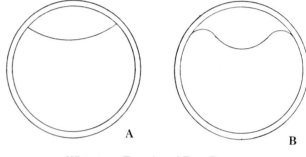

Whimtrays Type A and Type B.

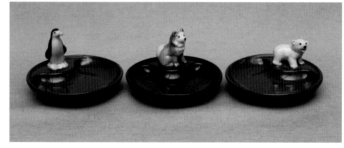

Whimtrays with Penguin, Husky, and Polar Bear Cub ($35 each, £14 each).

WHIMTRAYS, *1958 - 1965*

When the 1953 - 1959 series of Whimsies were withdrawn from the market, a large number of figurines remained, but not enough to form complete sets. To use up these figurines, a small tray was produced with a ledge incorporated into the tray on which to mount the left over Whimsies. The trays were given the name "Whimtrays." The early trays were produced by both George Wade and Son Ltd. and Wade (Ireland) Ltd. from 1958 to 1965.

The trays made in Ireland differed in shape from those made in Burslem. The ledge on the Irish tray is in the shape of a half circle with the edges curved back to blend in with the upturned edge of the tray (Type B). Trays made in England have ledges in the shape of an arc (Type A). The Irish made trays have Mark Type 40B on the base and were produced with yellow, green, black, blue/green, and pink glazes.

WHIMTRAYS, *1971 - 1987*

Production dates of the Whimtrays are not too clear. According to the late Derek Dawe, one time Sales Admin. Manager of George Wade & Son Ltd., the only Whimtrays in production in 1971 were the fawn, duck, and trout from the 1971 - 1984 sets of Whimsies. These trays, which were manufactured at the Irish pottery, were produced with black, blue, or green glazes and had Mark Type 40B on the base. These Whimtrays were discontinued in 1987.

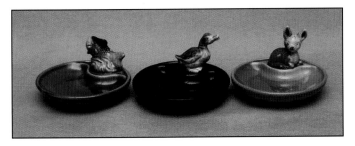

Whimtrays with Trout, Duck, and Fawn ($25 each, £8 each).

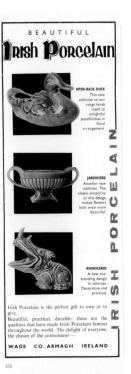

BEAUTIFUL
Irish Porcelain

OPEN-BACK DUCK
This new addition to our range lends itself to delightful possibilities in floral arrangement.

JARDINIERE
Another new addition. The classic simplicity of this design makes flowers look even more beautiful.

RHINOCEROS
A new outstanding design in ashtrays. Decorative and practical.

Irish Porcelain is the perfect gift to own or to give.
Beautiful, practical, durable; these are the qualities that have made Irish Porcelain famous throughout the world. The delight of everyone, the choice of the connoisseur.

WADE CO. ARMAGH IRELAND

IRISH PORCELAIN

232

Advertisement from the March 1962 issue of *The Pottery Gazette and Glass Trade Review*.

BALLY - WHIM VILLAGE, *1984 - 1987*

With the popularity of the English village series "Whimsie-on-Why," Wade (Ireland) Ltd. introduced a series of miniature houses typical of those found in an Irish Village. The Irish village was given the name "Bally-Whim." Each miniature house is mold marked Wade Ireland and each model bears its number in the series.

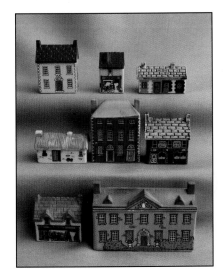

Top row: Undertaker's House measures 2" high by 1-1/2" long ($30, £12). Moore's Post Office measures 1-1/2" high by 1" long ($30, £12). Barney Flynn's Cottage measures 1-1/8" high by 1-3/4" long ($30, £12). Middle row: Kate's Cottage measures 1-1/8" high by 1-3/4" long ($35, £14). The Dentist's House measures 2" high by 1-3/4" long ($35, £14). Mick Murphy's Bar measures 1-3/4" high by 1-1/2" long ($35, £14). Bottom row: W. Ryan's Hardware Store measures 1-1/2" high by 1-1/2" long ($35, £14). Bally-Whim House measures 2" high by 3-1/4" long ($35, £14).

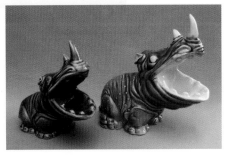

Left: Grey Rhino measures 7" high by 8-1/2" long and is unmarked ($160, £80). Right: Brown Rhino measures 8-1/2" high by 10-1/2" long and is unmarked ($200, £100).

RHINOCEROS ASHTRAY, *1962*

This figure, described as a new outstanding design in ashtrays in the March 1962 issue of *The Pottery Gazette and Glass Trade Review*, has been found in three sizes.

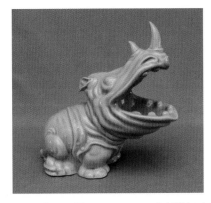

Light Green Rhino measures 8-1/2" high by 10-1/2" long and is unmarked ($200, £100).

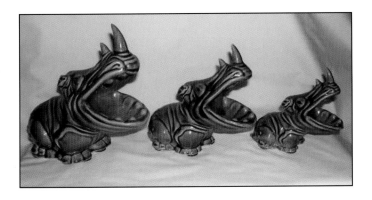

Left: Large Size Rhino measures 8-1/2" high by 10-1/2" long and has Mark Type 30 on the base ($200, £100). Center: Medium Size Rhino measures 7" high by 8-1/2" long and has Mark Type 33 on the base ($160, £80). Right: Small Size Rhino measures 5-1/2" high by 6-1/2" long and has Mark Type 33 on the base ($160, £80). The rubber stopper in the base of the figure reads: CHEKALEKE Regd. No. 698795.

LARGE ANIMAL FIGURINES,
1978 - circa 1980

A series of large animal figurines consisting of Walrus, Polar Bear, Koala Bear, Rhino, Elephant, Panda, Monkey, and Lion was produced by Wade (Ireland) Ltd. in the late 1970s. The set was not connected to the earlier "Blow-Up" polar bear, polar bear cub, and seal that were produced in the early 1960s by George Wade & Son Ltd.

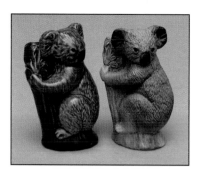

Koala Bears. The bears measure 4-1/4" high and are unmarked ($470 each, £280 each).

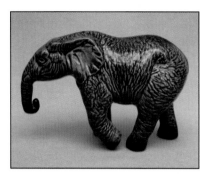

Elephant measures 3-3/4" high by 5-1/2" long and is unmarked ($650, £400).

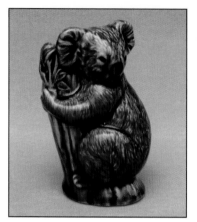
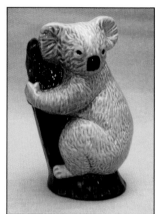

Left: Koala Bear. Color variation ($470, £280). Right: Dunstable Koala Bear. This figurine was issued for the October 1997 Dunstable Wade Fair and is marked: Koala Bear 1 of 1,500 Exclusive Limited Edition for the Dunstable Wade Fair ©UK Fairs Ltd. and Wade Ceramics Ltd. This figurine is shown for comparison only ($75, £42).

Panda measures 4-1/4" high and has a transfer mark: Wade Ireland ($650, £400).

Lion measures 4-1/2" high by 7-3/4 long and is unmarked ($560, £330).

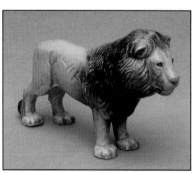

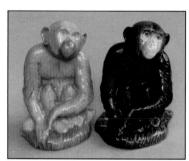
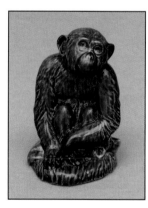

Left: Light Brown Monkey measures 4-1/2" high and is unmarked ($550, £325). Right: Dark Brown Monkey measures 4-1/2" high and is marked: Wade Ireland ($550, £325).

Monkey. Color variation ($550, £325).

Walrus measures 3-3/4" high by 6" long and is transfer marked: Wade Ireland ($650, £400).

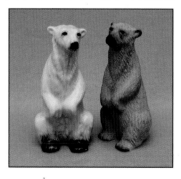

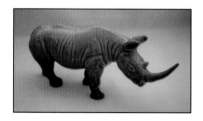

Rhinoceros. The figurine measures 2-3/4" high by 7" overall and is unmarked ($550, £325). The rhinoceros shown in *The World of Wade Figurines and Miniatures* was originally attributed to Wade but this has proven to be incorrect. The rhinoceros illustrated here is the figurine produced by Wade (Ireland) Ltd.

Polar Bears. The bears measure 5-3/4" high. The white bear is marked Wade Ireland ($560 each, £330 each).

WESTMINSTER PIGGY BANK FAMILY,
1983 - 1989

Starting in December 1983, a set of five piggy banks was introduced by The National Westminster Bank to be given to young depositors at various intervals of their Piggy account balance levels. All five Piggies are mold marked either "Wade England" or "Wade." Production of the series was divided between Burslem and Portadown. The 1998 issue of the piggy bank "Wesley" was made only in Burslem.

Collectors should be aware that forgeries of the Westminster Piggy Bank Family exist. The Sir Nathaniel piggy bank is often found with a white jacket. This version was not made by Wade, either in Ireland or England.

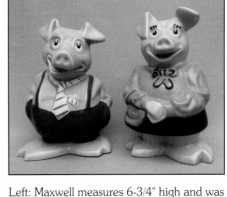

Left: Maxwell measures 6-3/4" high and was given after the second statement with a balance of 50 pounds sterling or more ($68, £45). Right: Lady Hilary measures 7" high and was given after the third statement with a balance of 75 pounds sterling or more ($60, £40).

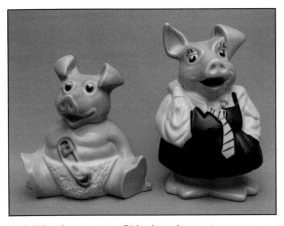

Left: Woody measures 5" high and was given upon opening an account ($30, £12). Right: Annabel measures 6-3/8" high and was given after the first statement with a balance of 25 pounds sterling or more ($35, £26).

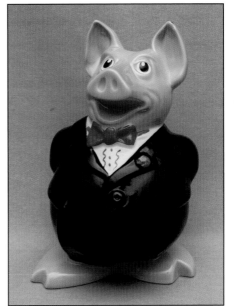

Sir Nathaniel measures 7-1/4" high and was given after the fourth statement with a balance of 100 pound sterling or more ($120, £80).

Moira Hamilton decorating the Maxwell piggy bank with a representative from the National Westminster Bank looking on.

Left: John A. Stringer, Managing Director, Wade (Ireland) Ltd. Center: A National Westminster Bank representative. Right: Claude Rowley, Sales & Marketing Director, Wade Heath and Co., Ltd., September 1986.

BIBLIOGRAPHY

Baker, Donna. *Wade Miniatures*. Atglen, Pennsylvania: Schiffer Publishing Ltd., 2000.

Carryer, the late H. Straker. Personal communication.

Carryer, Iris Lenora. Personal communication.

Carryer, Iris Lenora. *Searching for the Pony*. Privately published

Lee, Dave. *The Wade Dynasty*. Woking, Surrey, UK. The Kudos Partnership Limited, 1996.

Dawe, the late Derek. L. J. Personal communication.

Harper, William. K. Personal communication.

McCullough, the late R. Alec. Personal communication.

Murray, Pat. *Volume Two Decorative Ware 2nd. Edition*. Toronto, Ontario. The Charlton Press, 1996

Murray, Pat. *Wade Whimsical Collectables Fifth Edition*. Toronto, Ontario. The Charlton Press, 2000

Stringer, John. A. Personal communication.

Trouton, Muriel. Personal communication.

The Wade Watch. Arvada, Colorado. Wade Watch Ltd. Various Issues.

Wade Wholesalers Newsletter No.1, August 1956.

Wade Wholesalers Newsletter No.2, January 1957.

Wade Wholesalers Newsletter No.3, August 1957.

Wade Wholesalers Newsletter No.4, January 1958.

Wade Wholesalers Newsletter No.6, January 1959.

Wade Wholesalers Newsletter No.8, January 1960.

Warner, Ian and Posgay, Mike. *The World of Wade*. Marietta, Ohio. The Glass Press, Inc., dba Antique Publications. 1988.

Warner, Ian and Posgay, Mike. *The World of Wade Book 2*. Marietta, Ohio. The Glass Press, Inc., dba Antique Publications. 1994.

Warner, Ian and Posgay, Mike. *Wade Price Trends First Edition*. Marietta, Ohio. The Glass Press, Inc., dba Antique Publications. 1996.

Warner, Ian and Posgay, Mike. *The World of Wade Figurines and Miniatures*. Atglen, Pennsylvania. Schiffer Publishing Ltd., 2002.

Resource Centers

The Rakow Library, Corning Museum of Glass, Corning, New York, USA.

Toronto Reference Library, Toronto, Ontario, Canada.

The New York Public Library, Science and Technology Division, New York, New York, USA.

The British Library, Newspaper Library, London, England.

Websites of Interest

http://www.wade.co.uk
http://www.cscollectables.co.uk
http://www.redrosetea.com
http://www.kswader.com
http://www.wadeattic.com
http://www.benswade.co.uk
http://www.theworldofwade.com
http://www.whimsicalwades.com
http://www.ameriwade.com

INDEX